Seeing Science

Marvin Heiferman

How Photography
Reveals the Universe

aperture UMBC

03

**Photography
+ Science**
———————
Imagination

Foreword

by Scott Kelly

Photography's relationship to science has played a role in my career since I worked on the Hubble Space Telescope in 1999. Hubble is one of the biggest scientific and photographic pieces of hardware that has ever existed. I've thought about that telescope often ever since—the fact that it's been taking pictures for more than twenty years, and what it's shown us about our place in the universe.

In January 2015, a few months before I was scheduled to lift off and spend a year on the International Space Station, I was surprised to hear President Obama say in his State of the Union address, "Good luck, Captain—and make sure to Instagram it!" I was already on Instagram, but wasn't paying a lot of attention to it. Then, all of a sudden, my phone started blowing up as people from all over the world began following my account. When you've been in the military and the president asks you do something, you do it. If the commander in chief asks you to Instagram an experience, you say, "Yes, sir, I will!" And I knew that I was in a unique position to do just that, since I would be working as a scientist, be something of a science experiment myself, and serve as a spokesperson for science, all at the same time.

I didn't have a lot of personal experience with photography when I first came into the astronaut office in 1996. But as astronauts, we get a lot of photography training, just like we're trained to be plumbers, electricians, engineers, scientists, doctors, and dentists. On the space station, we use photography for a number of reasons—it is a big part of any expedition. One reason is scientific: we take pictures of experiments and make micro- and macroimages as we work. We also capture data by taking pictures of the cosmos and celestial events. Other times we're making photos of Earth's geography, 250 miles below, in order to measure the dynamic force of hurricanes, floods, and wildfires, or to document the environmental effects of urban growth or water depletion, for example. We also use photography for engineering purposes: a piece of hardware falls off or breaks and we take a close-up picture to communicate with people on the ground. And then, of course, we make pictures to share the experience of living and working on the space station, what that looks and feels like.

There were three different kinds of photographs I would take for the public: pictures of the mission itself—of the people and activity inside the space station; pictures of the natural world—of the stars and of places on Earth that are recognizable (where you know what you are looking at is water or Florida or North America); and then there were pictures that I took simply because they looked amazing to me. I had seen other people's photographs and reached out to former astronauts for tips on certain space photography techniques. The hardest pictures to make were the close-ups of cities at night. You're in a microgravity environment, traveling at five miles a second and using a camera with a slow shutter speed, while the Earth is moving by at 17,500 miles an hour. I had to hold the camera very still.

My social media presence was my personal project. In my free time, I was able to make photographs documenting what was going on (big snowstorms, the supermoon) when people on Earth were experiencing the same things, sharing them on social media at the same time. Other pictures were meant to capture a sense of wonder I felt and the beauty I saw.

Part of an astronaut's job is to advocate for science. We engage the public through the written word, photography, video, and sound, and images play a central role. Space photographs are, of course, inspirational. When you are an astronaut in space, the ability to share your experience and to capture the imagination of people is essential. You know that the subjects you are studying and photographing are not only important to NASA, but to society as well.

Scott Kelly is a retired NASA astronaut best known for spending a record-breaking year in space. He is a former US Navy fighter pilot, test pilot, and veteran of four spaceflights. Kelly commanded the space shuttle *Endeavour* in 2007 and the International Space Station for three expeditions.

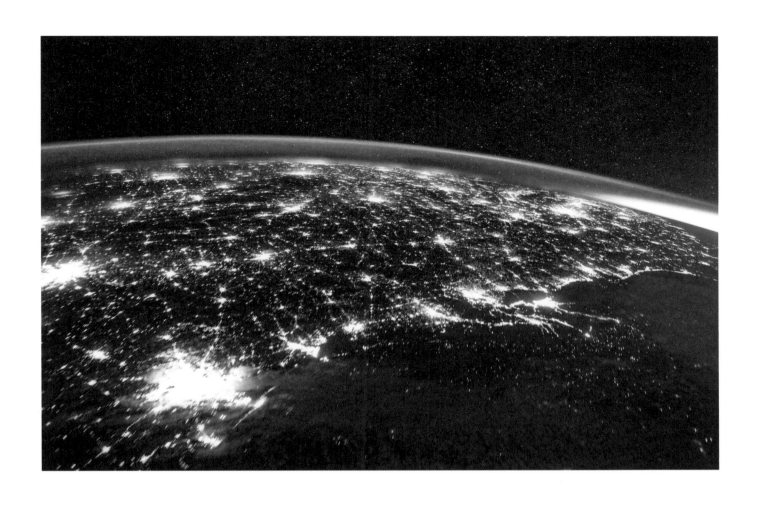

Scott Kelly,
Night lights of Houston and the Gulf Coast as seen from
the International Space Station, January 5, 2016

On Seeing Science

by Marvin Heiferman

Earthrise—one of the best known and most widely reproduced of all science photographs—was a fluke. On Christmas Eve, 1968, after three days of space travel, America's Apollo 8 spacecraft was on its fourth orbit around the moon when Frank Borman, the commander of the mission, began to reposition it so that the topography below could be better filmed to document potential future landing sites. During the brief time that the capsule's windows faced away from the lunar surface, astronaut William Anders looked through them and was startled by what he saw: "Oh my God! Look at that picture over there! Here's the Earth coming up. Wow, is that pretty!" Anders grabbed a Hasselblad camera, loaded it with 70 mm Ektachrome film, and hastily shot off a couple of frames to capture an unanticipated and spectacular sight: Earth's seeming ascent above the moon's rough surface.[1]

After splashdown on Earth and once Anders's film was processed, one image from it, circulated worldwide by the media, left viewers awestruck. Serene, if a little disquieting, the photograph presents the marbled, blue-and-white planet's fragile beauty that, seen from a distance, hints at Earth's insignificance in the vastness of space. Wonder and intimations of the sublime are the frequent by-products of science photography, and the most paradigm-changing of images can be simultaneously mind-boggling and sobering. "Wonder is tinged with awe . . . and it's also tinged with fear," science historian Lorraine Daston wrote. "It's an uncomfortable emotion. You don't have wonder. Wonder has you."[2] Once it does, and thanks to photography, we keep on looking.

The term *scientist* was coined by William Whewell, a British philosopher and colleague of Charles Darwin, in 1834. Five years later, the first public use of the word *photography* was attributed to Sir John Herschel, the photographic pioneer who is also credited with introducing the terms "negative" and "positive" into the discourse of the new imaging medium. Ever since then, science and photography have been inextricably intertwined, two observational disciplines that reimagine and redefine each other as the need to see, and new tools for seeing, evolve. Photography, born of and shaped by science, transformed the nature of observation and stretched the parameters of knowledge and humanity's sense of itself. Startling still images of subjects and phenomena—too small or intricate to be noticed by the human eye, too large or far away to be directly experienced, or changing too slowly or quickly for differences to be perceived—became objects of fascination and study. Photographs were immediately marshaled into service to help answer the most practical and existential of questions: What is that? Where and who are we? What happens next? Photography was deputized as one of science's most trusted agents, essential to enhanced viewing and to making "the invisible visible, the evanescent permanent, the abstract concrete."[3]

Today, science imaging frames many of the challenges of our time: how to recognize and counter climate change, conquer disease and hunger, and map the brain's neural network. Photography fuels information technologies that, soon after we create and adopt them, start restructuring our lives. In a series of controversial lectures delivered in the late 1950s, the British chemist and novelist C. P. Snow argued that the sciences and humanities represent two distinct and unbridgeable cultures. Six decades later, that gap has largely closed, as photographic images made in and of the sciences appear frequently—as news, on social media, in advertisements, in entertainment and the arts—and play significant roles in shaping public awareness, policy, and funding. Just as the sciences are altered by how images are constructed and read, so too is the public's perception of science, its practitioners, and its impact.[4] Science photography has moved from the background to the foreground in the twenty-first century's field of vision, and *Seeing Science* presents a range of images and texts to explore how that came to pass. Traditionally, projects about the relationship of photography and science tend toward circumspection, tracking technical firsts in evidential imaging and then reflecting upon how the implications and often unintended beauty of those remarkable images intrigue and inspire artists. The goals of *Seeing Science* are different and twofold: to broaden the definition of science photography by expanding upon the nature of images considered, and to acknowledge some of the ways that visual culture—appreciatively, critically, and sometimes irreverently—responds.

To that end, this book surveys a spectrum of visuals that contribute to the "modern-day scientific enterprise," underscoring the fact that science does not exist in a world of its own, but is embedded in a range of endeavors as

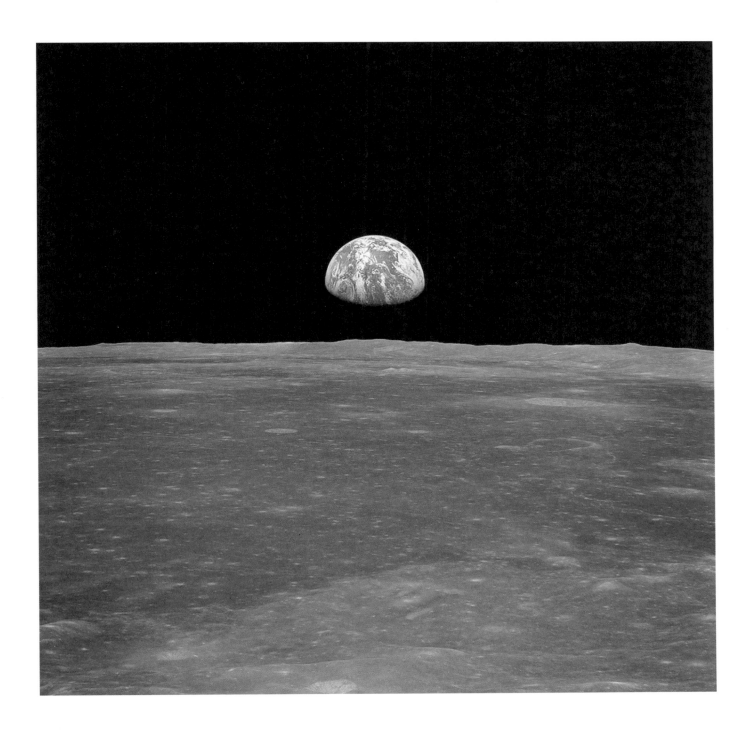

William Anders,
Earthrise, 1968

expansive as photography itself has become.[5] Both science and photography are observational systems with fluid borders and multiple constituencies. Images generated in fields as diverse as biomedicine, robotics, and astrophysics prove themselves to be as relevant and riveting to general audiences as to professional ones. The visionary writer Stewart Brand contends that

> Science is the only news. When you scan a news portal or magazine, all the human interest stuff is the same old he-said-she-said, the politics and economics the same sorry cyclic dramas, the fashions a pathetic illusion of newness; even the technology is predictable if you know the science. Human nature doesn't change much; science does, and the change accrues, altering the world irreversibly.[6]

Just as what constitutes science—and science photography—changes in content and form, images essential in the day-to-day work of the sciences lead multiple lives as they reverberate throughout visual culture and influence how nonscientists come to understand themselves and others, the world they know and others that they can only imagine. Because neither science nor photography exists in isolation, *Seeing Science* juxtaposes images made by scientists, artists, photojournalists, commercial and stock photographers, the entertainment industry, and amateur picture takers. The range of subject matter and variety of stylistic approaches represented in these pages highlight how powerfully our engagements with the sciences are conditioned by how and where science images are encountered and represented.

Three decades ago, Carl Sagan, one of science's proselytizers, lamented: "We live in a society exquisitely dependent on science and technology, in which hardly anyone knows anything about science and technology."[7] Since then, and as the sciences and our interactions with them have become increasingly frequent—and image-driven or -dependent—photographs function not only as data for, and artifacts of, the sciences, but also as the narrators and popularizers of science.

"When you're scientifically literate, the world looks different," astrophysicist Neil deGrasse Tyson points out, and photography's foundational role in teaching and promoting scientific literacy has never been clearer.[8] And as our engagements with scientific imaging expand so have the parameters and definition of science photography. As the photographic historian Kelley Wilder observed, "There was never *a* photographic method, but many individual methods, each particular to a time, a scientist, or laboratory, and most importantly, to a phase in the history of photography."[9]

The very first photographs were labor-intensive and fragile images that rested atop chemically treated pieces of metal and paper. In recent decades, advances in digital and

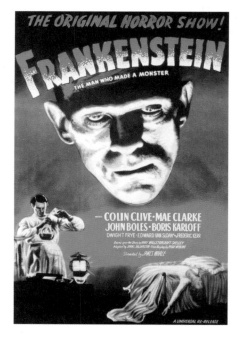

Poster for the 1931 film *Frankenstein*. The film's popularity demonstrates how the sciences and humanities are connected, how visual culture responds to scientific ideas.

Advertisement for cellophane, ca. 1950s. DuPont's photographic ad campaign praised science's role in modern life with the tagline: "Better things for better living . . . through chemistry."

computational imaging—the kinds that make it possible to, for instance, record a trillion frames per second or register the light of a single proton—have stretched the parameters of photography's definition, capabilities, and materiality. Detailed scientific imaging is no longer solely reliant upon the recording of light, but can be constructed by registering sound waves, thermal readings, and electrical impulses, and tracking paths of subatomic particles. If, in the past, photographic images were believed to be best left untouched in order to ensure their authority, today they are routinely adjusted to deliver more and better data.

It may seem obvious that the more we see, the more we know, but photography also reminds us of all that still lies beyond the borders of the frame—and our perception—and all that is left to learn. "The most beautiful thing we can experience is the mysterious," Albert Einstein said. "It is the source of all true art and science. He to whom this emotion is a stranger, who can no longer pause to wonder and stand rapt in awe, is as good as dead: his eyes are closed."[10] For those with open eyes, who believe that looking is learning, the history of observation is understood as an ever-evolving narrative. It tracks, as Lorraine Daston and Elizabeth Lunbeck have written, "how experience has been shaped and sharpened to scientific ends: how the senses have been schooled and extended; how practices for recording, correlating, and displaying data have been developed and refined; and how the private experiences of individuals have been made collective and turned into evidence."[11]

Science is, to a large extent, investigative work "molded by image-making and image-reading."[12] Thus science typically involves the act of seeing, and as physicist Lawrence M. Krauss notes, "If history is any guide, every time we have built new eyes to observe the universe, our understanding of ourselves and our place in it has been forever altered."[13] From daguerreotypes of the moon to snapshots made by astronauts when they first stepped on its surface, from the first X-rays that unsettled the public in 1895 to diagnostic images regularly captured by insertable and ingestible cameras, from mugshots parsed by racist eugenicists to the vast image databases that make facial recognition and artificial intelligence possible, photography has transformed science—and vice versa.

Once photography started to "push into spheres beyond the limits of human vision," Phillip Prodger observed in *Darwin's Camera*, it "came to assume a privileged place in the visual realm."[14] Photography was charged with transforming "information generated by almost any wavelength— interacting with an object of any size, at any distance, and in all four dimensions—into something two-dimensional that we can see."[15] It introduced an unprecedented form of "virtual witnessing" that enabled viewers to collect and share evidence based upon investigative looking that was accurate and vivid enough to diminish "the necessity for either direct witness or replication."[16] For example, Maria

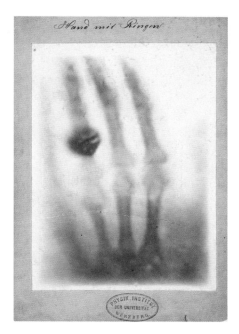

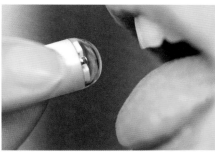

Wilhelm Conrad Röntgen,
Hand with Rings, 1895; one of the first x-ray images.

David Gray,
A pill camera used for endoscopic examinations, is about to be swallowed during a display in Sydney, October 16, 2001. The capsule, developed by NASA using Israeli military technology, contains a color video camera, light source, transmitter, antenna, and battery. Seven hours of footage can be condensed into two and viewed by a doctor.

first female astronomer, carefully packed one of the fragile first glass negatives to depict stars in her luggage and was able to discuss it with Sir George Biddell Airy, England's Astronomer Royal, after crossing the Atlantic Ocean in 1857. The showing and sharing of photographs that were essential in the classification, ordering, and archiving of data became indispensable in education, where the study of clinical medical photographs would become routine by the 1880s and 1890s. The trend continues at academic and professional conferences today, as posters summarizing presenters' research often feature eye-catching photos to snare the attention of passersby and potential collaborators. As an 1882 essay titled "What Photography Does for Science" pointed out, "When photography is used as means of investigation . . . more interest attaches to the subject."

To a large extent, the rigorous demands placed on the production of science photographs are what determine their utility, authority, and often-radical look. Photography "transforms phenomena into codified information," and for the sake of accurate recording, interpretation, and ease of retrieval, the fewer flourishes, the better. Most science photographs have a no-nonsense style: Subjects are often shot frontally and against neutral backgrounds. They are evenly lit, rendered in sharp focus, and are often annotated with indicators of scale, all in the service of legibility. When duration or change over time need to be documented, before-and-after shots, multiple exposures, and sequential imaging are called into service.

Before photography, science images were artifacts handmade by scientists or produced by artists working under their direction in a collaborative process known as "four-eyed sight." But no matter how meticulously subjects were rendered, subjectivity inevitably crept in. Even the most detailed of drawings, paintings, etchings, or lithographs were susceptible to aestheticization and presented "nature perfected, excerpted, smoothed." When photography was introduced, it was appreciated for its instantaneity and precision. If humans tasked with accurate representation might tire out, photography would not. "It was indiscriminate, and therefore objective," Kelley Wilder explains. "It was optical, and consequently reliable. Or so went the rhetoric."

But, it would become clear, even mechanized vision has its limits, and objectivity is never easy to deliver. Until the manufacture of photographic plates, films, chemistry, and papers was standardized toward the end of the nineteenth century, the quality and stability of images and their substrates fluctuated and measurements based upon them could be problematic. Even today, researchers and clinicians need to be trained to not only look carefully at what they anticipate seeing, but also to scan for unexpected data or relationships that might, upon reflection, turn out to be of significance. Science photography represents "two layers of observation, one made at the moment, and all subsequent observations." One of the best-known examples of those

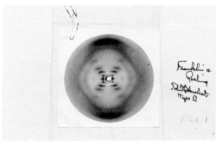

A dissection of a human abdomen showing the duodenum, pancreas, and bile ducts, ca. 1900, is an early example of clinical medical photography used for education and research.

Raymond G. Gosling and Rosalind E. Franklin, This iconic X-ray diffraction image of cell DNA, known as "Photo 51," led to a better understanding of the double helix architecture of DNA, 1952

sorts of photographic second thoughts occurred when James Watson and Francis Crick were credited with conceptualizing the three-dimensional architecture of DNA's double helix, which only occurred after the scientists were shown, and had reflected upon, a tiny, two-dimensional X-ray diffraction photograph made by Raymond G. Gosling, a graduate student working under the direction of Rosalind E. Franklin, that would become one of the most consequential science photographs ever made.[27]

Because a single, unmanipulated image is not always the clearest carrier of information, in some instances postproduction edits may take place. Before NASA and the Hubble Space mission release pictures of newly seen galaxies for public consumption, for example, images made by multiple cameras, each receptive to specific sections of the light spectrum, are often stitched together, colorized, and sharpened in order to make the image's content more readable. The continual upgrading of imaging technology to best represent new subjects and phenomena underscores why photography and science have always been closely associated with concepts of modernity. "Scientific progress in the mid-nineteenth century struck contemporaries as faster, more violent, and less continuous than in previous generations," Lorraine Daston and Peter Galison wrote in the book *Objectivity*. "The headlong pace of scientific progress experienced within a single lifetime seemed to threaten the permanence of scientific truth."[28] By 1882, Britain's *Photographic News* was reporting: "Fifteen years ago it would not have been difficult to enumerate . . . the chief duties photography discharged in connection with science. She was a species of upper-servant then, performing valuable service enough, but rather of a light order. To-day she is a maid-of-all-work, put upon, on every occasion, to discharge all sorts of functions, whether menial or high-class."[29] Setting the gender and class assumptions of that observation aside, it points to the central role photography would play in structuring the hybrid activity science would become.

Once science-related photographs made in the late nineteenth century began to be prominently exhibited in international expositions and regularly reproduced in newspapers, magazines, and books, public interest in the sciences grew dramatically as "virtually every season, a 'new discovery' dominated the weekly and monthly magazines."[30] Novel images of flora and fauna, geological marvels, engineering feats, planetary objects, medical anomalies, and purported representations of departed souls intrigued audiences who "followed news of bacteria with the mixture of apprehension and thrill with which they followed news of criminals."[31] By the twentieth century, not only the sciences but also scientists themselves were being pictured regularly enough to become recognizable figures whose accomplishments were hailed in the picture press, newsreels, feature films, and television shows. In 1919, when photographs made by Arthur Eddington during a solar

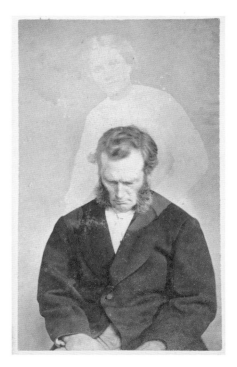

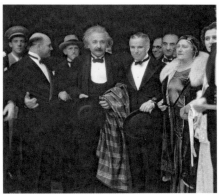

William H. Mumler,
Bronson Murray, 1862–75. A "spirit" photograph representing supposed nineteenth-century scientific developments.

Charlie Chaplin attending the premiere of his film, *City Lights*, flanked by his guests of honor—Albert and Elsa Einstein, 1931

eclipse—confirming that light waves from distant stars were deflected by the sun's gravitational forces—appeared on the front pages of newspapers worldwide, they not only proved Albert Einstein's theory of relativity to be correct, but were instrumental in turning the physicist into a much-photographed and global celebrity.[32]

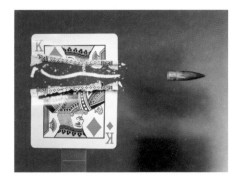

In the twentieth century, to account for the fact that "the naive and trained eye see differently," more narrative approaches to science imagery began to evolve.[33] Images made in the course of research would require, at the very least, captions—to explain their content and import to wider audiences, and because photographs can be "irrefutable as evidence but weak in meaning."[34] When *National Geographic*, a text-heavy and scholarly magazine when it began in 1888, ran its first extended photo-story in 1905—featuring eleven pages of Tibetan views—the innovative presentation was so well received that editor Gilbert H. Grosvenor wrote that he was repeatedly stopped on the street and thanked by appreciative readers.[35] Unlike science images that are required to adhere to straightforward methodologies, those designed to attract public attention are conceived and constructed with other criteria in mind. Generic stock photographs of, for example, lab-coated technicians hoisting test tubes of brightly colored liquids up for inspection function as eye candy and, used often enough to illustrate science in action, function like flash cards. Harold E. Edgerton, the electrical engineer who revolutionized stroboscopic lighting techniques in the 1930s, "labored to make his images concise and compelling, as easy to read as advertisements, so that they would speak to people with no scientific training at all."[36] The narrative and graphic clarity of his time-stopping photographs—showing elegant coronas kicked up by milk drops and the paths of speeding bullets as they ripped through mundane household objects—thrilled the public by dramatizing concepts previously of interest only to specialists.

In 1925, Science Service—a not-for-profit news agency established to promote the sciences—circulated on-the-scene pictures of the Scopes Monkey Trial in Tennessee, where a local high school instructor was charged with teaching evolution, catapulting the event to national attention. It did so by picturing the vivid personalities involved and visualizing frictions that arise when scientific facts and religious beliefs collide.

Tensions of a different sort are depicted in dubious science images that periodically pop up in the media and call the proverb "seeing is believing" into question. One of the most infamous of them, purported to be a British doctor's blurry shot of a sea monster rising from the wavelets of Scotland's Loch Ness, caused a sensation in 1934 and continues to inspire the production and spread of other factually murky pictures. Mid-twentieth-century snapshots purporting to confirm sightings of unidentified flying objects have fueled the fantasies and careers of alien hunters, science-fiction writers, and filmmakers. They have also vexed

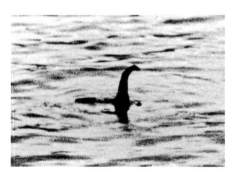

Harold E. Edgerton,
Cutting the Card Quickly, 1964

Watson Davis,
Tennessee v. John T. Scopes trial: Outdoor proceedings on July 20, 1925, showing William Jennings Bryan seated at left and Clarence Darrow standing at right, 1925

Photographer unknown,
Image purporting to depict Scotland's fabled Loch Ness monster, 1934

government officials who, as one 2017 report revealed, have been secretly investigating UFO image captures as part of the Pentagon's Advanced Aviation Threat Identification Program.

The popularization—and the merchandizing—of yet another genre of science imaging, nature photography, has played a pivotal role in heightening public engagement in environmental issues and activism. More than eight million copies of the Sierra Club's calendars, lauded for their lush photography, have been sold since they were introduced in 1967. Decades prior to that, the club's conservation goals were already so closely associated with Ansel Adams's majestic views of the American West that it was "hard to tell which has shaped the other more—Ansel Adams or the Sierra Club." Today, equally striking contemporary images by photographers such as James Balog and Subhankar Banerjee—whose projects focus attention on the cryosphere and the politics of resource wars—tend to be more specific in their targeting and goals. In the media, when the frequency and dollar value of damage triggered by extreme weather events—from earthquakes and tropical storms to volcanic eruptions, floods, and wildfires—increases, professional and amateur imaging of them spikes in tandem.

Historically, the images that popularize science have been the purveyors of good news, bad news, and controversy. Certain photographs—of atomic bomb blasts and unborn fetuses, for example—have proven to be so startling and politically and ethically charged that they instantly became galvanizing and iconic. Calligraphic streams of smoke filling images of the *Challenger* space shuttle's explosion in 1986 delivered a tragic and cautionary message: how the smallest of miscalculations might result in catastrophe. The distinctive shape of nuclear reactors turned menacing as soon as illustrated reports of a 1979 meltdown at Pennsylvania's Three Mile Island generating station began to circulate. In the late 1990s, seemingly benign photos of a sheep—Dolly, the first mammal to be successfully cloned from an adult cell—stoked heated arguments over the promises and pitfalls of genetic modification. And yet only a few years ago, the carefully curated photos NASA uploads to its social media accounts proved so popular that the space agency credited them with helping to triple the number of applicants who applied for the handful of astronaut positions that opened up between 2015 and 2016.

Still, and somewhat surprisingly, even as online venues for science imagery multiply, mainstream media outlets for science journalism seem to be "basically going out of existence," as *New York Times* science writer Natalie Angier has noted. The situation might be less dire if significant advances in the sciences occurred with the clockwork regularity that scheduled science columns have to stick to. "There's something about the human mind that wants to have a sustained story-line, and we're not getting that," Angier went on to say. Trevor Quirk, another commentator, points out that "a common solution chosen by today's science

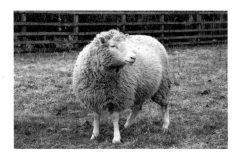

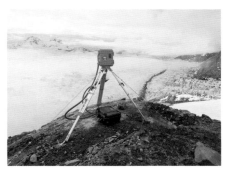

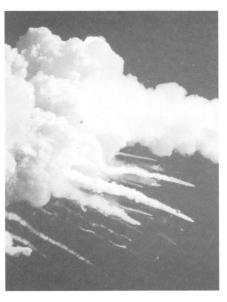

Dolly the Sheep (1996–2003) was the first mammal to be cloned from an adult cell by scientists at the Roslin Institute, University of Edinburgh

Adam LeWinter,
Columbia Glacier, Alaska, 2009. One of many time-lapse cameras used in the Extreme Ice Survey, a long-term program founded by photographer James Balog to track glacial change.

Seventy-three seconds after takeoff, NASA's space shuttle *Challenger* exploded, killing all seven crew members. Taken by a tracking camera, this image shows the crew cabin exiting the contrail cloud before it crashed into the Atlantic Ocean, January 28, 1986

communicator[s] is to make science less complicated and more entertaining" by emphasizing "stories that either dramatize the working lives of scientists or speculate about the impact of a scientific idea on American society and culture."[41]

The media's predilection for human-interest stories encourages science reporters to feature photographs that stress attitude and looks as strongly as accomplishment. Dickenson V. Alley's sensational circa 1899 photograph of Nikola Tesla, seemingly calmly seated in a room crisscrossed by million-volt bolts of electricity, hints at superhuman powers of concentration as it inscribes clichés about mad scientists. In the 1960s, articles about the young Jane Goodall's work with Tasmanian chimpanzees so consistently represented it as a "beauty-and-the-beast-type thing" that they boosted awareness of and funding for her research, something the primatologist—in a 2016 interview conducted by another comely celebrity, Jane Fonda—acknowledged to have been quite helpful.[42]

Not all scientists, though, have been as sanguine or appreciative of the ways they are represented in pictures. In 1863, Charles Darwin declared, "all my photographs and portraits make me look either silly or stupid or affected."[43] As digital portraits for a 2013 profile in London's *Observer* magazine were being shot, biologist Richard Dawkins asked to review the images and when he did, complained that they made him look "too harsh." The photographer responded by saying his intention was to portray Dawkins's "gravitas." The scientist replied: "I don't want fucking gravitas . . . I want humanity."[44] A black-and-white, early twentieth-century image of Marie Curie examining a laboratory beaker had become so deeply etched into cultural consciousness that when a 2001 reenactment of it—a publicity photo of an actress starring in a popular one-woman play about Curie—circulated widely, it was mistakenly represented as Curie on commemorative postage stamps issued by a number of countries, because it presented an attractive woman appearing exactly as the scientist was expected to.[45]

When, why, and how women in the sciences are depicted in photographs is a complex and often vexing matter. Even as women are more consistently recognized for their contributions to science in the twenty-first century, evidence of what historian Margaret W. Rossiter calls the "Matthew Matilda effect"—or, how women scientists' achievements often drop from sight—lingers.[46] The accomplishments of women in the sciences are still underrepresented and when they are reported upon, women are frequently misrepresented, as Declan Fahy quantified in *The New Celebrity Scientists*: "One in five newspaper profiles of male scientists referred to their appearance, clothing, physique, or hairstyle—but one in two profiles of women referred to these elements."[47] During Women's History Month in 2009—and in an effort to better caption the portraits in its Science Service holdings—the Smithsonian Institution Archives started uploading photos

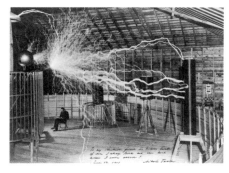

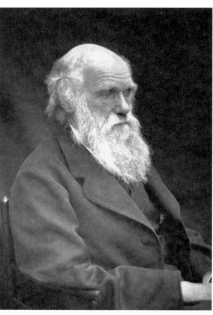

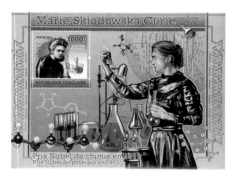

Dickenson V. Alley,
Nikola Tesla, with his equipment for producing
high-frequency alternating currents, ca. 1899

Leonard Darwin,
Charles Darwin, 1878

Souvenir stamp issued in 2011 honoring Marie
Curie's contributions that mistakenly drew from
a publicity photograph of an actress portraying
Curie rather than her portrait.

of unidentified female science workers to the photo-sharing platform Flickr, and as crowdsourcing took effect, the Smithsonian was able to attach specific names and career accomplishments to faces long forgotten.[48]

Projects on other social media platforms have also helped to redress areas of underrepresentation in science, such as Pinterest boards where pictures honor the contributions of African American scientists, from botanist George Washington Carver to Valerie Thomas, who developed image processing systems for America's Landsat satellite program.[49] In the past, however, the representation of African Americans in science photography has more often been less than laudatory. In the 1850s, Harvard University naturalist Louis Agassiz "commissioned" daguerreotypes of unclothed slaves to document the physical characteristics he claimed to be evidence of racial inferiority. The images were largely unseen until their discovery in an attic of Harvard's Peabody Museum of Archaeology and Ethnography in 1976, and their subsequent publication helped to kickstart a new era of critical inquiry into photography's relationships to race, power, and the body, as well as to science.[50]

Throughout the nineteenth century and well into the twentieth, images of racial and ethnic "types"—made by or for scientists, colonizing nations, and entrepreneurs fueling the public's fascination with "a wide range of 'curiosities,' exotica and racial and cultural stereotypes"—were popular and profitable.[51] Marketed in affordable formats, such as cartes des visite and stereo cards, and to mostly white audiences, ethnological photographs functioned as educational artifacts and entertainment for viewers intrigued with the "otherness" of the faraway people and places that photography could clinically and conveniently put on display. Photography's role in the perseverance of racial stereotyping was made clear again a century later, in 1987, when a *Time* magazine cover story, "Those Asian-American Whiz Kids," featured six smiling students posed amid books and next to a computer.[52] Even more recently, in 2015, when a black software developer noticed that Google Photos had labeled an image of him and a friend as "gorillas," the persistence of bias in imaging, key wording, and their implications in the burgeoning field of artificial intelligence became disturbingly obvious.[53]

If the formulaic nature of certain science images perpetuates prejudices, misunderstandings, and cultural blind spots, the innovative visual qualities embodied in others sometimes examine and challenge cultural norms, particularly when images shaped by the sciences' prescribed standards are appropriated by artists and to other ends. As the intricacies and beauty of photomicroscopy became more familiar in the early twentieth century, for example, stunningly detailed close-ups began to define something new, "a space firmly situated between science, industry, photography and art."[54] Geometric patterns and organic shapes visualized in the course of scientists' imaging began to spark interest and echo through the sensibilities and work

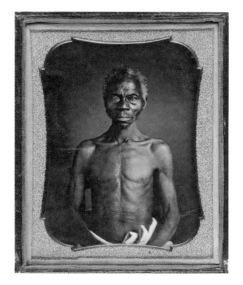

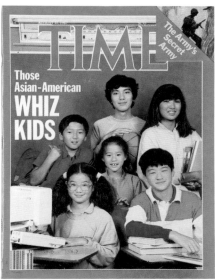

J. T. Zealy,
Renty, Congo, on plantation of B. F. Taylor, Columbia, South Carolina, 1850. Harvard naturalist Louis Agassiz "commissioned" images of unclothed slaves to show physical characteristics he claimed were evidence of racial inferiority.

Cover of *Time* magazine, August 31, 1987. Photography's continual role in pervasive racial stereotyping is clear here.

of Bauhaus-era designers, Futurist painters and sculptors, and photographic innovators as diverse as Karl Blossfeldt, László Moholy-Nagy, and Carl Strüwe.

But while rigorous methodologies compel science's picture-makers to adopt a neutral and third-person perspective, art-making is celebrated as an arena of first-person expression.[55] Artists have been "exhorted to express, even flaunt, their subjectivity, at the same time that scientists were admonished to restrain theirs."[56] Both are encouraged to take risks and push against the limits of what can be seen and pictured. But the sciences advance by sticking to a step-by-step process, a "scientific method" that builds upon prior knowledge through investigation, the acquisition of new knowledge, the reconciliation of the two, and then requiring that similar outcomes can be replicated by others. Art operates and advances in a less linear manner, as practitioners delve into the sorts of hard-to-quantify issues—personal, aesthetic, social, political, and spiritual— that scientists are cautioned to distance themselves from. Forthright depiction is a goal of and the hallmark of science photography. Questioning the forthrightness of visuals is what many artists relish.

As a result, much of the imagery in *Seeing Science* aligns itself with efforts in the field of science studies to contextualize the sciences by examining the cultural conditions that shape inquiry and representation alike.[57] An interdisciplinary perspective in the sciences, arts, and visual culture at large turns out to be helpful when reflecting upon the range of situations in which science-related photos are encountered, and how variously they are called upon to access the past, assess the present, and suggest a future. On any given day, pulsing lasers penetrate overgrown landscapes to reveal long-lost archaeological sites buried beneath them, and security cameras and license-plate readers surveil where we are and then posit where we have been or might be heading. Facial- and object-recognition algorithms and the functioning of self-driving vehicles are all dependent upon vast photographic data sets that depict and categorize the objects, relationships, and situations they have been programmed to recognize and respond to. Access to our personal digital devices, homes, workplaces, and border crossings is, increasingly, approved or denied based upon data extracted from photographic imaging.

The extraordinary range of circumstances in which imaging is produced and put to use highlights why science photography, as an enterprise, is difficult to characterize. In order to improve and advance, science photography is constantly reengineered and upgraded to better "grasp the ungraspable, visualize the invisible, and conceptualize the inconceivable."[58] In contrast to the still, optical images produced two centuries ago to concretize a universe in flux, what we comprehend as a photographic image today really "isn't actually an image any more, but . . . a radical mathematical matrix, of which every single aspect then becomes

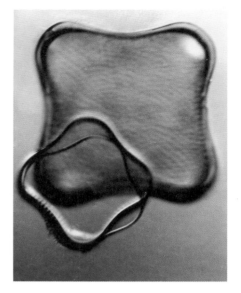

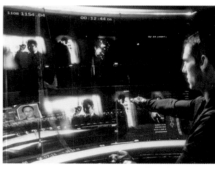

Carl Strüwe,
Square Form of a Diatom, 1929. Strüwe's art-photography is informed by the geometric patterns and organic shapes of scientific imagery.

Film still, *Minority Report* (2002). The detective work of Tom Cruise's character relies on facial-recognition software.

manipulable."[59] Science photography—in the shifting forms it takes, contexts it is encountered in, and ways data and meaning are extracted from it—is unique in how it impresses upon us how enmeshed in the universal scheme of things we are, and yet how limited our comprehension of and impact on that scheme of things may be.[60]

To move science forward, more images must be made, shared, and analyzed. To maintain the momentum of, funding in, and authority of the sciences—particularly as areas of inquiry, such as environmental science, are targeted and come under political attack—images produced will need to more clearly "present science as science in action" and not as a rarified pursuit.[61] An example of that occurred on April 22, 2017, when more than one million demonstrators gathered for Earth Day events in Washington, DC, and more than six hundred cities around the globe.[62] The "March for Science" was organized in response to what is widely perceived to be President Donald J. Trump's support of a "war on science," which plays out in controversial cabinet appointments, rollbacks of protective legislation, the slashing of science advisory positions and research funding, censorship of agency reports and websites, and vociferous attempts to brand climate change as a hoax.[63] A nonpartisan event, the march advocated for "an open and respectful dialogue about science and its impact on policy and society."[64] As photos of crowds and placard-bearing science workers and enthusiasts went viral, they played a strategic role in sustaining the event's messaging and newsworthiness, illustrating yet again how photography reflects and advances the sciences' interests and goals.

"The nature of the human mind is such," Galileo Galilei wrote in 1610, "that unless it is stimulated by images of things acting upon it from without, all remembrance of them passes easily away."[65] If early in the nineteenth century, scientific observation and photography were valued as passive processes of data collection, today both are widely understood to be active and interconnected activities. As images in this book attest, science photography grounds us in the particulars of our earthly and extraterrestrial adventures, and astounds us when it reveals what lies beyond the parameters of sight, imagination, and human control. Through its stunning revelations and beauty, science photography "tells us there is nothing especially privileged about our position." It also reminds us that, given our place in the universe, "we are eternally in 'the middle of things.'"[66] That situation, alternately thrilling and sobering, explains why we keep on looking.

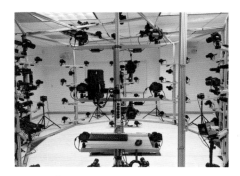

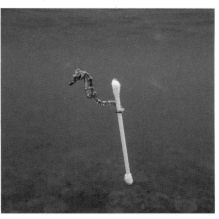

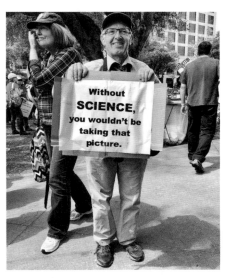

Stephen Babcock,
3-D-scanning room at University of Maryland, Baltimore County, 2015. Ninety digital cameras in a circular formation take photos of a subject that are then processed into a virtual 3-D model.

Justin Hofman,
A small estuary seahorse, *Hippocampus kuda*, drifts in the polluted waters near Sumbawa Besar, Sumbawa Island, Indonesia, 2016

Beth Yarnelle Edwards,
A demonstrator at the March for Science in Washington, DC, on Earth Day, April 22, 2017

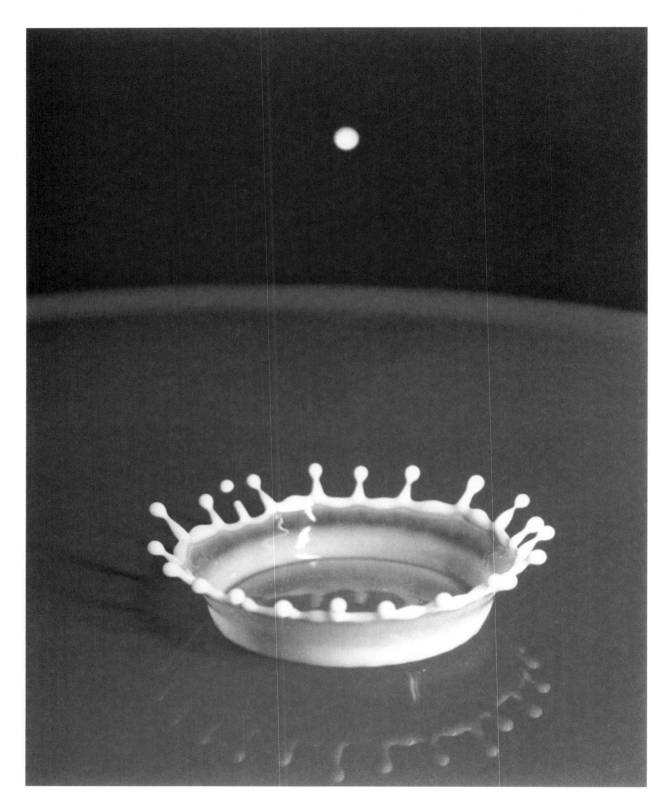

Harold E. Edgerton,
Milk Drop Coronet, 1957

Endnotes

01 Robin McKie, "The Mission That Changed Everything," *Guardian*, November 29, 2008, https://www.theguardian.com/science/2008/nov/30/apollo-8-mission.

02 Lorraine Daston, "Monsters, Marvels, and the Birth of Science," interview by Steve Paulson, *Nautilus*, no. 004 (August 1, 2013): http://www.chicagomanualofstyle.org/book/ed17/part3/ch14/psec213.html.

03 Lorraine Daston and Elizabeth Lunbeck, eds., *Histories of Scientific Observation* (Chicago: University of Chicago Press, 2011), p. 1.

04 David Malin, "The Aided Eye: What Is Different About Scientific Images?, A Challenging Variety," http://encyclopedia.jrank.org/articles/pages/1107/The-Aided-Eye.html.

05 Trevor Quirk, "The Problem with Science Writing," *Nautilus*, September 23, 2016, http://nautil.us/blog/the-problem-with-science-writing.

06 Stewart Brand, quoted in the introduction to *The Third Culture: Beyond the Scientific Revolution*, by John Brockman (New York: Simon and Schuster, 1996), p. 18.

07 Carl Sagan, "Why We Need to Understand Science," *Parade* magazine, September 10, 1989.

08 Declan Fahy, *The New Celebrity Scientists* (Lanham, MD: Rowman and Littlefield, 2015), p. 193.

09 Kelley Wilder, "Visualizing Radiation: The Photographs of Henri Becquerel," in Daston and Lunbeck, *Histories of Scientific Observation*, p. 352.

10 Alice Calaprice, Daniel Kennefick, and Robert Schulmann, *An Einstein Encyclopedia* (Princeton, NJ: Princeton University Press, 2015), p. xxiii.

11 Daston and Lunbeck, *Histories of Scientific Observation*, p. 2.

12 Lorraine Daston and Peter Galison, *Objectivity* (New York: Zone Books, 2010), p. 6.

13 Lawrence M. Krauss, "Finding Beauty in the Darkness," *New York Times*, February 11, 2016, https://www.nytimes.com/2016/02/14/opinion/sunday/finding-beauty-in-the-darkness.html.

14 Phillip Prodger, *Darwin's Camera: Art and Photography in the Theory of Evolution* (Oxford, UK: Oxford University Press, 2009), p. 32.

15 Malin, "The Aided Eye."

16 Steven Shapin and Simon Schaffer, *Leviathan and the Air-Pump: Hobbes, Boyle, and the Experimental Life* (Princeton, NJ: Princeton University Press, 1986), quoted in Jennifer Tucker, *Nature Exposed: Photography as Eyewitness in Victorian Science* (Baltimore: Johns Hopkins University Press, 2013), p. 8.

17 "Maria Mitchell in Her Own Words," *Maria Mitchell's Attic* (blog), Maria Mitchell Association, September 18, 2017, https://www.mariamitchell.org/maria-mitchell-in-her-own-words-65-14230.

18 Tucker, *Nature Exposed*, p. 172.

19 Chris Woolston, "Conference Presentations: Lead the Poster Parade," *Nature* 536 (August 4, 2016): pp. 115–16, https://www.nature.com/nature/journal/v536/n7614/full/nj7614-115a.html.

20 "What Photography Does for Science," *Photographic News* 26 (March 3, 1882).

21 Martha Schwendener, "The Photographic Universe: Vilém Flusser's Theories of Photography, Media, and Digital Culture" (PhD diss., City University of New York, 2016), p. 148, https://academicworks.cuny.edu/gc_etds/693.

22 Daston and Galison, *Objectivity*, pp. 83–84.

23 Ibid., p. 53.

24 Kelley Wilder, *Photography and Science* (London: Reaktion Books, 2009), p. 18.

25 W. I. B. Beveridge, *The Art of Scientific Investigation* (New York: W. W. Norton, 1950).

26 Kelley Wilder, "4. Observation," Photography and Science, *Still Searching . . .* (blog), Fotomuseum Winterthur, May 12, 2012, https://www.fotomuseum.ch/en/explore/still-searching/series/27039_photography_and_science.

27 Fergus Walsh, "The Most Important Photo Ever Taken?," BBC, May 16, 2012, https://www.bbc.com/news/health-18041884.

28 Daston and Galison, *Objectivity*, p. 211.

29 "What Photography Does for Science," *Photographic News* 26 (March 3, 1882).

30 Kelley Wilder, "Showing Science Photography," in *Revelations: Experiments in Photography*, ed. Ben Burbridge, (London: MACK in association with Media Space, 2015), p. 85.

31 Tucker, *Nature Exposed*, p. 184.

32 Fahy, *New Celebrity Scientists*, p. 2; see also Dennis Overbye, "The Eclipse That Revealed the Universe," *New York Times*, July 31, 2017, https://www.nytimes.com/2017/07/31/science/eclipse-einstein-general-relativity.html.

33 Daston and Lunbeck, *Histories of Scientific Observation*, p. 5.

34 John Berger, "Appearances," in *Understanding a Photograph*, ed. Geoff Dyer (London: Penguin, 2013), p. 66.

35 Gilbert H. Grosvenor, "Editor's Note," *National Geographic*, November 1954, p. 68.

36 J. Kim Vandiver and Pagan Kennedy, "Harold Eugene Edgerton," *Biographical Memoirs* 86, (Washington, DC: National Academies Press, 2005), p. 150, http://www.nap.edu/read/11429/chapter/7.

37 "Does Pentagon Still Have a UFO Program? The Answer Is a Bit Mysterious," Reuters, December 16, 2017, https://www.reuters.com/article/us-usa-pentagon-ufos/does-pentagon-still-have-a-ufo-program-the-answer-is-a-bit-mysterious-idUSKBN1EA0QP.

38 Robert Turnage, "Ansel Adams: The Role of the Artist in the Environmental Movement," March 1980, Ansel Adams Gallery blog, http://anseladams.com/ansel-adams-the-role-of-the-artist-in-the-environmental-movement/.

39 Mariella Moon, "NASA Gets Inundated with Astronaut Applications," Engadget, February 20, 2016, https://www.engadget.com/2016/02/20/nasa-record-number-astronaut-applications/.

40 Mallary Jean Tenore, "Angier: Newspaper Science Reporting Is 'Basically Going out of Existence,'" Poynter, December 10, 2009, https://www.poynter.org/2009/angier-newspaper-science-reporting-is-basically-going-out-of-existence/99822/.

41 Trevor Quirk, "The Problem with Science Writing," *Nautilus*, September 23, 2016, http://nautil.us/blog/the-problem-with-science-writing.

42 Jane Goodall, interview by Jane Fonda, *Interview* magazine, March 26, 2016, https://www.interviewmagazine.com/culture/jane-goodall.

43 Prodger, *Darwin's Camera*, p. 76.

44 Fahy, *New Celebrity Scientists*, p. 41; see also Andrew Anthony, "Richard Dawkins: 'I Don't Think I Am Strident or Aggressive,'" *Observer*, September 14, 2013, https://www.theguardian.com/science/2013/sep/15/richard-dawkins-interview-appetite-wonder.

45 Michael Zhang, "Widely Used Photo of Marie Curie Is Actually of an Actress," September 29, 2016, https://petapixel.com/2016/09/29/widely-used-portrait-marie-curie-actually-actress/.

46 Margaret W. Rossiter, "The Matthew Matilda Effect in Science," *Social Studies of Science* 23, no. 2 (May 1, 1993), pp. 325–41.

47 Fahy, *New Celebrity Scientists*, p. 119.

48 "Depictions of 20th Century Women in Science: The Smithsonian Collection," *Women in Science* (blog), March 21, 2009, http://blog.sciencewomen.com/2009/03/depictions-of-20th-century-women-in.html?m=1.

49 "Valerie Thomas," Lemelson-MIT Program, https://lemelson.mit.edu/resources/valerie-thomas.

50 Mary Carmichael, "Louis Agassiz Exhibit Divides Harvard, Swiss Group," *Boston Globe*, June 27, 2012, https://www.bostonglobe.com/metro/2012/06/26/harvard-fight-over-racist-images/oct8ccOKAGAm3H0qE9WY4H/story.html; see also Brian Wallis, "Black Bodies, White Science: The Slave Daguerreotypes of Louis Agassiz," *Journal of Blacks in Higher Education*, no. 12 (Summer 1996): pp. 102–6.

51 Elizabeth Edwards, "Evolving Images: Photography, Race and Popular Darwinism," in *Endless Forms: Charles Darwin, Natural Science and the Visual Arts*, ed. Diana Donald and Jane Munro (New Haven, CT/London: Yale University Press, 2009), p. 168.

52 Joan C. Williams, Marina Multhaup, and Rachel Korn, "The Problem With 'Asians Are Good at Science,'" *Atlantic*, January 31, 2018, https://www.theatlantic.com/science/archive/2018/01/asian-americans-science-math-bias/551903/.

53 Tom Simonite, "When It Comes to Gorillas, Google Photos Remains Blind," *Wired*, January 11, 2018, https://www.wired.com/story/when-it-comes-to-gorillas-google-photos-remains-blind/?CNDID=22723778&mbid=nl_011118_daily_list1_p1.

54 Wilder, "Showing Science Photography," p. 85.

55 Hedda Hassel Mørch, "Is Matter Conscious?," *Nautilus*, April 6, 2017, http://m.nautil.us/issue/47/consciousness/is-matter-conscious.

56 Daston and Galison, *Objectivity*, p. 37.

57 See Marita Sturken and Lisa Cartwright, "Scientific Looking, Looking at Science," in *Practices of Looking: An Introduction to Visual Culture* (Oxford, UK: Oxford University Press, 2001).

58 Vilém Flusser, *Into the Universe of Technical Images* (Minneapolis: University of Minnesota Press, 2011), p. 16.

59 Wolfgang Ernst, "Selling the Archive's Soul," interview by Damian Zimmermann, *L. Fritz*, no. 2 (August 17, 2015): pp. 26–27, https://issuu.com/photoszene/docs/l_fritz_mag_02.

60 Alex Blasdel, "'A Reckoning for Our Species': The Philosopher Prophet of the Anthropocene," *Guardian*, June 15, 2017, https://www.theguardian.com/world/2017/jun/15/timothy-morton-anthropocene-philosopher.

61 Jop de Vrieze, "Bruno Latour, a Veteran of the 'Science Wars,' Has a New Mission," *Science*, October 10, 2017, http://www.sciencemag.org/news/2017/10/latour-qa.

62 "Our History," March for Science, https://www.marchforscience.com/our-history.

63 "President Trump's War on Science," *New York Times*, September 9, 2017, https://www.nytimes.com/2017/09/09/opinion/sunday/trump-epa-pruitt-science.html.

64 "What We Do," March for Science, https://www.marchforscience.com/what-we-do.

65 Galileo Galilei, "The Starry Messenger (1610)," in *Discoveries and Opinions of Galileo*, trans. Stillman Drake (New York: Anchor Books, 1957), p. 23.

66 Robin Dunbar, *The Trouble with Science* (Cambridge, MA: Harvard University Press, 1996), p. 10.

Photography
+ Science

Knowledge

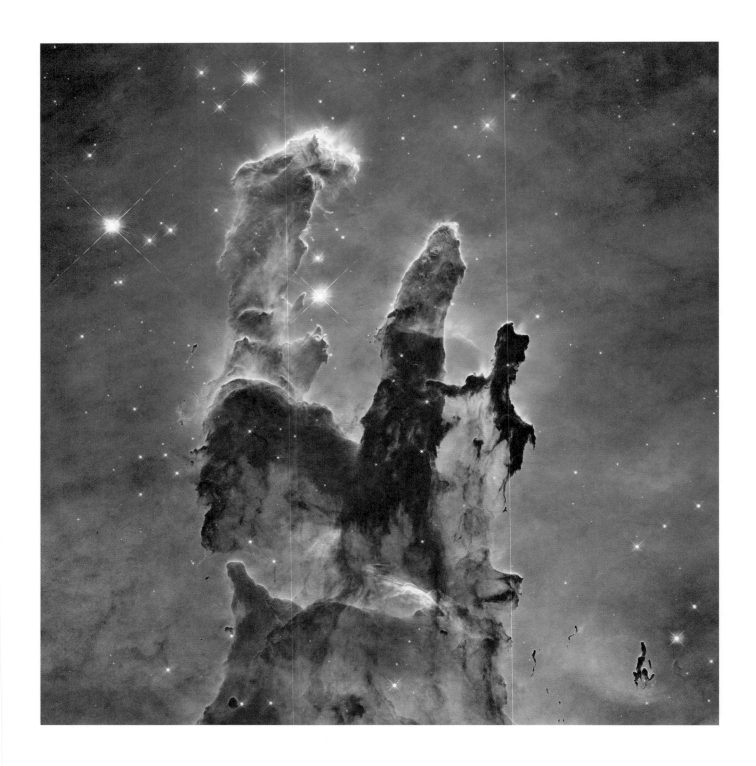

NASA/ESA/Hubble Heritage Team,
Eagle Nebula's "Pillars of Creation," 2015

Pillars of Creation

A conversation among visual culture experts who gathered online to discuss a selection of science-related news and media photographs on December 1, 2016, in an event sponsored by Reading the Pictures and the Center for Art, Design and Visual Culture.

Nathan Stormer Max, this is from your shop, isn't it? Why don't you tell us about this?

Max Mutchler It's impossible for me to have an unbiased and objective view of this image, both because I'm very close to it and because it is generally pointed to as the most iconic image from the Hubble Space Telescope. It shows three towers of gas and dust in the Eagle Nebula (M16) that are light-years tall and giving birth to new stars. The original image was actually taken in 1995 with a much older camera. You may remember the Hubble images from the 1990s had a funny cutout; it almost looked like part of the image was redacted in the upper corner, but that was because it was a strange camera in the way it took images. And that earlier image quickly became an iconic image, which was great. I wasn't a part of that 1995 image, which was done by some independent investigators, but it had become so associated with Hubble that we decided to revisit it in 2015, since we have much better cameras on board now than we had in the 1990s. To be honest, I initially argued against remaking it, because it is kind of like playing your hit song from the '60s instead of writing something new. But I am really glad that we went back and revisited this because this more recent version of it has the quality it really deserves. When I look at that 1995 image now, it looks terrible to me!

Nathan Stormer Well, I think this is interesting, because one of the challenges in seeing science is that there's so much of this sort of, "*Wow*, look at what we're looking at," and not so much of "why are we looking at it?"

Max Mutchler I think that in many science images, we have some frame of reference, some sense of scale—there's at least some familiar objects. But in images from space, you're often looking at something where there's no reference point, there are no familiar objects, and so you're really, literally, adrift, trying to get your bearings. There was an interesting PhD thesis many years ago, comparing these Hubble images to landscapes, landscape paintings, and that's how we get our bearings as we view them. We think of an image like this one the way we might think of a mountain range in an Ansel Adams photo, and I think that was a very interesting analogy.

Marvin Heiferman	The issue of scale in this image is incredible. I read an article about this image that pointed out that this depicts events that were happening 6,500 years ago, and that each of the little protuberances on the top of those pillars is equivalent in scale to our solar system. I'm fascinated by how photography tries to deal with scale, and this is probably as big as it gets. It's pretty overwhelming.
Max Mutchler	I could ruin this image for everybody by getting too technical and scientific. And I would say the romantic view of it is pretty cool, because it does address our origin story. What you're seeing here are stars being born, stars just like our sun, which presumably can have planets forming around them, so we're learning about our own history, our own origin story, and the fact that stars are the engine for everything, the cosmic recycling that leads to the heavy elements, planets—that leads to life. That's the really amazing story that you see here, but of course, when you first take a look at it, it's just beautiful. But that's an invitation to maybe dig a little bit deeper and understand what you're looking at.
Ben de la Cruz	When I saw the caption, *The Pillars of Creation*, it made me think about and look again at Michelangelo's *Creation of Adam*, because there's something about the way the pillars are shooting up that reminded me of the fingers touching in the Sistine Chapel. For me, this image is a bit of a Rorschach test, and trying to figure out what this was, that was the first thing that came to mind—and, of course, partially because of the title.
Kurt Mutchler	Max, when you were talking about how scientists reach the public, it reminded me that this image was made by three black-and-white sensors that were combined to create a final color image. The black-and-white data is what's most useful to astronomers in their work, but when they were building Hubble, someone must have said, "No, we've got to use color to show the public what this beautiful instrument can do."
Max Mutchler	It's true that Hubble only takes black-and-white images. So, when we design an observation like this, we have many filters that isolate different chemical elements and capture different wavelengths of light. So, we construct color images from that, and while sometimes people accuse us of painting these images, that's absolutely not true. It's that we will image a subject multiple times using different filters in the optical and infrared ranges. If you look at our website you can see that and how things look different in each image. And yes, we do then apply colors that we know. For example, we maybe use a filter that isolates hydrogen because we know that hydrogen glows red, so that might get us the red channel, so there is a physical truth to the color in the images. It's not our goal to just make pretty pictures with Hubble; there's scientific data that we carefully calibrate and prepare for so that we make scientific measurements from it. It just so happens that nature is beautiful, so

certain objects we image are going to be beautiful. And a task of the Hubble Heritage team that I'm a member of is to image things that we know are beautiful and follow all the best practices to make sure that it is outstanding science data that goes into our archive and that people can do science with. But we are also unashamedly picking targets that we know are going to be visually stunning.

Nathan Stormer These images invite you to play with them a little bit. You want to have them, you want to interact with them. I feel a kind of warmth from them, even though obviously in terms of the stellar distance, they are going to be cold. They have a little life to them that goes beyond the scientific aspects, too, which is significant.

Max Mutchler There's definitely more depth and dynamic range to this image than you can show in any one particular stretch or presentation. People would be stunned to know how many technical and artistic decisions and how much work goes into producing this one image. And to your point, we do invite people to interact with images. This actual data is in our archive, so you can access it and play; there are many amateur image processors who do just that. The archive is available for scientists to do science with, but the public is welcome to get in there, get at the actual data behind this image, and play with it, make their own color compositions, stretch the image differently than we did. You can see the results of that all over the web, and we are delighted when people do that.

The **Center for Art, Design and Visual Culture**, University of Maryland, Baltimore County, is a nonprofit organization dedicated to organizing comprehensive exhibitions, the publication of catalogues, media, and books on the arts, as well as educational and community outreach projects. The center's programs serve as a forum for exploring the social and aesthetic issues of the day.

Reading the Pictures is a web-based, non-profit educational and publishing organization dedicated to visual culture, visual literacy, and media literacy through the analysis of news, documentary, and social media images.

Ben de la Cruz is an Emmy-nominated documentary filmmaker and journalist. He joined NPR as a multimedia editor for the Science Desk. In this role, he serves as the visual architect for NPR's coverage of global health, science, environment, energy, food, agriculture, and development.

Kurt Mutchler is a senior science photo editor at *National Geographic* magazine. He has held several positions at *National Geographic*, including photo editor, deputy director of photography, and executive editor of photography.

Max Mutchler is a manager of the Space Telescope Science Institute and the head of their Research and Instrument Analysis Branch. He works on solar system observations with the Hubble Space Telescope and also contributes to planetary missions such as Dawn and New Horizons.

Nathan Stormer is a visual scholar and professor of communication and journalism at the University of Maine, specializing in rhetorical history, argument, and persuasion.

Photography and Science

by Berenice Abbott, 1939

We live in a world made by science. But we—the millions of laymen—do not understand or appreciate the knowledge which thus controls daily life. To obtain wide popular support for science, to that end that we may explore this vast subject even further and bring as yet unexplored areas under control, there needs to be a friendly interpreter between science and the layman.

I believe that photography can be this spokesman, as no other form of expression can be; for photography, the art of our time, the mechanical, scientific medium which matches the pace and character of our era, is attuned to the function. There is an essential unity between photography, science's child, and science, the parent.

Yet so far the task of photographing scientific subjects and endowing them with popular appeal and scientific correctness has not been mastered. The function of the artist is needed here, as well as the function of the recorder. The artist through history has been the spokesman and conservator of human and spiritual energies and ideas. Today science needs its voice. It needs the vivification of the visual image, the warm human quality of imagination added to its austere and stern disciplines. It needs to speak to the people in terms they will understand. They can understand photography preeminently.

To me, this function of photography seems extraordinarily urgent and exciting. Scientific subject matter may well be the most thrilling of today. My hope of moving into this new field comes logically in my own evolution as a photographer. After I had explored the possibilities of portrait photography in Paris for some years, I set myself the task of documenting New York City. Now after ten years of work at this interpretation, I find this phase of my career rounded out with the publication of my book, *Changing New York*.

The problem of documenting science, of presenting its realistic subject matter with the same integrity as one portrays the culture morphology of our civilization, and yet of endowing this material so strange and unfamiliar to the public with the poetry of its own vast implications, would seem to me to lead logically from my previous experience. I am now seeking channels through which this new creative task may be approached.

Berenice Abbott is best known for *Changing New York*, the classic series of photographs she made under the auspices of the Federal Art Project in the 1930s. But Abbott also made equally extraordinary photographs about science, a subject in which her interest was long-standing. Abbott's images were published in *Science Illustrated* in 1946 and in the textbook *American High School Biology* in 1948, when she was employed as the photography editor of *Science Illustrated* magazine. In 1958, Abbott began working with the Physical Science Study Committee (PSSC) to help rethink how photographic images might be better incorporated into teaching materials. The high school textbook *Physics*, first published in 1960, featured Abbott's photographs on its covers, as chapter openers, and to illustrate the texts.

This 1939 letter to Charles C. Adams is reproduced from *Documenting Science* (Gottingen, Germany: Steidl, 2012).

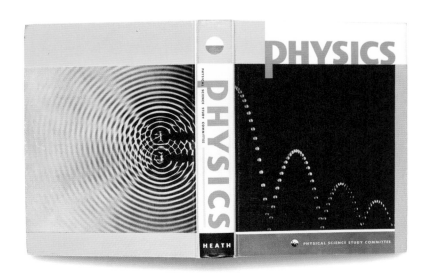

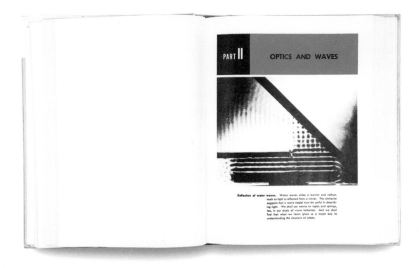

The high school textbook *Physics*, first published in
1960, featured Abbott's photographs on its covers, as
chapter openers, and to illustrate the texts.

Data Collection Radically Reformed

Anna Atkins, often credited as the first woman to take a photograph, was a British botanist who learned about photography from family friends and early imaging innovators William Henry Fox Talbot and Sir John Herschel. The images she made were produced by placing plant specimens she had collected on sheets of light-sensitive blueprinting papers. The books of bound photographs she produced between 1843 and 1853, including *Photographs of British Algae: Cyanotype Impressions* and *Cyanotypes of British and Foreign Ferns*, are among the earliest examples of photographic atlases; only seventeen copies are now known to exist. Photography, eagerly embraced and customized by early adapters in the sciences, would radically transform data collection, as well as how scientists illustrated and shared their work.

Clockwise from top left:

Anna Atkins,
all from *Cyanotypes of British and Foreign Ferns*

Asplenium chinensis, England, 1853

Botrychium lunaria, England, 1853

Pteris rotundifolia, England, 1853

Asplenium ruta muraria, British, England, 1853

Asplenium Chinense

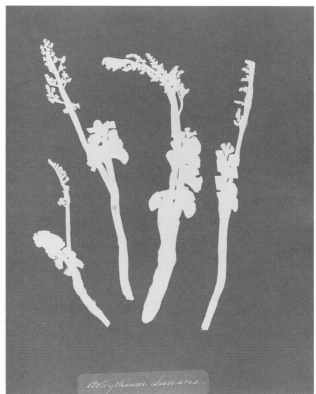

Botrychium Lunaria

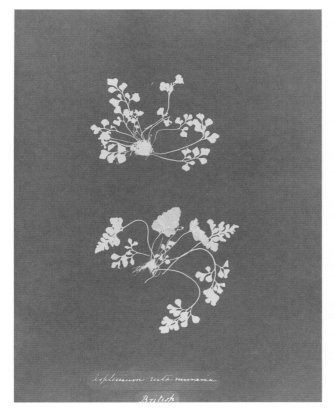

Asplenium ruta-muraria

British

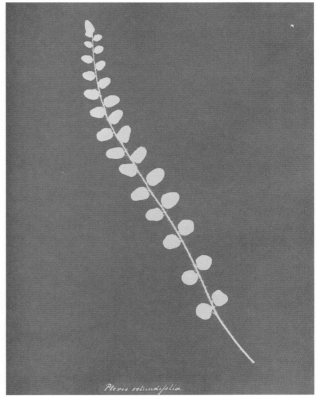

Pteris rotundifolia

Shock and Emotion

Guillaume-Benjamin-Amand Duchenne de Boulogne, a French neurologist, began experimenting with a form of acupuncture that employed electric currents around 1833, early in his career and two years after Michael Faraday's discoveries about how electricity flows were announced. Working in Paris in the 1840s, Duchenne continued to refine his process of "electrotherapy," which he believed could help in the treatment of nervous and muscular disorders and to clarify the relationship between musculature and emotion. By the 1860s and after learning the basics of photography, Duchenne began to take still-startling images to document his research on subjects, ranging from the physiognomy of smiles to the nature of paralysis. His sitters included patients, actors, indigents, and children, and photographs of them were collected in an influential book, *Mécanisme de la physionomie humaine ou analyse électro-Physiologique de l'expression des passions applicable à la pratique des arts plastiques* (Mechanism of human physiognomy or electro-physiological analysis of the expression of passions applicable to the practice of the visuals arts), in 1862. A decade later, Charles Darwin included some of Duchenne's images in *The Expression of the Emotions in Man and Animals*, one of the first widely distributed and photographically illustrated science books, which traced the connection and evolution of mental states to neurological organization, bodily gestures, and movement.

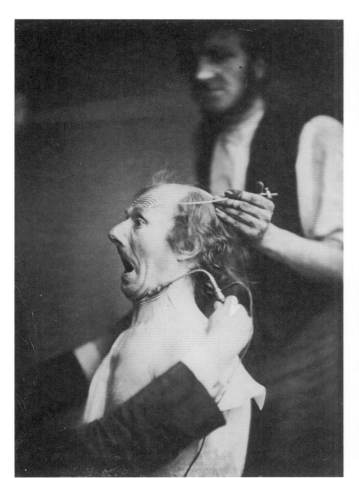

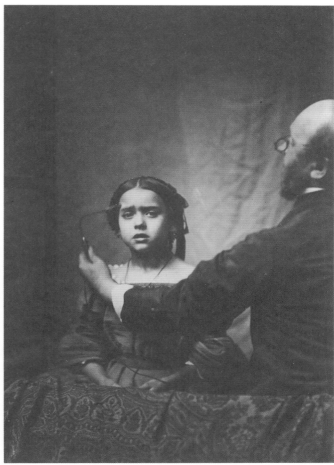

Guillaume-Benjamin-Amand Duchenne de Boulogne,
Terror, 1854–56, printed 1862; from *Mécanisme de la
physionomie humaine ou analyse électro-Physiologique de
l'expression des passions applicable à la pratique des arts
plastiques* (Paris: Chez ve Jules Renouard), 1862

Pain, 1854–56, printed 1862; from *Mécanisme de la
physionomie humaine*

The Secret Lives of Animals

"There are no words that can tell the hidden spirit of the wilderness, that can reveal its mystery," Theodore Roosevelt, American president and ardent conservationist, wrote in 1884. But while words inevitably fail to describe nature adequately, photography, once it was introduced, became an indispensable tool for depicting nature and its inhabitants. Late nineteenth-century expedition photographers from the West excitedly captured and shared images of animals exotic-to-them, such as penguins and albatrosses. In the early twentieth century, George Shiras, who pioneered the use of camera traps that he lit with flash photography, mesmerized the public with his images when they appeared in the pages of *National Geographic*. Now, motion-activated, battery-powered, and fully automated cameras are in wide use, strategically positioned not only to capture animals' presence, but also to record their behaviors, biomass, and migration patterns. Digital photographs—produced by professional researchers mapping animal diversity and migration, as well as photos by students, hunters, and citizen-scientists recording wildlife in their communities—allow for data to be easily uploaded and shared on local and global research networks and in real time. Today, camera traps literally shed light on the lives of the world's most elusive animals. They allow for wildlife photography to be created even without a photographer, or major expense, and with minimal environmental intervention.

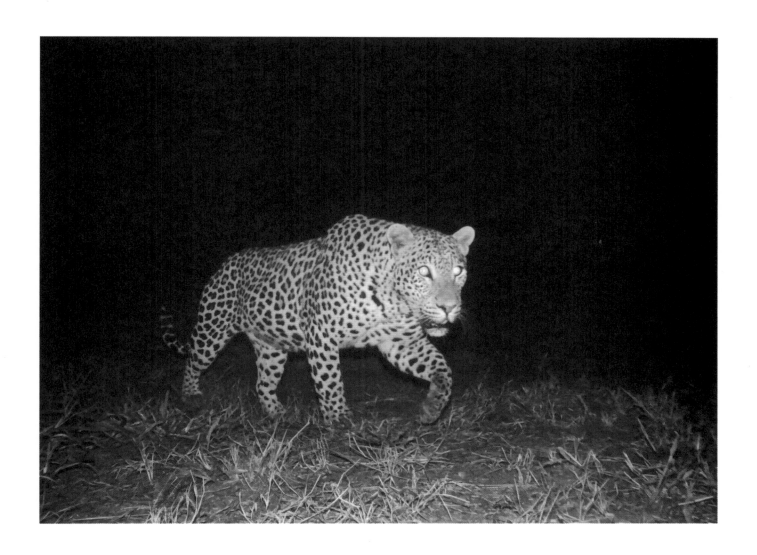

Photograph by Panthera,
Camera trap image of South African leopard, 2017

The Measurers Measured

by Seth Barry Watter

Paul Emanuel Byers was perhaps an unlikely candidate for the serious pursuit of behavioral science. He dropped out of undergraduate studies at the University of Chicago during World War II in order to travel abroad and write. After Pearl Harbor he joined the US Navy, shipped out for Australia, and soon became expert in cryptanalysis, or code breaking. Twenty years after the cessation of wartime activities, he was still breaking codes—only they were no longer those transmitted by the enemy, but those given off by persons communicating spontaneously.

Byers became, in short, a scholar of interaction: the more or less systematic exchange of signals among living beings. "Human behavior," he wrote, "is patterns of patterns of patterns, decreasing in size beyond what we normally use in social seeing. . . . If 1/100ths of a second are not critical in behavioral analysis with our present analytic techniques, it can be demonstrated that 1/10ths of a second sometimes are." Accordingly, he used sequential still photography to isolate the instants and reconstruct the patterns.

Some of his early studies were concerned with childhood development; later he focused on conversation analysis of the Kalahari Bushmen, the Netsilik Inuit, and the Maring of New Guinea. But Byers is best known for the book *The Small Conference* (1968), which he authored in conjunction with Margaret Mead. Together they used methods of behavioral science for analysis of those who had created these methods, namely themselves and some others within their research circle. And they studied their subjects in a typical habitat—the academic conference—much as one studied Inuit in a tundra.

Byers first met Mead in 1951 in Australia, where he remained for a while following his naval service and worked as a staff writer for the magazine *People* (an Australian equivalent of America's *Life*). Mead had already been famous for decades; no other anthropologist was such a household name. In that capacity she sought out young persons whose work she could foster and from whom she could learn. Hence she made use of Byers's photography for purposes of study, and Byers paid tribute to his mentor as "a teacher who can discover, illuminate, and encourage talents that are often obscure even to their possessors."

After returning to the States in 1953, Byers was mainly employed as a commercial photographer. Family portraits were his specialty and they trained him, early on, in the nature of human systems. For a family is a system, almost like an organism, whose members give and receive signals like organs secrete chemicals. Moreover, the system was open: its units were aware of Byers and played to his camera. He felt himself by degrees annexed to that system; he became temporarily a part of its functioning. The groups of scientists he photographed later were ultimately no different in their systemic quality.

Byers resumed his formal education in 1959; he received a PhD from Columbia University thirteen years later. Mead was not the only factor in his late-career shift. Contact with Gregory Bateson, the ethnographer-epistemologist, and

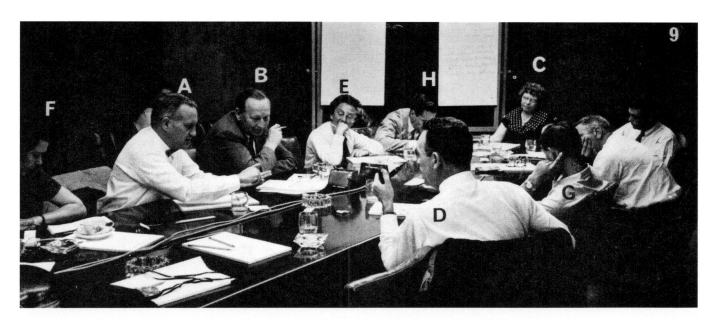

A speaks; extends hands toward C, touching right fingers to left hand.

B suspends hand/cigarette before face; looks at A's hands.

D suspends hand/pipe before face and looks toward A or B.

C tilts head and looks at A.

G begins to move; changes head position; looks, perhaps, at C.

74

Notice now that A, B, and D appear to concentrate on A's hands. A does not use them in parallel. One hand is now used to tap the other. C has increased her head tilt. By using a magnifying glass on large photographs, one can discover that B often is not actually looking in the direction he may appear to look. He tends to look sideways or up or down while holding his head still. Note the parallelism of B and D with their hands and pipe/cigarette. This parallelism will continue.

Paul Emanuel Byers,
plate from *The Small Conference: An Innovation in Communication* (The Hague: Mouton & Co., 1968)

Ray Birdwhistell, a pioneer of body motion study, brought Byers more fully into the orbit of communications research. From them he gained awareness not only of the structure and periodicity of behavior, but also of the infinitesimally small units out of which behavior is composed. The phrase "nothing never happens" was rule of thumb in this period, and the camera a means to record that which happened—to record, that is, the "patterns of patterns of patterns" of interaction constitutive of what we so innocently call life.

Academic conferences, too, have patterns of patterns of patterns, and *The Small Conference* looks in part at the patterns of scientists whose object of research is human communication. The ten conference participants held up for scrutiny include Byers's own mentors—Mead, Bateson, and Birdwhistell. They are all clearly visible in images Byers shot with his setup; and though named neither in captions nor text, they are, in fact, key players in the drama. Figures B (Bateson), C (Mead), and D (Birdwhistell) are pitting themselves against an unknown Figure A (Robert Prall), a fellow participant whose views they reject. They do this with posture long before they do so in words. They may not even know that they are doing it. Yet a grimace shifts the conversation and a cocked head speaks volumes. Pipe and cigarette perform a kind of dance. The strength or weakness of an argument transpires in the hands. If legs and feet were visible as well, we might see another drama with different protagonists.

For Byers, these one-tenths of seconds and the micromovements during them were the physical conditions under which ideas flourish and die—where to "share a position" was more than a mere turn of phrase. It was a turn of the body. And if others did not turn, an idea was rejected. We need only look at the images to see this for ourselves. A four-minute segment of conference activity contained many such turnings, and equal turns untaken.

Seth Barry Watter is a film and media historian. His work has appeared in *Grey Room, Cinema Journal, Camera Obscura, Millennium Film Journal,* and *NECSUS*. He lives and teaches in New York.

Paul Emanuel Byers, plate from *The Small Conference: An Innovation in Communication* (The Hague: Mouton & Co., 1968)

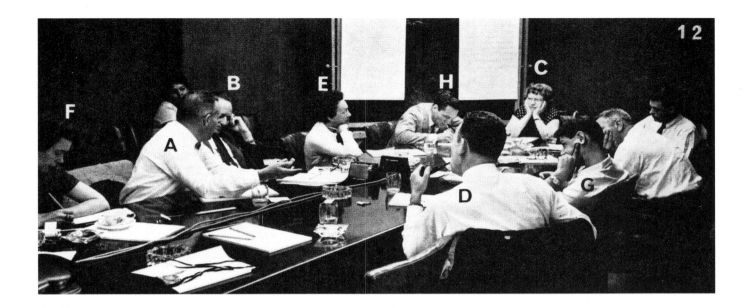

A is speaking; holds hands with palms open and up; leans body toward C.

C has put chin/face into hands; looks at A.

B shifts head/hand position; looks down; mouth slightly pulled back; eyes may be closed.

D continues holding pipe to mouth; head forward toward B and tilted.

G has head down but has raised brows and looks at A.

76

Now B has adopted a waiting position, resting his head on his left hand with his eyes almost closed. The speaker, who has been keeping C in view, now turns so that B is included in his vision. C also has taken on a waiting position with head in hands. D is still watching B. The silent trio B–D–C are keeping track of each other and B is the one making the most significant movements or gestures.

The Nature of Polyhedra

A polyhedron is a solid, three-dimensional form shaped from multiple and multisided faces that are joined along their straight edges or at their sharp corners. Cubes and pyramids are two of the most basic examples of these often-complex geometric shapes. Polyhedra were studied in ancient Greece by Plato, Aristotle, and Archimedes; in third-century China by mathematician Liu Hui; by seventeenth-century German mathematician and astronomer Johannes Kepler; and the nineteenth-century French mathematician/physicist Louis Poinsot, known as the inventor of geometrical mechanics. The form and potential complexity of polyhedra have fascinated artists ranging from Leonardo da Vinci to M. C. Escher. These photographs reproduce some of the pages from *Vielecke und Vielflache: Theorie und Geschichte* (*Polygons and Polyhedra: Theory and History*), which was published in 1900. An encyclopedic endeavor, the book illustrated elegant models made by **Johannes Max Brückner**, a German geometer, and summarized current knowledge of polyhedral shapes at that point in time.

Johannes Max Brückner,
plates from *Vielecke und Vielflache: Theorie und Geschichte* (*Polygons and Polyhedra: Theory and History*) (Leipzig: B. G. Teubner, 1900)

Brückner, Vielecke und Vielflache.

Brückner, Vielecke und Vielflache.

Tafel IX

Lichtdruck von Römmler & Jonas, Dresden.

Tafel VIII

Lichtdruck von Römmler & Jonas, Dresden.

The Moon: Considered as a Planet, a World, and a Satellite

One of the earliest, most influential, and still-startling collections of lunar imagery—*The Moon: Considered as a Planet, a World, and a Satellite*—was published in 1874. With three decades of "assiduous observation" behind them, British scientists **James Nasmyth** and **James Carpenter** not only summed up lunar knowledge to date, but also cleverly exploited photography's descriptive powers to work around the medium's late nineteenth-century technical limitations. While highly detailed close-ups of the moon's surface were yet to be taken, based upon notes and drawings they made while looking through telescopes, Nasmyth and Carpenter crafted accurate plaster models of the moon's surface, which when "placed in the sun's rays, would faithfully reproduce the lunar effects of light and shadow," and once photographed would "produce most faithful representations of the original." The twenty-four woodburytype images produced are, to contemporary eyes, beautiful and audacious, particularly in light of photo-fakery charges that would bedevil images shot by America's Apollo astronauts, who orbited and walked on the moon a century later.

PLATE XXI.

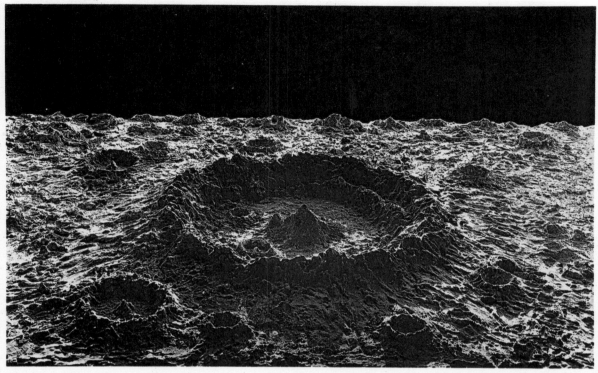

J. Nasmyth. Heliotype

NORMAL LUNAR CRATER.

James Nasmyth,
Normal Lunar Crater, page from *The Moon: Considered
as a Planet, a World, and a Satellite* (1874)

One Giant Leap for Mankind

One of the simplest and most haunting photographs ever made was taken on July 20, 1969, when astronaut Neil Armstrong stepped off the Apollo 11's lunar module and placed his left foot on the surface of the moon (bottom right). The image was taken by fellow astronaut Buzz Aldrin. It was Richard Underwood, NASA's chief of photography in the 1960s, who taught the astronauts how to expose, frame, and focus their shots. "Your key to immortality," he said to motivate them, "is in the quality of the photographs and nothing else." The images they captured—on six missions over the course of a three-year period—ranged from workaday documentation to the extraordinary. And as more astronauts landed on and explored the moon's surface, the more footsteps they left behind. What was startling and novel the first time it was photographed became a pictorial constant. In 2011, conspiracists who claimed that these pictures were faked were proven wrong when a NASA lunar orbiter captured the sharpest images of landing sites ever taken and revealed the astronauts' footsteps to still be there—where, it is estimated, they will remain for at least a million years.

Clockwise from top left:

Neil Armstrong,
An Apollo 11 Hassleblad image from film magazine 40/S-EVA, 1969

Neil Armstrong,
Buzz Aldrin Deploys Apollo 11 Experiments, 1969

Buzz Aldrin,
An Apollo 11 Hassleblad image from film magazine 40/S-EVA, 1969

Photographer unknown,
Boot prints with camera on the Lunar Surface, 1969

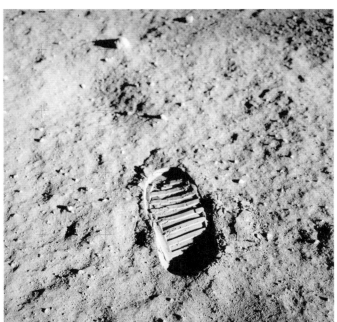

Naturalistic Photography

by Peter Henry Emerson, 1890

At a meeting of the French Academy of Sciences, held in Paris on the 19th day of August, 1839, Louis Jacques Mandé Daguerre, in the presence of the flower of Parisian art, literature and science, gave a demonstration of his new discovery—the Daguerreotype. The success of the séance was complete, and the gathering of illustrious men was intoxicated with enthusiasm. . . . Let us see what this cool young goddess, born of art and science, who generally comes to stay and finally to oust the old goddesses from their temples, has been doing these fifty years.

In the fields of science she has been most busy. She has been giving us photographs of the moon, the stars, and even of the nebulae. She has recorded eclipses and a transit of Venus for us. She has drawn too the Sun's corona, and registered those great volcanic explosions which playfully take place there periodically. She has shown us that there are stars which no telescope can find, and she has in another form registered for us the composition of the sun and many of the stars; and now she is busy mapping out the heavens. Like an all-powerful goddess, she plays with the planets and records on our plates, with delicate taps, the stars. She runs through the vast space of the kosmos doing our biddings with a precision and delicacy never equaled—in short she is fast becoming the right hand of the astronomer.

Not content with her vast triumphs in space over the infinitely great, she dives down to the infinitely small, and stores up for us portraits of the disease-bearing generation of *Schizomycetes,* the stiff-necked bacteria, and the wriggling vibrio, the rolling microccus, and the fungoid actinomycosis— with deadly tresses; these she pictures for us, so that we may either keep them on small plates, or else she throws them on large screens so that we are enabled to study their structure. On these screens too we can gaze on the structure of the Proteus-like white blood corpuscle, and we are able to study the very cells of our tongues, our eyes, our bones, our teeth, our hairs, and to keep drawings of them such as man never had before. So the kindly bright goddess stints us in nothing, for wherever the microscope leads there will she be found at our bidding. With the greatness of an all-seeing mind, it matters not to her whether she draws the protococcus or the blood-cells of an elephant, whether she depicts the eroding cancer cell or the golden scale on the butterfly's wing— anything that we ask of her she does; if we will but be patient.

But the little goddess, the light-bearer, is not content with these sciences but she must needs go and woo chemistry and register the belted zones of the spectrum and tell us the mysterious secrets of the composition of matter.

Meteorology, too, has claimed her, and she draws for the meteorologist the frowning nimbus and the bright rolling cumulus. She scratches quickly on his plate the lightning's flash, and even measures the risings and fallings of the mercuries in his long glass barometers and thin-stemmed

First Photograph
of Lightning

J.N. Jennings

William N. Jennings,
First Photograph of Lightning, ca. 1885

thermometers, so that the meteorologist can go and rest in the sun; and good-naturedly, too, she hints to him that his registerings are but fumblings after her precise and delicate work. This versatile little goddess, too, is playing with and hinting to the surveyors how she will not be coy if they will but woo her, for, says she, "have I not already shown you how to measure the altitude of mountains, and how to project maps by my aid?"

The geographer, too, is another lover well favoured by the dainty goddess, he always takes her on his travels now-a-days, and brings us back her inimitable drawings of skulls, savages, weapons, waterfalls, geological strata, fossils, animals, birds, trees, landscapes, and men, and we believe him when we know the light-bearer was with him, and soon in all his geographies, in all his botanies, in all his zoologies, in all his geologies, his entomologies, and all the rest of his valuable "ologies," we shall find the crisp and inimitable drawings of his dainty companion.

The horny-handed engineer, too, is wooing her; he makes love to her away down in dark caissons half-buried in river beds; whilst above-ground she scatters his plans far and wide. . . . The earnest doctor and the curious biologist are amongst her lovers, and the dainty one does not disdain their work, for she knows it to be good; for though she is fickle, she is kind at heart. For them she goes into the mysterious globe of the eye. . . . The tumour-deformed leg, the tossing epileptic, the deformed leprous body, the ulcerous scalp, the unsightly skin disease, the dead brain, the delicate dissection, the galloping horse, the flying gull, and erring man does she with quick and dainty strokes draw and give her lovers the physician and biologist. . . .

Incredible indeed seems the all-pervading power of this light-bearing goddess. Next to printing, photography is the greatest weapon given to making for his intellectual advancement.

Southworth & Hawes,
Early Operation Using Ether for Anesthesia, 1847

David Peck Todd,
The transit of Venus taken from the Lick Observatory on Mount Hamilton, California, 1882

Peter Henry Emerson, who lived and trained as a doctor in Britain, left his surgical practice to become a photographer. In his work and writing he explored the nature of seeing and its representation in photography, and he was a staunch proponent of the medium as an art form. Emerson's publications include *Life and Landscape on the Norfolk Broads* (1886), *Pictures from Life in Field and Fen* (1887), *Pictures of East Anglian Life* (1888), and *Naturalistic Photography for Students of the Art* (1889).

This piece is excerpted from the introduction to *Naturalistic Photography for Students of the Art* (London: Sampson Low, Marston, Searle & Rivington, 1890), pp. 1–8.

Lights, Camera, Specimen

While the desire to achieve objectivity in science photography is strong, it has been and always will be a work in progress. Many of the photographs **Sanna Kannisto** has made in the past two decades explore the parameters and slipperiness of scientific photographic depiction. For her work, Kannisto has traveled to lush rainforests in South America and the Caribbean, where she lives among researchers while pursuing personal projects that focus not only on native flora and fauna, but also on the conventions of scientific and exploration photography, and processes of specimen imaging and collection. Austerity is a hallmark of science photography, but many of Kannisto's canny works remind us that simplicity and objectivity are sometimes hard-won and demand a degree of willfulness and theatricality. These carefully staged images—with their curtains, controlled lighting, and referencing early conventions in botanical illustration—are reminders of challenges of, and photography's central role in creating ordered views of ecosystems in flux.

Sanna Kannisto,
Amanita muscaria, 2016

Leptophis ahaetulla, 2006

Snow Crystals

Growing up in Vermont, where snowfalls were high, **Wilson A. Bentley** became fascinated with snowflakes. Looking through a microscope given to him for his fifteenth birthday, Bentley studied and made drawings of them. Working with his very first camera in 1885, he cleverly developed techniques to capture and keep snowflakes cool, take microphotographs of them, and produce the labor-intensive enhanced prints that captured their unique structures and beauty. During his lifetime, Bentley photographed more than five thousand snow crystals, and his innovative images of them—published in magazines, including *National Geographic*, *Popular Science*, and *Scientific American*—became so iconic that he was nicknamed "Snowflake" Bentley. In 1931, the book *Snow Crystals* was published, featuring 2,500 of Bentley's photographs and research by William J. Humphreys, a US Weather Bureau physicist. Later that year, Bentley died at the age of sixty-six of pneumonia after a six-mile-long walk in a blizzard.

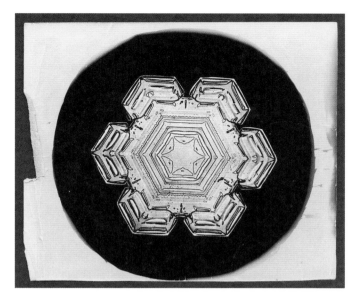
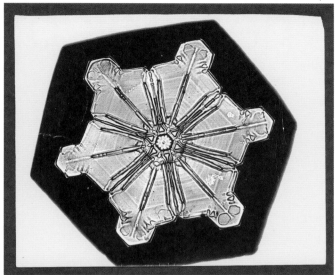
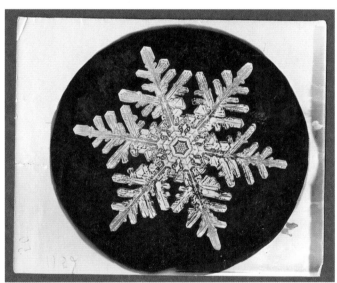

Clockwise from top left:

Wilson A. Bentley,
Snowflake 1206, ca. 1890

Snowflake 976, ca. 1890

Snowflake 482, ca. 1890

Snowflake 1152, ca. 1890

The Look of Criminality

After its public introduction in 1839, photography quickly became an essential tool in the collection, study, and sharing of data. In 1879, **Alphonse Bertillon**, son of a French statistician, began work as a low-level clerk at the Prefecture of Police in Paris. His firsthand experience with the disorganized ways authorities tried to keep track of criminals led Bertillon to develop an elaborate anthropometric system. *Bertillonage*, as it was called, involved the systematic measurement and photography of parts of the human body—head, face, hands, forearms, and feet—in order to better distinguish between individuals and more accurately identify suspected criminals. Bertillon also pioneered the use of mug shots to track repeat offenders and introduced new crime scene techniques, such as photographing victims' bodies from above in order to better document the scenes. His system was widely adopted and used worldwide until it was replaced, early in the twentieth century, with the less labor-intensive process of fingerprinting. But Bertillon's legacy lives on in twenty-first-century advances in, and reliance on, facial recognition algorithms and software.

Alphonse Bertillon,
Tableau synoptique des traits physionomiques: pour servir a l'étude du "portrait parlé" (Summary chart of physical traits for the study of the "spoken portrait"), ca. 1909

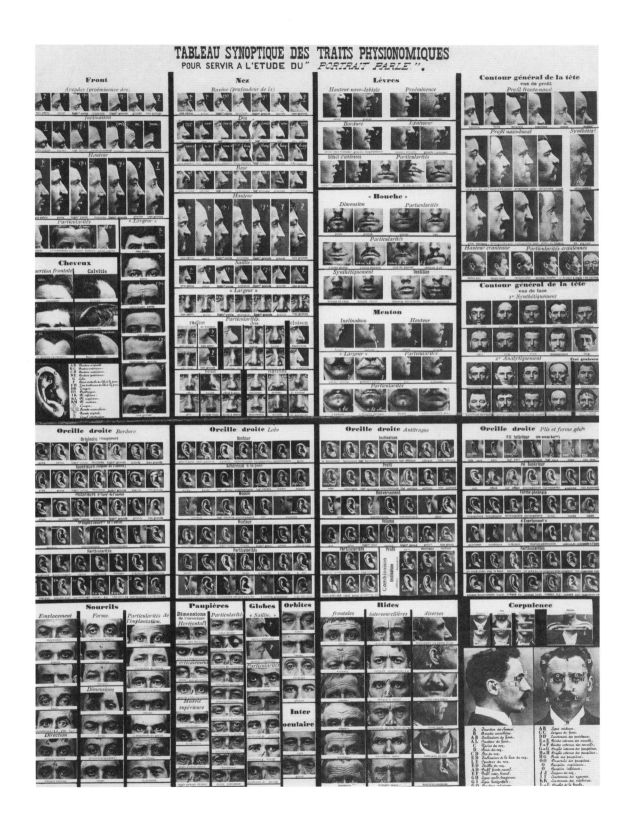

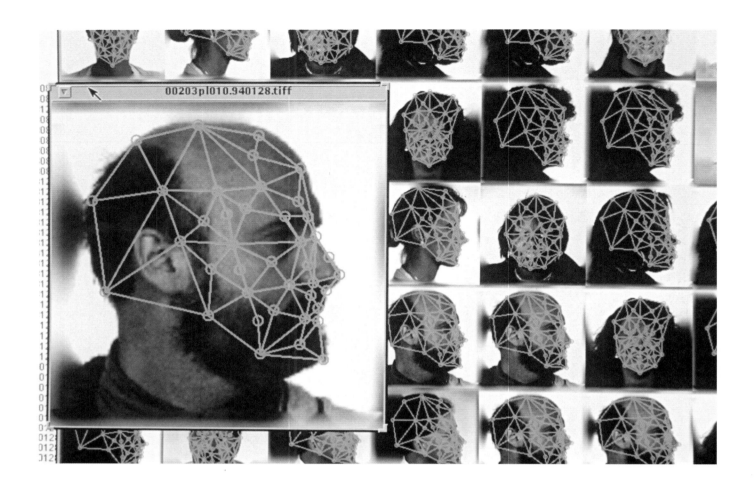

The window title bar reads: 00203pl010.940128.tiff

Photograph by Stegerphoto,
Multiple Facial Recognition Grids with Specific Male/
Female Points 2/2, date unknown

Facial Recognition

A conversation among visual culture experts who gathered online to discuss a selection of science-related news and media photographs on December 1, 2016, in an event sponsored by Reading the Pictures and the Center for Art, Design and Visual Culture.

Corey Keller [Alphonse] Bertillon is someone who is fascinating, a man with a rather unpromising-looking future, who got a job as a clerk for the Paris police [in 1879] at the moment when photography was starting to be used widely as a way of identifying criminals, particularly for identifying recidivism. The camera was actually introduced as a gentler alternative to branding, which was one of the ways that they identified repeat criminals at that time. Bertillon looked at all of the thousands of pictures of criminals he was filing away and thought it was ridiculous that there was no way to easily locate them again. So, he figured out that by taking all the complicated measurements and attaching quantifiable data to images of people, it would help classify, quantify, and make it easier to find them again. He called the mugshot a *portrait parlé*, a "spoken portrait," which is interesting because it underscored the embrace of photography as an objective way of making records, but also its total inadequacy, because in fact the picture couldn't be recalled except for someone being able to recognize the person in the picture. Similarly, facial recognition software, which is extraordinary, builds on very similar principles and biometric measurements. But what's different about facial recognition software is that it is not just identifying people who have already been identified as criminals, but looks at the general population and, in order to make identifications, has to have a data set against which to compare this information, and a lot of that information is now coming from the pictures that we upload ourselves onto social media and other places. The abundance of information used to map the human population is not necessarily being supplied by the police department, but by us. In both cases, what is interesting is how the picture itself is inadequate without the attached or comparative data, or the ability to recall the data; otherwise it is just information that can't be used.

Rebecca Adelman	I think it is an important corrective to discourses about facial recognition, as a thing that is supposedly inevitable and infallible, when we know that those systems often don't work. They're very difficult to implement and they also require corroboration, so I think that what you are saying is an important reminder, a counter to these totalizing narratives, but also points out how we voluntarily make ourselves available for these systems.
Corey Keller	There was an article in the *New Yorker* in 2017 about the "super-recognizers" that Scotland Yard employs. While there are some people who have difficulty recognizing faces, there are also some people who are specially gifted at recognizing faces, and London has more surveillance cameras per capita than any other city in the world. They have massive quantities of data but if you have a picture of someone who's committed a crime, but they have never committed a crime before, you have nothing against which to match the facial recognition. And so, they actually employ detectives who go out into the field to use their eyes to compare the collected data to the real world, which is kind of extraordinary. We have this massive quantity of information and we're still at the level where sometimes human intervention is required to interpret it.
Marvin Heiferman	This picture [p. 53] reminds me of work being done in object recognition as well, and the license plate readers that police routinely use to capture images of our license plates as we're driving our cars by. What Corey was saying, about how nineteenth-century police couldn't easily access photographic information, is interesting because today data from license plate readers can easily be transmitted from one police department to another, and systems collaborate so they can track a car as it drives from one town to another and one city to another. We've come a long way in terms of collecting and sharing images for data that is usable, searchable, and shareable. These systems are fallible, and there's certainly privacy issues linked to or triggered by them. But gigapan cameras have been used to scan stadiums to find terrorists, and surveillance cameras can target shoppers in their cars as they drive by malls to offer them coupons for what they might buy if they walked in the door.
Kurt Mutchler	There's a scene in the Tom Cruise film *Minority Report* [2002] where he walks into a store, is immediately recognized and offered things like what he might need, all based on his image and profile. And I think what we are looking at here is a one-hundred-year leap and Lord knows where we'll be in the next hundred years.
Nathan Stormer	Given the frame of *Seeing Science*, we're seeing science here in relationship to police work, criminality, and recognition. We're seeing science in relationship to what it does—as opposed to its mechanisms.
Corey Keller	It is so interesting to me how these concerns fueled Bertillon's projects. As he was making these sheets of images, rural populations were increasingly moving into cities full of different kinds of people—not people you might have met in a village, but strangers from many places—and people were trying to make sense of these populations to figure out who somebody was by looking at them. When you think about that in the context of what's going on today and the sort of fear we have in racial profiling, and how when you look at someone you want to know who they are, and if they are dangerous, it is kind of astonishing how little has changed and how the technology has changed but the impulse has changed so little.

Nathan Stormer I think the desire that is expressed to recognize, to be able to recognize, and for what purposes, underscores the way in which we use the extraordinary capacities of science to pursue all kinds of things. Some of them are extraordinarily noble; some of them are really not noble at all, or are easily convertible into ignoble causes.

Marvin Heiferman These images also speak to practices like anthropology and to eugenics, too, which is something to consider: the idea that measuring is everything, that measurement is what reveals the truth, which is certainly part of the fallacy of eugenics and some kinds of anthropological image-making. Sometimes measurement is exactly what we're after and sometimes it's not at all what you need to know.

Ben de la Cruz Symbolically and visually, [the facial grids on p. 54] illustrate a point: the fallacy of eugenics is that it seems to create a mask over a person's face, so you can't actually see them as a person. I don't know if it's purposeful or inadvertent, but you can barely see who the people are in that second image. All we see are the data points.

Nathan Stormer We're seeing by obscuring them. We're burying them under the information so that we can see them, which is of course not seeing at all—it is making them into something else.

The **Center for Art, Design and Visual Culture**, University of Maryland, Baltimore County, is a nonprofit organization dedicated to organizing comprehensive exhibitions, the publication of catalogues, media, and books on the arts, as well as educational and community outreach projects. The center's programs serve as a forum for exploring the social and aesthetic issues of the day.

Reading the Pictures is a web-based, non-profit educational and publishing organization dedicated to visual culture, visual literacy, and media literacy through the analysis of news, documentary, and social media images.

Rebecca Adelman is an associate professor of media and communication studies at University of Maryland, Baltimore County, specializing in visual culture, political theory, trauma studies, ethics, and cultural studies of war, terrorism, and militarization.

Ben de la Cruz is an Emmy-nominated documentary filmmaker and journalist. He joined NPR as a multimedia editor for the Science Desk. In this role, he serves as the visual architect for NPR's coverage of global health, science, environment, energy, food, agriculture, and development.

Corey Keller is curator of photography at the San Francisco Museum of Modern Art, where she has organized a number of exhibitions, including *Brought to Light: Photography and the Invisible, 1840–1900* (2008), which explored the use of photography in nineteenth-century science.

Kurt Mutchler is a senior science photo editor at *National Geographic* magazine. He has held several positions at *National Geographic*, including photo editor, deputy director of photography, and executive editor of photography.

Nathan Stormer is a visual scholar and professor of communication and journalism at the University of Maine, specializing in rhetorical history, argument, and persuasion.

A Lab in a Smartphone

Photographic imaging has played a central role in transforming medical education, diagnosis, and treatment for nearly two centuries and in the past three decades, the development of sophisticated and noninvasive imaging technologies—such as CT and PET scans and MRIs—has radically changed how medicine is practiced, treatment is evaluated, and what patients have come to expect. The production and interpretation of medical imaging has expanded to become a multidisciplinary effort and often an expensive one. Costs can spiral with the services of radiologists, sonographers, and support staffs; the profit incentives of fee-for-service billing; and the expense of hardware, software, data record keeping and even real estate are factored in. As insurers, government agencies such as Medicare, and the public balk at ever-rising health care expenses, new imaging options are being fast-tracked by researchers and medical entrepreneurs. Artificial intelligence (AI) and deep learning programs are being introduced that can, for example, sharpen MRI images, detect skin cancer from photos, and read medical scans with an accuracy that currently equals and will soon surpass that of humans. Ultrasound tools that plug into smartphone jacks have recently become available. And game-changing apps for phone cameras, which will allow for the results of a wide array of liquid and paper-based medical tests—administered at home, in doctors' offices, or in the field—to be photographed and shared instantly, promise to further automate and democratize medical imaging and restructure health care in the process.

Promotional photograph of Butterfly iQ, a handheld
whole-body ultrasound system, ca. 2017

Ornithological Photographs

To capture images for his project Ornithological Photographs, **Todd R. Forsgren** set up a rudimentary photo studio at various sites in the Western Hemisphere. The stunning photographs show birds trapped in what are called mist nets, set up by the ornithologists he accompanied and whose goal was to trap, identify, measure, and band the birds—as a way to research and track species behavior, migration, and survival—before they were set free. "Most people gasp when they first see the images," Forsgren says. "They think it's an environmental tragedy of some sort that I'm documenting." But the pictures are, in fact, more subtle and complex than that, as they summon up multiple references. The grids and clarity of focus impart a scientific look to the project. The subject matter and drama echo both James Audubon's *Birds of America* (1827–38), and later sequential images by Eadweard Muybridge and Étienne-Jules Marey. Ultimately, Forsgren's work also calls into question the logistics and ethics of nature photography, the roles images play in environmental stewardship, and, on a metaphoric level, the existential nature of freedom itself.

Clockwise from top left:

Todd R. Forsgren,
Wedge-Tailed Sabrewing (Campylopterus curvipennis), 2014

Boat-Billed Flycatcher (Megarynchus pitangua), 2012

Summer Tanager (Piranga rubra), 2013

Black-and-White Warbler (Mniotilta varia), 2009

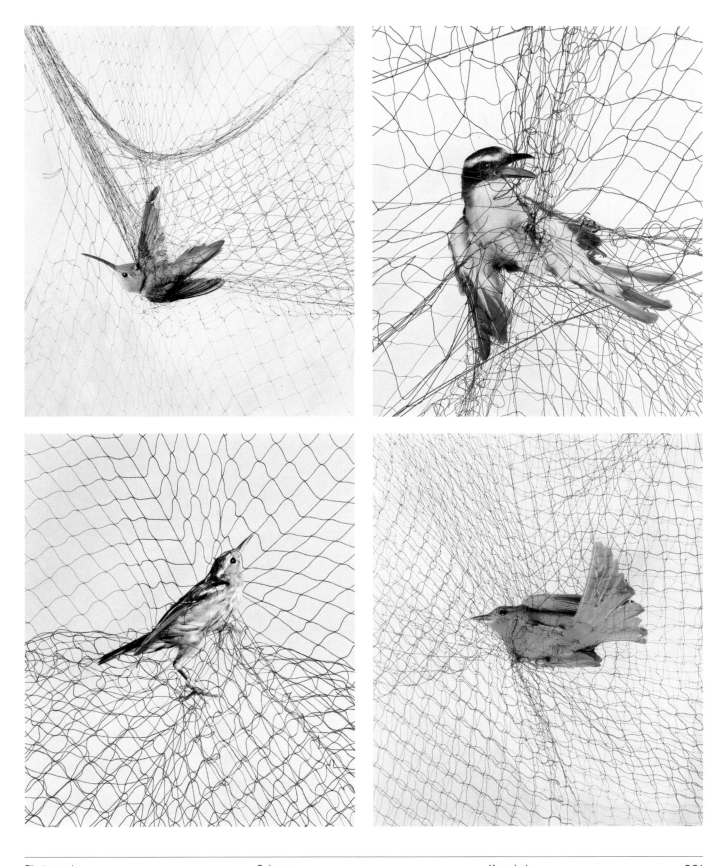

Animal Locomotion

In recent years, scientists have worked with advanced motion-picture cameras capable of shooting at astonishing speeds—trillions of frames per second—to learn more about, for example, the movement of light, sonic booms, and the process of heat transfer. But stop-motion imaging has long been an essential scientific research tool. It was pioneered by the entrepreneurial English-born photographer **Eadweard Muybridge**, who rigged up a system of a dozen cameras in California in the 1870s to help Leland Stanford—railroad tycoon, racehorse owner, politician, and the cofounder of Stanford University— to settle a bet about a thoroughbred's gait and whether all four hooves ever left the ground at one time. (The sequential and elegant images Muybridge produced proved that they did.) Muybridge continued to perfect his camera-synchronization setup and further study locomotion by photographing human models and, in the 1880s, an assortment of the animals housed in the Philadelphia Zoological Gardens. His composited images, often shot against gridded backgrounds in order to make movement easier to note and measure, were widely published and instrumental in transforming the practice, scope, and look of scientific photography.

Eadweard Muybridge,
The Horse in Motion, "Sallie Gardner," owned by Leland Stanford; running at a 1:40 gait over the Palo Alto track, June 19, 1878

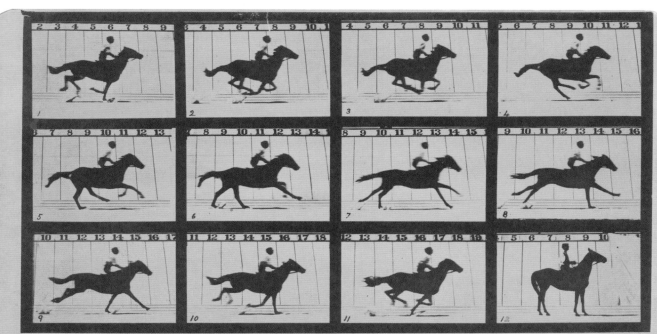

The Horse in Motion.

Illustrated by

MUYBRIDGE.

MORSE'S Gallery, 417 Montgomery St., San Francisco

Patent for apparatus applied for.

AUTOMATIC ELECTRO-PHOTOGRAPH.

"SALLIE GARDNER," owned by LELAND STANFORD; ridden by G. DOMM, running at a 1.40 gait over the Palo Alto track, 19th June, 1878.

The negatives of these photographs were made at intervals of twenty-seven inches of distance, and about the twenty-fifth part of a second of time; they illustrate consecutive positions assumed during a single stride of the mare. The vertical lines were twenty-seven inches apart; the horizontal lines represent elevations of four inches each. The negatives were each exposed during the two-thousandth part of a second, and are absolutely "untouched."

Wax Bodies of La Specola

Before photography was introduced in the nineteenth century, scientists employed a range of visual media as observational, educational, and communication tools. In 2006, **Tanya Marcuse** visited La Specola, a small natural history museum in Florence, Italy, where she saw and became fascinated by a display of wax anatomical models sculpted in the eighteenth century to document anatomy, childbirth, and disease. (She later traveled to a medical museum in Vienna to photograph a near-identical set of Italian models that were differentiated only by their paler skin and hair coloration.) At first, Marcuse planned to photograph the life-size models in a "restrained, cool, and categorical" way, but their startling presence and the evocative historical settings suggested a different approach. As she explained it, "I came to see the medium of photography as an analogue to Enlightenment concepts of seeing and understanding the world. Both have the look of truth, with a stranger fiction not far beneath the surface."

Clockwise from top:

Tanya Marcuse, *Wax Bodies No. 222, "La Specola,"* *Florence*, 2008

Wax Bodies No. 249, Josephinum, Vienna, 2007

Wax Bodies No. 254, "La Specola," Florence, 2008

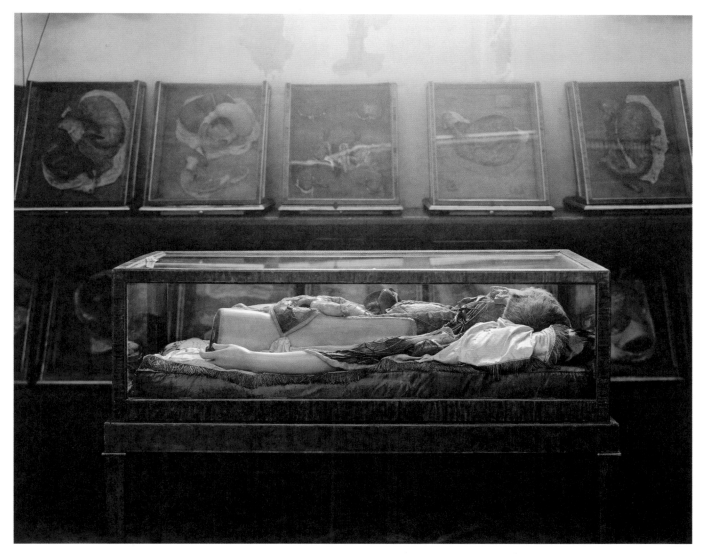

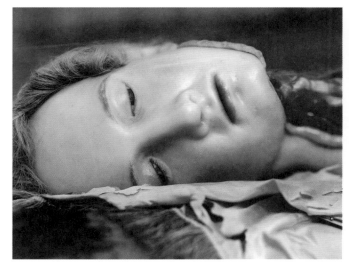

Startling Infrastructure

X-rays were shocking to their first viewers in the nineteenth century. "I have seen my death," Anna Bertha Röntgen is said to have exclaimed in 1895 when her husband, German physicist Wilhelm Conrad Röntgen, showed her an eerie X-ray image of her hand. Six years later, Röntgen would be awarded a Nobel Prize for "the discovery of the remarkable rays subsequently named after him." But the impact of X-rays was so sensational and immediate that just a month after Röntgen's discovery, the Austrian photo-chemists **Josef Maria Eder** and **Eduard Valenta** published an elegant volume of photogravures that reproduced X-rays depicting the skeletal structure of animals, human body parts, the materiality of everyday objects, and the silhouettes of natural materials. Late nineteenth-century popular culture was saturated with fuzzy photographs purporting to capture the existence of fairies, people's spiritual auras, and ghosts of the deceased. But the public was mesmerized anew by hauntingly clinical, beautiful, and truly revolutionary images that revealed what had been.

Josef Maria Eder and Eduard Valenta, *Ratte*, 1896

Cameen in Goldfassung, 1896

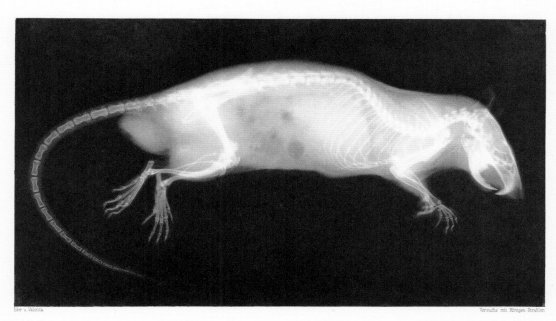

Eder u.Valenta. Versuche mit Röntgen-Strahlen.

Ratte.

Eder u.Valenta. Versuche mit Röntgen-Strahlen.

CAMEEN IN GOLDFASSUNG.

Displaying the Sciences

It was, surprisingly, funding from the estate of James Smithson, a British chemist and mineralogist who never traveled to America, that established the Smithsonian Institution in Washington, DC, in 1846; he defined his mission for the institution as the "increase and diffusion of knowledge." Photography, introduced less than a decade earlier, soon came to play a pivotal role in achieving that goal and shaping the Smithsonian's collecting, displays, management, and public outreach. In 1870, **Thomas W. Smillie** became the first official photographer at the Smithsonian and was named its curator of photography in 1896. Like many photographic enthusiasts in the nineteenth century, Smillie had a broad understanding of the various ways the new medium might function. He built a collection of photographic equipment, which included Samuel Morse's daguerreotype camera and apparatus (p. 209), for which he paid $23, made photographs to document the museum's collection objects and installations, organized the Smithsonian's first photography exhibit in 1913, and worked closely with Smithsonian scientists, helping them to better understand how photographic images could be used in and further their research.

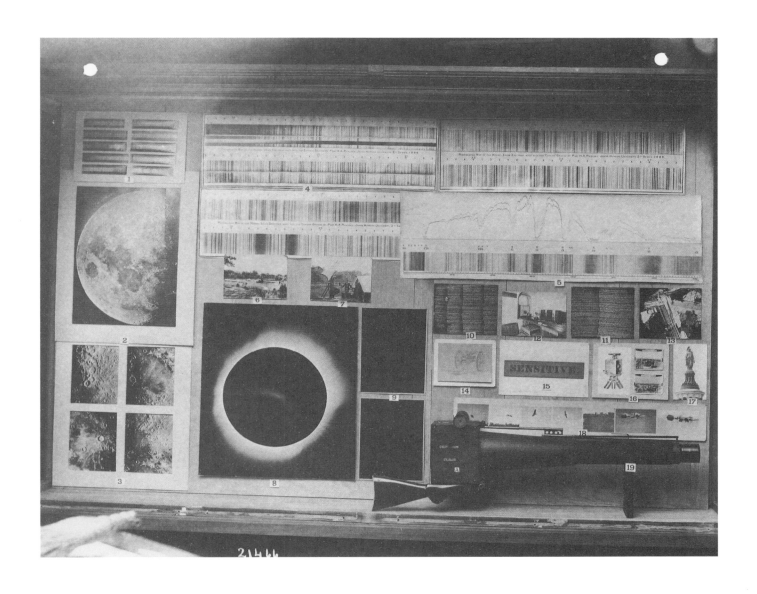

Thomas W. Smillie,
Installation view of a scientific photography exhibition,
Smithsonian Institution, ca. 1915

The "Bird Woman" of Block Island

In the nineteenth century, images played a central role in ornithology, including James Audubon's exquisite drawings, paintings, and prints and Eadweard Muybridge's serial photographs of birds in flight. More recently, **Katherine Wolkoff** has produced striking avian-themed works, inspired by Elizabeth Dickens, who, early in the twentieth century, began collecting bird specimens to teach children living on Block Island, off the coast of Rhode Island, about migratory patterns. Over time, Dickens amassed 172 taxidermied birds, most of which were not intentionally killed by humans but perished for various reasons—by, for example, flying into windows and buildings or being chased by cats. Dickens's work was celebrated and written about in ornithology journals, newspapers, and magazines such as *Life* and the *Saturday Evening Post*. More than seventy years later, Wolkoff—whose work often and elegantly explores the natural world—first learned about the "Bird Lady" on a ferry ride to Block Island. Interest piqued, Wolkoff produced a series of haunting silhouettes of some of the birds from Dickens's collection that, as the artist describes it, "abstracts them a little bit," and in that process further elevates "the ordinary into the extraordinary."

Clockwise from top left:

Katherine Wolkoff,
Great Egret, Casmerodius albus, *Brought to Block Island by Captain Alfred Jacobsen, Alighted on fishing vessel* Frairs *at Georges Bank during N.E. storm, April 2, 1931,* 2005

Northern Oriole, Icterus galbula, *Taken by a cat from Elizabeth Dickens, May 1, 1924,* 2005

Northern Lapwing, Vanellus vanellus, *Evidently shot, Salvaged by Thelma Tinker, November 20, 1932,* 2005

Greenbacked Herons, Butorides striatus. Left: *Immature, taken from a cat, September 23, 1944.* Right: *Male, Wire victim found by Mary Elizabeth Lewis, May 18, 1944,* 2005

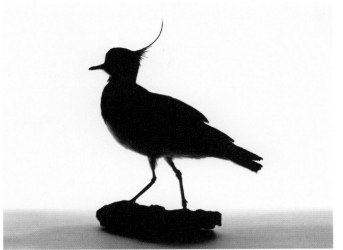

The Story of Photo 51

by Marcel Chotkowski LaFollette

Peer deep into this photograph's heart, eye, vanishing point. Despite the beauty, no hammered stare, of any length, unlocks meaning or maker. The image (inviolate) defies casual analysis. Perhaps, you wonder, identification of topic or photographer is irrelevant. No clues visible (except perhaps to a biologist). Ah, now you read the label. The shoulders sigh (aesthetic surmises fade), the eye winks (no joke), and a scientist strides onto the stage and grips the podium (serious stuff).

This is the iconic X-ray diffraction photograph of DNA taken by physical chemist Rosalind Elsie Franklin and PhD student Raymond G. Gosling. The genetic material glimpsed in *Photo 51* connects all living things and the image thus metaphorically captures human past, present, and future. It also marks an important milestone in science. In the last half-century, research that drew from Franklin's photograph has brought advances in biology, medicine, paleontology, and many other parts of life.

Under a microscope, cells reveal their own truths, possessing the potential to separate conception from context. By convention, science (which makes the invisible visible) renders the visualizer invisible. Discoveries are disassociated (divorced) from he (or she) who stained the cell, mixed the reagents, pushed the buttons, coded the data. In an era when cameras record every baby step and every entertainer's misstep, it may be difficult (if you are outside that world) to comprehend a culture in which (in theory) the photographer does not attach to the image. Analysis matters. Publication matters. Claiming credit first matters. The photographs themselves are allegedly, well, just part of the work.

This particular image had led Franklin to conclude in 1952 that the strands of DNA might form a helical structure but she was cautious and wanted more data. And therein lies the back story: Franklin's own vanishing point.

Novelist Josephine Tey once accused historians of flattening the past into a "peepshow," drawing historical actors as "two-dimensional figures against a distant background." Let us pull Franklin into the foreground, replace the center of the image with her face (three-dimensional), and consider whether knowing about the photographer matters.

In January 1953, Maurice Wilkins, one of Franklin's colleagues in the laboratory at King's College, London, shared her photograph (without her knowledge) with two other scientists also in the DNA hunt. James Watson and Francis Crick (the men who, in another famous picture, seem to be ogling a curvy "double helix" model as if it were a naked Venus) interpreted the image (and other material attributed to Franklin). Watson, Crick, and Wilkins raced into print, pushed Franklin aside, and achieved fame and fortune. Franklin was

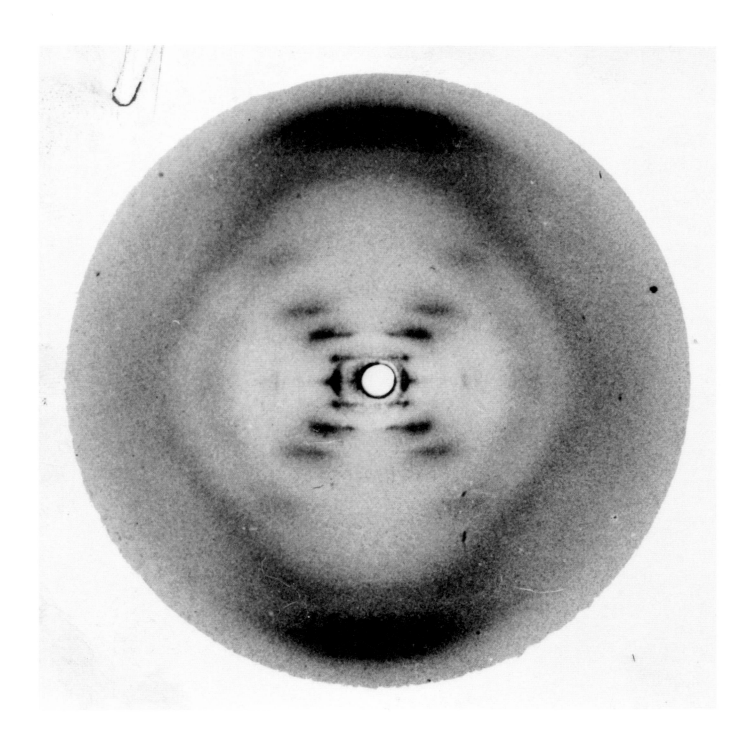

Raymond G. Gosling and Rosalind E. Franklin,
Known as Photograph 51, this two-dimensional X-ray
diffraction image of DNA from a calf thymus led to
how the three-dimensional double helix architecture
of DNA is conceptualized, 1952

allowed to stand at the back of the stage: her article was the third in the journal issue. Watson's arrogant dismissal of Franklin's work continued for decades after her death. Credit should go to the flyboys, the creative geniuses, not the others. "Technical stuff" was "woman's work."

Franklin had grasped the image's essential truth, before others saw it, but the Nobel Prize is not awarded posthumously. Die too soon and you never get to wear a fancy dress. Watson, Crick, and Wilkes made the list four years after Franklin's death. It is left to history to reconsider (some would say "redress") such matters. Scientific encyclopedias up through the 1990s included "Franklin, Benjamin" but not "Franklin, Rosalind." Newer works now recognize Rosalind's contributions and dissect the social and cultural attitudes that reinforced and stood silent at her marginalization.

The notion that a photographer's identity might, as a matter of cultural practice, be detached from her photograph may seem an anathema within the world of art, where exhibitions celebrate the vision of those who hold the cameras, even if their names are unknown. Credit is a cultural practice: a matter of grace and humility when shared, a matter of despicable boorishness when unfairly stolen. Fortunately, there is a form of historical geometry: a line (reinforced) attaching Franklin to this photograph and its meaning in time.

At first glance, such context remains obscured from the viewer. The photograph's mysterious, cloudy strands loop themselves around our eyes and engender thoughts of beauty. But for those who value integrity, well, pull on that line and reach for Rosalind E. Franklin. No vanishing point to memory or to our common humanity. Credit due.

In her work, historian **Marcel Chotkowski LaFollette** explores the boundaries of science, politics, and the public, with special attention to popularization and ethics. Her recent books include *Science on American Television: A History* (2013); *Science on the Air: Popularizers and Personalities on Radio and Early Television* (2008); and *Reframing Scopes: Journalists, Scientists, and Lost Photographs from the Trial of the Century* (2008). Since 2008, LaFollette has been a research associate at the Smithsonian Institution Archives, researching the history of science's popularization through photography.

This piece originally appeared online as "Woman's Work: How Rosalind Franklin's 'Photo 51' Told Us the Truth about Ourselves," Hillman Photography Initiative, December 2014, http://www.nowseethis.org/thispicture/posts/934/essay/17.

Photography
+ Science

Culture

02

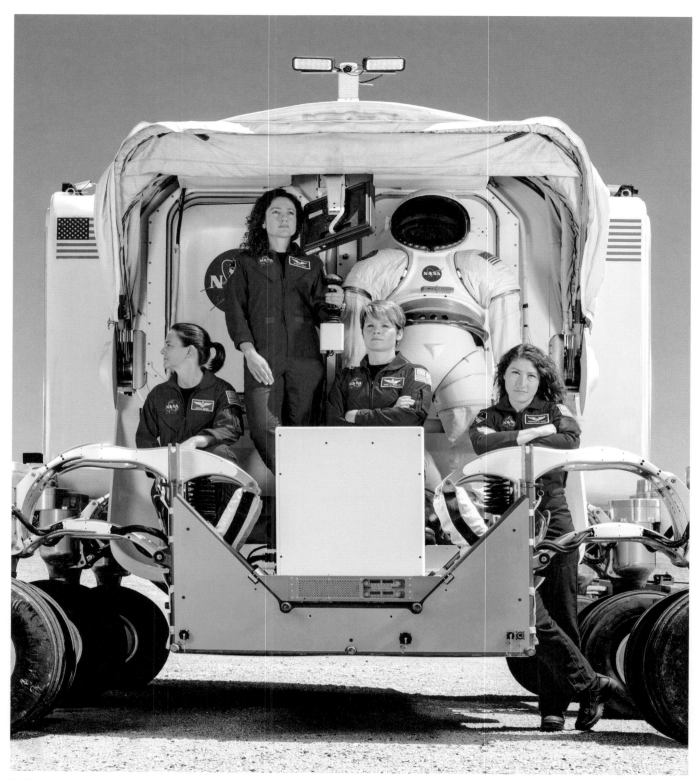

Todd Spoth,
The New Women of NASA, from left to right: Nicole
Aunapu Mann, Jessica Meir, Anne McClain, and
Christina Koch, 2016

The Women of NASA

A conversation among visual culture experts who gathered online to discuss a selection of science-related news and media photographs on December 1, 2016, in an event sponsored by Reading the Pictures and the Center for Art, Design and Visual Culture.

Corey Keller I have two distinctly different reactions to this image. I've worked with a lot of astronauts over the years who launched and serviced the Hubble Space Telescope. I don't know these astronauts, but if you read their bios, they are obviously exceptional people who put the rest of us to shame. I look at them and I know they must be awesome people. And I think it is very inspiring, especially to girls, to look at an image like this, which was clearly one of the intentions of this. But it is sad to me that NASA and many of us still feel like we have to make pictures like this because I'd like to think that we've gotten past this. But unfortunately, STEM fields— science, technology, engineering, and math—are still too dominated by men and, in particular, white men. So, I think we do still need to do things like this to inspire young women and underrepresented minorities to pursue STEM fields. To me, science and technology are all about hope and finding solutions to our problems, and if we are excluding people then we are missing a lot of people's talents and ideas. Who knows what diseases might have been cured or what discoveries might have already been made if we had had a more diverse group of scientists, engineers, and astronauts all along. I've got mixed feelings about this image, I guess. How long ago was it that Sally Ride rode on the space shuttle? We're still climbing up that hill of being more inclusive, and getting the best of everybody's talents, and that's what we need to solve the problems of the world and make progress.

Marvin Heiferman This picture makes you think about the ways women have, and have not, been represented in the sciences. Back in the 1990s, "the Matilda effect" was a phrase coined to describe the fact that women scientists often didn't get proper credit for the work that they do. And that, of course, carries over into the photographic

depiction of the world and work of science. I'm looking at this and thinking about images of Amelia Earhart, for example, and how some images make her into a performer of science. More traditional pictures of scientists tend to show people intently at work, but this image presents the women in it as self-assured and sort of turns them into celebrities. The photograph also underscores how carefully organizations like NASA now use photography to get their message across. Openings for NASA's latest class of astronauts had three times the number of applicants as the previous class, and when NASA was asked what that was about they said it was the high visibility of NASA's activities on social media that encouraged people to get enthusiastic. And so, images like this create buzz and get results when they get out into the world.

Corey Keller Actually, I'm intrigued by the fifth figure in this photograph, which is the looming space suit. I can't decide if it's dominating them or if it's just showing off the feats that they have to pull off to operate in space. But that figure, to me, is critical to the picture and stands in contrast to the very human co-subjects.

Max Mutchler I do believe that at its core, of course, NASA is about exploration and scientific discovery, but when you really boil it down—what we're doing with Hubble and what the astronauts do—a big part of what we do is inspire the next generation. And this image obviously falls into that category. That seems to be the intent of it.

Rebecca Adelman When I read the news story that this picture was an illustration for, at least one of the women depicted said "I don't want this to be news. Or I don't want the fact of me potentially going to Mars or my being an astronaut and also being a woman to be news." And yet it was interesting that in the profile there was a lot of emphasis on how extraordinary these women were, and it was much more a story about them personally, as opposed to being a story about the kinds of science that they would be doing. I thought that was an interesting dynamic, and I was thinking about how setting these women up as extraordinary, there's a tension in the image. On the one hand, yes, they're serving this important, inspirational function. But if we set them up as extraordinary, it also potentially re-genders science as male. If these women become extraordinary it serves also to reaffirm the thing that they are fighting against.

Ben de la Cruz It is worth noting how some of them are looking in different directions and not at the camera. The astronaut on the bottom right is looking right at us, and confronts us about who she is. In contrast, the astronaut with the ponytail, I can barely see her, and I'm wondering if this would have been more powerful or more about the sisterhood if they were all looking right at the viewer. It tends to make us a little more comfortable when we see people in three-quarters stance like this, versus an Errol Morris–style documentary shot where subject looks right into the camera, and viewers feel they can't avert their gaze. So, for me, I think this picture could have been a little more powerful if the women were posed differently. This picture seems to be letting the reader off the hook a little bit.

Corey Keller But when they don't look at you directly, you have the chance to look at and study them in a different way. The three women on the left, in a sort of strange way, become almost part of the equipment. Especially with the symmetry of the composition and the way they don't engage you, it lets you look at them the same way you would look at the space suit, but the woman on the right prevents that by engaging you directly with her eyes.

Marvin Heiferman The posing is complicated. Two people are looking kind of directly at the camera. The second woman on the left is looking up into space, which suggests there's almost a spiritual connection to be made through what this job might be, and the person on the left is looking off to the side, which might speak to the nature of the work that they actually do, which is to be observant, diligent, and make sure that everything is going OK. It's a complicated picture, a team picture, but not the kind where everyone's facing the camera. It an image that suggests how people work together and behave differently as they do.

The **Center for Art, Design and Visual Culture**, University of Maryland, Baltimore County, is a nonprofit organization dedicated to organizing comprehensive exhibitions, the publication of catalogues, media, and books on the arts, as well as educational and community outreach projects. The center's programs serve as a forum for exploring the social and aesthetic issues of the day.

Reading the Pictures is a web-based, non-profit educational and publishing organization dedicated to visual culture, visual literacy, and media literacy through the analysis of news, documentary, and social media images.

Rebecca Adelman is an associate professor of media and communication studies at University of Maryland, Baltimore County, specializing in visual culture, political theory, trauma studies, ethics, and cultural studies of war, terrorism, and militarization.

Ben de la Cruz is an Emmy-nominated documentary filmmaker and journalist. He joined NPR as a multimedia editor for the Science Desk. In this role, he serves as the visual architect for NPR's coverage of global health, science, environment, energy, food, agriculture, and development.

Corey Keller is curator of photography at the San Francisco Museum of Modern Art, where she has organized a number of exhibitions, including *Brought to Light: Photography and the Invisible, 1840–1900* (2008), which explored the use of photography in nineteenth-century science.

Max Mutchler is a manager of the Space Telescope Science Institute and the head of their Research and Instrument Analysis Branch. He works on solar system observations with the Hubble Space Telescope and also contributes to planetary missions such as Dawn and New Horizons.

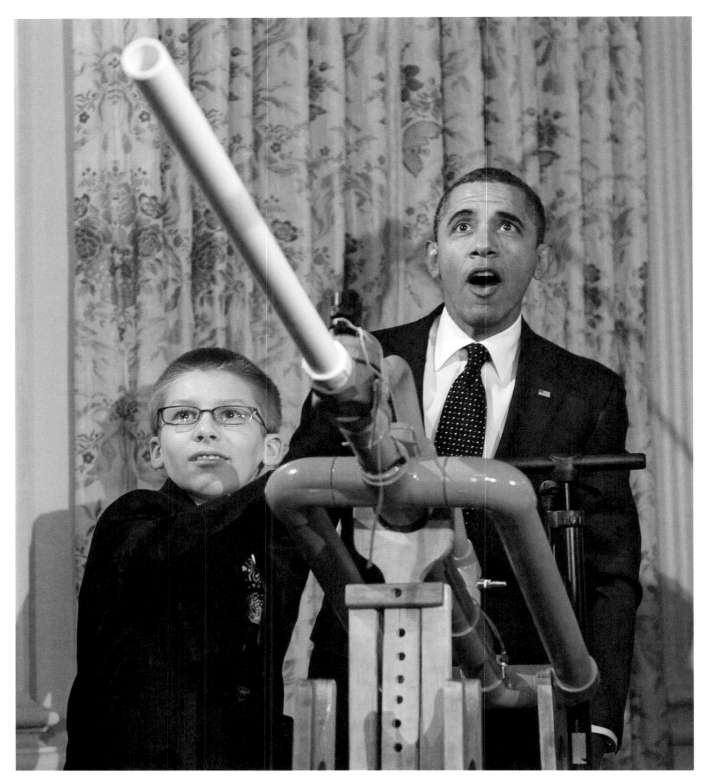

Saul Loeb,
US President Barack Obama reacts as 14-year-old Joey Hudy of Phoenix, Arizona, launches a marshmallow from Hudy's "Extreme Marshmallow Cannon" during a tour of the White House Science Fair in the State Dining Room of the White House in Washington, DC, February 7, 2012. Obama announced new policies to recruit and support science, technology, engineering, and math (STEM) teacher programs, including requesting $80 million in his upcoming budget for teacher preparation, with the goal of training one million additional STEM students over the next decade, 2012

At a White House Science Fair

A conversation among visual culture experts who gathered online to discuss a selection of science-related news and media photographs on December 1, 2016, in an event sponsored by Reading the Pictures and the Center for Art, Design and Visual Culture.

Kurt Mutchler You know, in any kind of photography, and especially in science photography, humor is always welcome. This picture is wonderful in regards to that and because there's a lot going on, which is why I like it. There's the boy's wonder, the look on Obama's face, and the proud nature of a boy showing the president of the United States how to launch a marshmallow—it is just great. And then aesthetically, I love those drapes, I can't get over those drapes.

Nathan Stormer This does have a 1950s feel to it, maybe because of those drapes? I also have a sense that it is like a throwback to a more innocent time when science was fun and seen as a frontier, not something that is deeply contested or seen as full of hoaxes or misinformation the way science is often presented today. It's a naive image of science, I guess, which I enjoyed about it.

Corey Keller It's all about the ears, for me.

Kurt Mutchler It is a fitting picture now because here we had a president who embraced and valued science, and the importance of that can't be said enough. So, it will be interesting to see what happens in the next couple of years.

Max Mutchler I had the pleasure of being at two such White House events. The Obamas also hosted two star parties on the south lawn of the White House, so there's pictures of the president looking just like this with a telescope in front of him, and a young girl showing him some star. These science fairs and star parties are unique; historians have said there have never been events like this at the White House, and it is special. It makes me appreciate having a president who reveres science—and the focus was on elementary and middle school kids, like you see in this image, to inspire them and encourage them, and it's an apolitical thing, too.

Marvin Heiferman	It also speaks to the role of mentorship, although this picture presents a role reversal. There's no Mr. Wizard or Bill Nye the Science Guy here, just a little kid showing the president how cool science is, which is sweet.
Nathan Stormer	Because you know he wants to launch a marshmallow. You know Obama wants to launch a marshmallow. He really does.
Ben de la Cruz	My young son wanted to know what images we were going to be looking at, and kids love seeing other kids, so in terms of mentorship, that connection that other kids can make is important. A photograph like this inspires other kids to say, "Hey! If I do a science project I get to hang out with the president and get my picture taken!"
Corey Keller	Displays of science go all the way back to the nineteenth century, and making science accessible to the public through hands-on demonstrations has been a popular part of scientific education for the public ever since. The thing I love about this picture is the color palette and its approach to science, and what a different sense it gives of what the practice of science looks like.
Rebecca Adelman	I think we could probably talk about gender in the image, too, although I don't want to be the only grumpy person talking about it in that way when everyone else seems so enthusiastic about it, but I think it is an interesting contrast.
Nathan Stormer	Well, the boy has a cannon; that's the first thing that came to my mind. This science project was to launch something at high speed and a cannon is an easy way to suggest progress in terms of scientific work. People do talk about the ways in which science is implicated in violence, though that's often weeded out by the ways science is represented, which is not to say that silence is never critical of science. Corey, you mentioned historic education. I was reminded of how people took orreries, spinning models of planets, to coffeehouses in the seventeenth and eighteenth centuries, and other early and amateur displays of scientific information shared for the benefit of others.
Corey Keller	Back in the nineteenth century, people thought that having a public that was educated about the newest developments in science would make for a better democracy. That idea, unfortunately, seems to be going out of favor. I was thinking earlier about the pictures of microscopic animals that people chose to put under a microscope: cheese mites, lice, and dust mites, whatever disgusting thing you could find. The creepy crawlies you would find in your house that photographs made poignant and accessible at the same time. That's what science fairs and pictures like this, ideally, should do—make the basic principles of science engaging and accessible.
Nathan Stormer	Well, we've talked about it a couple times, but this image does make me think of our current president and the state of science and what will happen to it and to the rest of us along with it. This particular image, and having had a previous president who was enthusiastic about science, is heartbreaking in a way.

The **Center for Art, Design and Visual Culture**, University of Maryland, Baltimore County, is a nonprofit organization dedicated to organizing comprehensive exhibitions, the publication of catalogues, media, and books on the arts, as well as educational and community outreach projects. The center's programs serve as a forum for exploring the social and aesthetic issues of the day.

Reading the Pictures is a web-based, non-profit educational and publishing organization dedicated to visual culture, visual literacy, and media literacy through the analysis of news, documentary, and social media images.

Rebecca Adelman is an associate professor of media and communication studies at University of Maryland, Baltimore County, specializing in visual culture, political theory, trauma studies, ethics, and cultural studies of war, terrorism, and militarization.

Ben de la Cruz is an Emmy-nominated documentary filmmaker and journalist. He joined NPR as a multimedia editor for the Science Desk. In this role, he serves as the visual architect for NPR's coverage of global health, science, environment, energy, food, agriculture, and development.

Corey Keller is curator of photography at the San Francisco Museum of Modern Art, where she has organized a number of exhibitions, including *Brought to Light: Photography and the Invisible, 1840–1900* (2008), which explored the use of photography in nineteenth-century science.

Kurt Mutchler is a senior science photo editor at *National Geographic* magazine. He has held several positions at *National Geographic*, including photo editor, deputy director of photography, and executive editor of photography.

Max Mutchler is a manager of the Space Telescope Science Institute and the head of their Research and Instrument Analysis Branch. He works on solar system observations with the Hubble Space Telescope and also contributes to planetary missions such as Dawn and New Horizons.

Nathan Stormer is a visual scholar and professor of communication and journalism at the University of Maine, specializing in rhetorical history, argument, and persuasion.

Light, Camera, Action

In the early decades of the twentieth century, once photographic illustrations in newspapers and magazines became widespread, images about science began to appear with regularity. Interest in science grew as news reports of aeronautical firsts; breakthroughs in astronomy, medicine, and technology; and illustrated articles about archaeological finds like the tomb of King Tutankhamun sparked the public's curiosity and imagination. In 1920, newspaper publisher E. W. Scripps joined with the American Association for the Advancement of Science, National Academy of Sciences, and the National Research Council to establish an organization known as Science Service. Its goal was to popularize science through the mass media and photographs, particularly graphically striking ones, which played an increasingly important role in capturing attention and raising public awareness of and enthusiasm for the sciences. "Drama lurks in every test tube," an issue of *Science News*, a journal sponsored by Science Service, claimed in 1927. How to best visualize science still remains a challenge to this day, as photographic images continue to impact research, science education, policy, funding, and advocacy, as much as journalism.

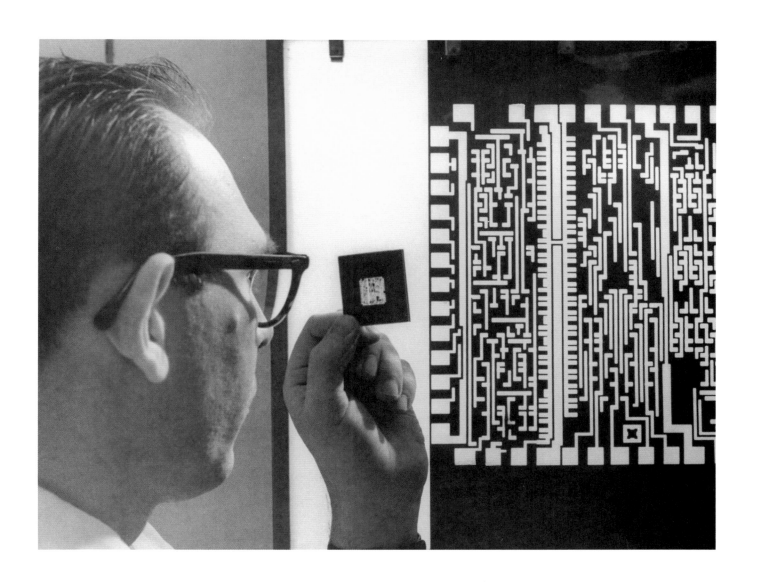

Photographer unknown,
IBM Makes Masks for Integrated Circuits Automatically, 1967

Guide to Computing

As numerous corporations, such as Olivetti, IBM, and Apple, have repeatedly proven, technology can be beautiful—even sexy. So are the photographs in Guide to Computing (2016), an ongoing project by London-based **James Ball**, a photographer and art director (also known as Docubyte) who is enthralled with the history and look of early computers. Ball seeks out vintage pieces in the collections of places like the Computer History Museum in Mountain View, California, London's Science Museum, and the Dresden Technical Collections in Germany. He photographs carefully and then gives each of them the full glamour treatment, which involves extensive retouching and presenting the computers against brightly colored backgrounds. The photographs that result are as seductive as they are evidential, a reminder of how photography helps to create excitement as powerfully as it does discovery.

Clockwise from top:

James Ball,
all from the series Guide to Computing

CDC 6600, 2016

IBM 729, 2016

EAI PACE TR-48, 2016

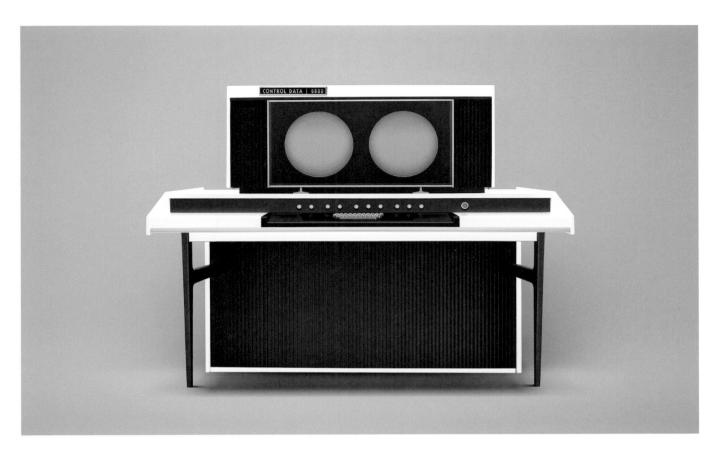

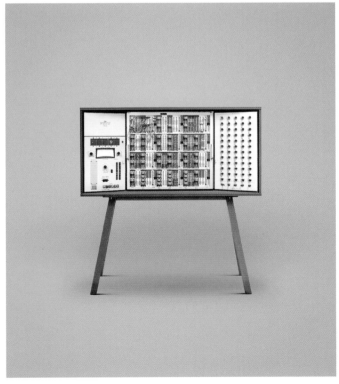

When Workers Suit Up

In the course of their work, scientists often wear items of protective clothing: goggles, lab coats, gloves made of latex or plastic. Outside of laboratories and in the face of very different challenges, hazmat suits are worn by those whose jobs insert them into extreme situations and direct contact with hazardous materials, contaminants, and conditions. For his Security series (2004–7), **Paul Shambroom**—known for work that explores power, safety, and fear—traveled to simulated environments known as Terror Town, New Mexico, and Disaster City, Texas, to photograph both facilities and emergency workers in training to prepare for and respond to terrorist attacks. The portraits feature people in bulky, hi-tech gear designed to keep them safe from heat, biochemical agents, explosives, and radiation. Simultaneously documentary and surreal, the photographs are full of contradictions. They are still images that speak to potentially out-of-control situations, and portraits made with the calmness of eighteenth-century paintings, but that reflect the science and technology of twenty-first-century threats and prevention.

Clockwise from top left:

Paul Shambroom,
all from the series Security

Level A hazmat suit, aluminized, "Disaster City" National Emergency Response and Rescue Training Center, Texas Engineering and Extension Service (TEEX), College Station, Texas, 2004

Level A hazmat suit, yellow, "Disaster City" National Emergency Response and Rescue Training Center, Texas Engineering and Extension Service, College Station, Texas, 2004

Level A hazmat suit, blue, Ordnance Munitions and Electronic Maintenance School, US Army, Redstone Arsenal, Huntsville, Alabama, 2007

Bomb suit, robot, 148th Explosive Ordnance Disposal, Minnesota Air National Guard, Duluth, Minnesota, 2005

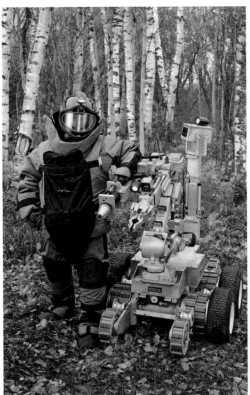

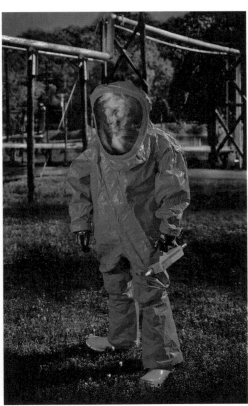

Photography and Environmental Practice

by Jennifer Tucker

From the nineteenth century to today, photographic images have impacted public opinion, policy and funding, science education, and the many aspects of visual and popular culture that are affected by ecological issues. They have shaped scientific and cultural perceptions of natural areas as well as awareness of the impacts of pollution and toxic waste on human communities. What stories then can be told (or not) with images? Under what conditions are people moved? What new or different kinds of images are adequate for addressing contemporary problems and the future?

Bill McKibben, one of today's leading environmental writers—in pointing to literary authors from the past, such as George Perkins Marsh, John Muir, and Rachel Carson—famously called attention to the fact that "each advance in environmental practice was preceded by a great book," a situation that he described as being "perhaps unique in American letters."

Yet advances in environmental practice have also quietly influenced the production of great and consequential images that have played pivotal roles in shaping environmental science.

Images of the environment serve as both a catalyst and as a mode of understanding. Visual portrayals help shape the context in which politics take place, and are often instrumental in stimulating dialogue and debate. In our relationship to environmentalism, sometimes pictures have a chance to change history by creating a larger understanding of the subject, bringing a greater awareness to pressing issues.

Take for example the American photographer Carleton Watkins, whose 1861 photographs of Yosemite were shown to Congress by Senator John Conness (R-California). The American wilderness held a special power, as symbol and resource, and the presentation of Watkins's photos were said to have influenced President Abraham Lincoln to sign an 1864 bill declaring Yosemite Valley inviolable—legislation that paved the way for creation of the country's national parks.

A century later, the newly created US Environmental Protection Agency sponsored the Documerica project in 1972. Nearly one hundred leading photographers under the direction of World War II veteran and photojournalist Gifford Hampshire were contracted to document subjects of environmental concern. The monumental project, reminiscent of the Farm Security Administration photo-documentary project of the 1930s, produced more than twenty thousand photographs depicting a remarkable breadth of situations: water, air, and noise pollution; unchecked land development; poverty; the environmental impact on public health; and images of Americans creating positive change in their surroundings. The photographs were exhibited widely and nationally in art museums, educational institutions, and at the Smithsonian Institution.

Similarly, in 2003, during a debate in the US Senate about oil drilling in the Alaska Arctic National Wildlife Refuge, Senator Barbara Boxer (D-California) urged members of Congress to visit a Smithsonian exhibit of photographs by the young physicist Subhankar Banerjee, showing the biodiversity and human habitation of the refuge. Among Banerjee's goals, he wrote, was to counter impressions of the Arctic as a "frozen wasteland of snow and ice" by using color photography as "a wonderful visual language to help us unlearn some of these intolerances." In the end, the bill to open the refuge to oil drilling failed by four votes.

Yet as the environmental historian Finis Dunaway cautions, images that circulate to raise environmental awareness often leave crucial issues "outside of the frame"

Subhankar Banerjee,
Caribou Migration II, 2002; from the series Oil
and the Caribou

Michael Philip Manheim,
*Airplane Coming in for a Landing Over Neptune
Road Homes, Boston*, 1973, from the Environmental
Protection Agency's Documerica project (1972–77)

by focusing on individual, moral choices at the expense of structural, long-term environmental consequences. As Rebecca Solnit put it in a 2014 essay, "Are We Missing the Big Picture on Climate Change?," "It's a difficult subject to tell and to take in. . . . A lot of it is hard to see. . . . To know how things have already changed, you have to remember how they used to be." Yet the future is also challenging to photograph, as well (although to see possibilities for the future embedded in visual imagery may be one of society's greatest tests).

Can such complex and long-term processes be captured by still or moving images?

One possibility may come from photography by scientists themselves. Helen Poulos, an ecologist who specializes in plant distribution patterns and physiology, uses photography in innovative ways in the field work that she does in forests, deserts, and rivers across North America, documenting changes in the landscape in order to better understand the historically changing relationships between humans and ecosystems. The method that she uses is "repeat" digital photography (sometimes combined with repeat satellite imagery analysis). As she told me, "Environmental scientists around the world focus on documenting change, and repeat photography represents an important medium for doing just that." She explains: "Taking a picture at the same location at two points in time allows scientists to objectively document the effects of natural or anthropogenic changes in the landscape." For Poulos and other environmental scientists, new photographic methods provide quantitative as well as qualitative methods for demonstrating the shifting of landscapes.

Over one hundred and fifty years after Congress began to see Yosemite in new ways, in part through the mediation of photographs, learning how to see and communicate with visual images remains both important and increasingly consequential.

M. McClaran,
Photo station 71, Mexican blue oak in right upper corner in 1936 is present, as is mesquite in center midground. Prickly pear and barrel cacti present. Calliandra, ocotillo, Palmer agave, shrubby buckwheat also present. Sideoats grama, sprangletop, Lehmann lovegrass common; goldeneye (*Viguiera* sp.) dominates herbaceous layer, 2007

W. J. Cribbs,
Photo station 71, Santa Rita Experimental Range, Arizona, July 1936

Jennifer Tucker is associate professor of modern history and science in society at Wesleyan University and senior research scholar, Photographic History Research Centre, De Montfort University, Leicester, UK. She specializes in the study of Victorian science, photography, and visual culture. Her first book, *Nature Exposed: Photography as Eyewitness in Victorian Science* (2005), explored the history of debates over photographic evidence in Victorian science and popular culture. She currently serves as editor of the "Image, Technology, History" feature of the journal *History and Technology*, as a member of the *Radical History Review* editorial collective board, and as coeditor of the Photography, History book series published by Bloomsbury.

Beneath the Surface

The first known underwater photograph, taken in 1856 by William Thompson in England, was made by submerging a pole-mounted, glass-enclosed camera eighteen feet below water level to capture a faint image of boulders and seaweed. By the late 1890s, Louis Boutan, a French marine biologist, was regularly conducting deep-sea dives, using a specially designed flash camera to record underwater scenes in low-light situations. While Jacques Cousteau's impressive films and books of still photographs captured the public's attention in the second half of the twentieth century, today deep-sea images are increasingly made and circulated to focus public attention on ecological challenges—such as plastic debris afloat in oceans, and the death of coral reefs due to global warming. Sometimes, though, the most persuasive images are not the direst ones: vividly spectacular photographs can also communicate the importance of what is endangered. As the noted underwater photographer **David Doubilet** sees the situation, "Oceans still remain virtually unexplored. Species and ecosystems are disappearing before we have a chance to understand and document them. I want to identify and document the areas of greatest marine biodiversity, those under greatest threat . . . before they are irreversibly degraded from the combined effects of climate change and overharvest. Most importantly, I want to give a voice to the voiceless and continue to make pictures that make people care about, fall in love with, and protect the sea."

David Doubilet,
A school of surgeonfish swim in Tubbataha Reefs Natural Park, Tubbataha, Philippine Islands, 2017

Coral reef surrounding Number 6 Sand Cay, Queensland, Australia, 2009

Natural Wonders

In 1922, as snapshot photography, car ownership, and tourism spread across America, Kodak launched a national advertising campaign in which roadside signs, placed on scenic routes, exclaimed "Picture ahead! Kodak as you go!" And legions of on-the-move, amateur photographers did. Natural "wonders" were popular subjects, as they had been in late nineteenth-century England when scientists, as Jennifer Tucker notes in *Nature Exposed: Photography as Eyewitness in Victorian Science* (2005), asked amateurs to share their snapshots of lightning, storms, rainbows, and clouds with researchers gathering data about natural phenomena. These twentieth-century snapshots of geysers, from the collection of Peter J. Cohen, point to the public's continuing desire to observe and picture geological spectacles. Within his first months of collecting, Cohen realized that, without thinking about it, he had purchased multiple snapshots of "Old Faithful" in Yellowstone National Park. Why? "While all my other pictures had people as the subject," he explained, "the ones of geysers were majestic and dynamic at the same time . . . and while similar no two photos will ever be the same."

Clockwise from left:

Photographer unknown,
Geyser, August 1968

Photographer unknown,
Snapshot of geyser, date unknown

Photographer unknown,
Snapshot of geyser, date unknown

Equipment and Specimens

"I am interested," **Catherine Wagner** wrote in 1996, "in what impact the changes that emerge from contemporary scientific research will have on our culture—socially, spiritually, and physically. In my work I have tried to ask the kind of questions posed by philosophers, artists, ethicists, architects, and social scientists. All of these questions revolve around one central idea: who are we and who will we become?" Over a number of years and at various sites—including the Los Alamos and Lawrence Livermore national laboratories, Stanford University's linear accelerator, the University of California, and Washington University in Saint Louis, Missouri— Wagner made photographs for her project Art and Science: Investigating Matter. The images, shot in black and white, take a seemingly straightforward look at scientific equipment and specimens. On their surface, they seem forensic and to refer to documenting acts of collection, ordering, analysis, and storage. But looked at more carefully, each of Wagner's meticulous still-life photographs goes further, leading viewers to engage with the provocative issues that inevitably surround science's goals, methods, rigor, and reach.

Catherine Wagner,
DNA/RNA Synthesizer, 1992

The Green Bunny

Interests in storytelling impact the media and the field of science journalism, as well. Throughout the twentieth century, eye-catching images effectively focused public attention on, for example, NASA's extraordinary achievements. When the sequencing of genomes and debates about genetic modification made news at the cusp of the twenty-first century, those stories proved harder to picture as dramatically. But soon after **Eduardo Kac**'s images of Alba, a transgenic bunny, appeared in 2000, the world took notice. Kac had collaborated with a French geneticist to insert a jellyfish gene—which produces a protein that fluoresces green when exposed to blue light—into a white rabbit egg. The straightforward photographs Kac subsequently took of Alba proved to be provocative themselves. Kac wanted his art project, *GFP Bunny*, to turn into "a complex social event," and it did. Photographs of Alba on the front pages of newspapers fueled dialogues about the economic, ethical, and cultural implications of genetic engineering that continue today. "It's easy to fear what we don't know, that the transgenic is monstrous," Kac said. "But when the transgenic is sitting in your lap, looking into your eyes, then the meaning changes."

Clockwise from top left:

Eduardo Kac,
Free Alba! ("Folha de São Paulo"), 2001

Free Alba! ("Le Monde"), 2001

Free Alba! ("The New York Times"), 2001

Free Alba! ("Die Woche"), 2001

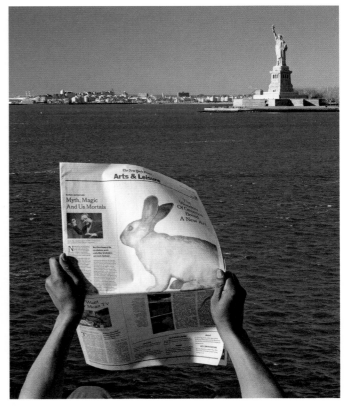

The March for Science

In February 2017, hundreds of scientists and their supporters gathered at Stand Up for Science, a demonstration in Boston's Copley Square outside the building where the American Association for the Advancement of Science (AAAS) held its annual meeting. The goal of the rally was to protest what participants called a "direct attack" on science funding and research by the newly installed Trump administration. Photographs of that rally—and then of subsequent and larger events organized on May 22, Earth Day, in Washington, DC, and over six hundred other cities around the world—featured hundreds of thousands of marchers and sign-holding participants. As one community organizer, Melissa Byrne noted, "Good protests always have to think about how they look." While scientists have organized and participated in demonstrations in the past, the marches signal a heightened awareness of how photography can be harnessed to promote science advocacy. Images from those events, published widely in mass media outlets and shared on social media accounts, became activist tools by visualizing the central role science and scientists play in shaping our everyday lives and the future we will share.

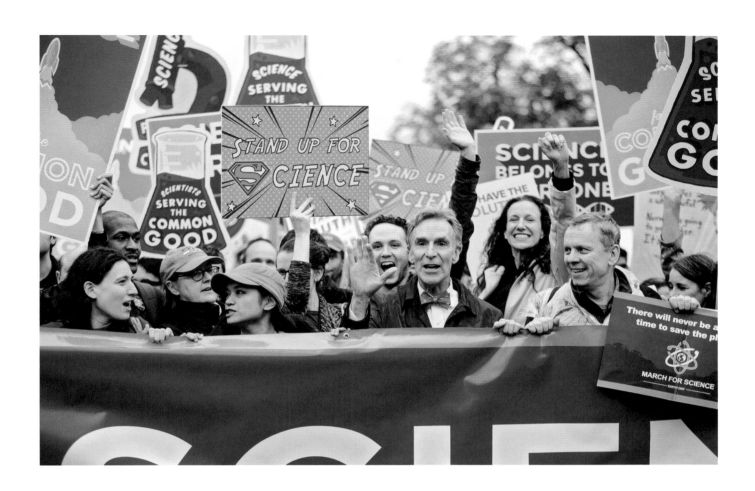

Molly Adams,
March for Science, Washington, DC, 2017

Escape Velocity

In Escape Velocity, **Jay Gould** explores drive, diligence, and delight within the specialized culture of weekend model rocket enthusiasts. Some of those depicted are amateurs "taking their first steps into hands-on science," as Gould describes it, while others are aerospace professionals whose workday challenges extend into their leisure pursuits. Model rocket groups grew in popularity during the early years of the "space race" and encourage members to use safe materials: cardboard, plastic, and balsa wood, propelled by single-use motors and outfitted with recovery devices. Gould, who briefly studied engineering and makes work bridging the arts and sciences, sees clear links between the two disciplines. "No matter what path we choose," he says, "whether it's art or space . . . we seek solace in exploring the unknown and learning what we can from it." Shot on Saturday mornings, in various states, and in fields far from metropolitan centers, these photographs underscore the equal roles that intense focus and awe play in our scientific engagements and adventures.

Clockwise from top left:

Jay Gould,
Excite, 2009

Level 1, 2009

Jeff, 2009

Neil, 2009

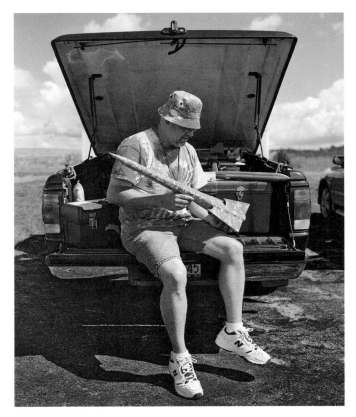

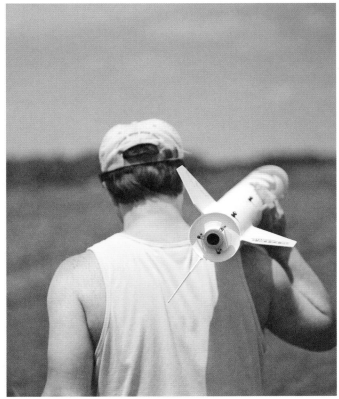

Psychokinesis Tests

Between 1979 and 2007, the Princeton Engineering Anomalies Research group—established by Robert G. Jahn, the university's dean of engineering—studied "psychokinesis," or mind control, and possible influences of the human mind on physical reality, engineering systems, and data processing systems. The group's findings were controversial, particularly when they proved to be difficult for other scientists to replicate or confirm. Years later, **Eric William Carroll** learned about this research and, given his interests in science and pseudoscience, devised a project in which voluntary participants were asked to try to control the outcome of events—such as coin tosses and the rolling of dice—through intense concentration. His photographs of them, made at the Minnesota State Fair and at the Walker Art Center, Minneapolis, have the look of science about them. They show subjects in front of a gridded backdrop that intentionally (and humorously) recalls the backgrounds in Eadweard Muybridge's groundbreaking animal locomotion images. But it is neither visible evidence nor usable data that is documented in or even the subject of Carroll's photographs, but rather what he calls a "look at the excitement, disappointment, and concentration" of those engaged in the "theater of science."

Clockwise from top left:

Eric William Carroll, *Subject D. B.*, 2015

Subject H. W., 2015

Subject J. H., 2015

Subject L. M., 2015

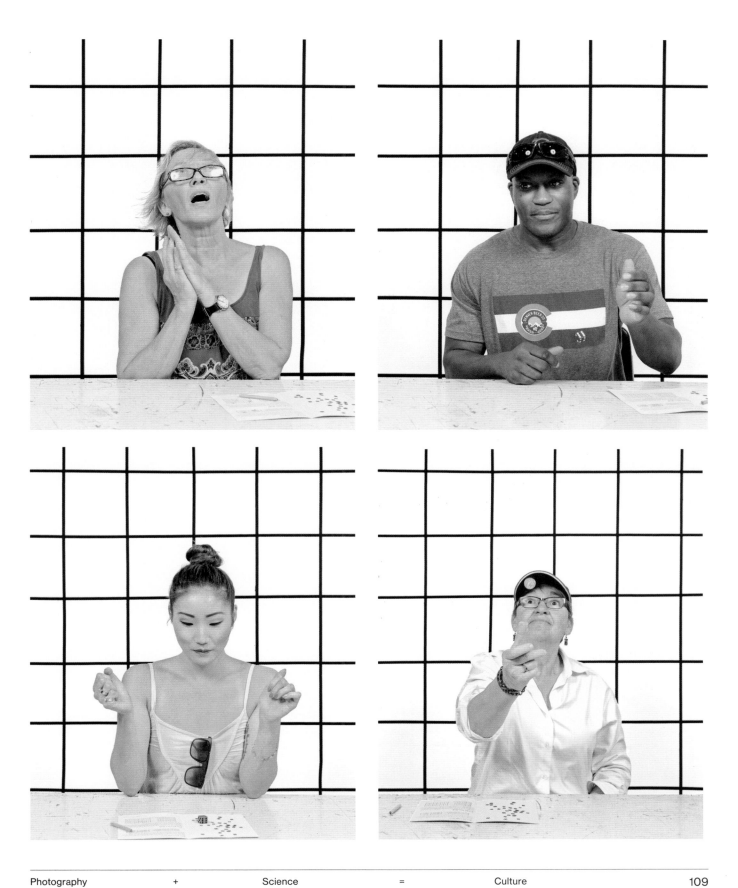

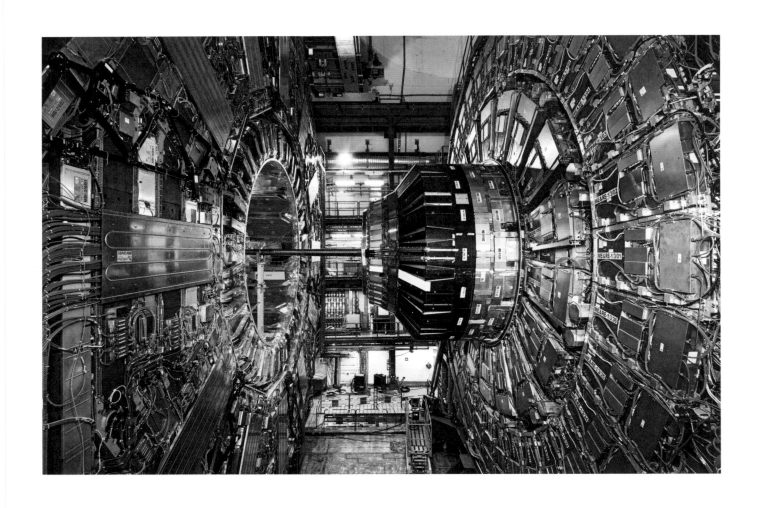

Enrico Sacchetti,
CMS experiment at CERN's Large Hadron Collider,
the world's largest and most powerful particle collider
located near Geneva, 2014

Hadron Collider

A conversation among visual culture experts who gathered online to discuss a selection of science-related news and media photographs on December 1, 2016, in an event sponsored by Reading the Pictures and the Center for Art, Design and Visual Culture.

Kurt Mutchler This picture of the Large Hadron Collider highlights one of the biggest problems in science photography, and that is a matter of scale. In it, you have no clue as to how massive this structure is; it is probably over five stories tall, and you get a hint of that from the turquoise man-lifter in the lower center of the image. When we photographed this for *National Geographic*, back in the day, the photographer captured the workers in the facility at the same time to give it a sense of scale, which I think really helps people understand what they're looking at, and it is something that we are always cognizant of.

Marvin Heiferman Do you think that the kind of Willy Wonka aspect of this picture is intentional? I'm fascinated by how colorful and animated it is, and how it tries to impart personality to something that, for many viewers, is pretty abstract.

Kurt Mutchler I can see that. And that's why I like working at *National Geographic* because, in most cases, we are not just looking at one image, but how a series of images works together to tell a story. I think a single picture only takes you so far. When there is more than one, I think the reader would get a better idea of the structure and how beautiful science can be in the way things are constructed.

Marvin Heiferman How does an institution like CERN [European Organization for Nuclear Research] try to engage image makers? When you go to their website, you see that they sponsor artist programs and residencies, and many people go there and make photographs. Does an institution like CERN also reach out to the science media and say, "Please come and we'll give you carte blanche to look around?"

Kurt Mutchler	I've always said that the people who help us out, who open their doors, understand what we're trying to do, and go out of their way to help us are the people that make the Earth spin. A while ago, when we were doing a story on sending humans to Mars and one of the experiments I learned about was being done at CERN, they said that whatever we wanted and whenever we could come, they would open their doors to us. They are terrific in that regard and also in getting scientists involved. A lot of times I'll ask them, "If you were sitting around the table with your twelve-year-old daughter or son, what would you tell them you do, or what this experiment was about, to give them a better understanding of these really complex topics?"
Nathan Stormer	I'm still thinking about that scale question, about how this thing that is so enormous and complex-looking is designed to find things that are incredibly small and to work with them. The weird contrast built into this apparatus and image is fascinating.
Rebecca Adelman	I was sort of relieved to hear that other people also found the image disorienting, because I thought it was just me, at first, not totally knowing what I was looking at and thinking about the difficulty getting our bearings in the image. It kind of functions as a visual metaphor for a larger question that we're dealing with here: how do you communicate science to a nonscientific, but educated and interested, audience? And something about the way that this picture functions dramatizes that. We know that something is happening in the picture, but maybe we don't know what it is, and that potentially dramatizes the larger problem of communicating science—communicating scientific knowledge.
Marvin Heiferman	That's an interesting point because while scientists often use photography to document things as evidence, once images hit the media there has to be a narrative element in them so the stories the pictures tell, or don't, are compelling to look at and interesting to think about.
Corey Keller	Looking at this, I was immediately reminded of Andreas Gursky's photographs, and before I read the caption, I thought it could have been one of his works. What's interesting to me is how the photographer has chosen to play off the accidental aesthetic of the equipment: the wires are all different colors, which creates an extraordinarily beautiful pattern, and the photographer has chosen to amplify those kinds of patterns and formal aspects that are found in a piece of equipment.
Kurt Mutchler	What is interesting to me, when I see this, is the absence of humanity; there's nobody here. Of course, this facility probably has thousands of people working on and in it and that collective mind is what creates the genius and effect of this. Maybe you all will think this is nuts, but you know looking at pictures like this, I think if I were the last person on earth and walked into this facility, I'd go, "Gee, I wonder how I could start this up?" Sometimes you really feel dumb when you look at a picture like this.
Ben de la Cruz	I feel like the picture—because of its intricacy, the way it's designed, and the color—is sort of a glorification at work, versus how, in some popular culture movies, there's often a darker vision of technology, like in *2001: A Space Odyssey*. This is more "wow, there's all of the cool wires, look at these bright colors, it's so shiny," which suggests that technology must be working perfectly. I don't know if that is what the photographer's intent was, but it definitely spoke to me that way on my initial look at it.

Max Mutchler I've been curious to hear everybody's responses and didn't want to get out in front because I'm a physicist. But I don't know that much about the Large Hadron Collider. It studies inner space; I study outer space. But I'm always impressed. I always say with Hubble, there's the technology, but as Kurt was saying, there's the people behind it. Here we're looking at the technology and, clearly, there's a lot of human ingenuity behind every little decision. It's such a complex scene, there's a symmetry to it, there's obviously a purpose to it. On the other hand, there is a lot of great pedagogical information out there about the Large Hadron Collider that shows the humanity behind it, like viral videos from a few years ago that you might remember. One of the best of them was of a Michigan State graduate student working on the Large Hadron Collider who did a rap song about it. So that's at the other extreme, showing the humanity in a very pedagogical and in an entertaining way, describing what this complex machine does. I feel like this image is actually a little intimidating, when you first look at it, and inspiring, and awesome, and maybe even a little frightening. But like any great image, I think it piques your interest and hopefully makes you want to dig a little deeper and learn what the heck it is.

The **Center for Art, Design and Visual Culture**, University of Maryland, Baltimore County, is a nonprofit organization dedicated to organizing comprehensive exhibitions, the publication of catalogues, media, and books on the arts, as well as educational and community outreach projects. The center's programs serve as a forum for exploring the social and aesthetic issues of the day.

Reading the Pictures is a web-based, non-profit educational and publishing organization dedicated to visual culture, visual literacy, and media literacy through the analysis of news, documentary, and social media images.

Rebecca Adelman is an associate professor of media and communication studies at University of Maryland, Baltimore County, specializing in visual culture, political theory, trauma studies, ethics, and cultural studies of war, terrorism, and militarization.

Ben de la Cruz is an Emmy-nominated documentary filmmaker and journalist. He joined NPR as a multimedia editor for the Science Desk. In this role, he serves as the visual architect for NPR's coverage of global health, science, environment, energy, food, agriculture, and development.

Corey Keller is curator of photography at the San Francisco Museum of Modern Art, where she has organized a number of exhibitions, including *Brought to Light: Photography and the Invisible, 1840–1900* (2008), which explored the use of photography in nineteenth-century science.

Kurt Mutchler is a senior science photo editor at *National Geographic* magazine. He has held several positions at *National Geographic*, including photo editor, deputy director of photography, and executive editor of photography.

Max Mutchler is a manager of the Space Telescope Science Institute and the head of their Research and Instrument Analysis Branch. He works on solar system observations with the Hubble Space Telescope and also contributes to planetary missions such as Dawn and New Horizons.

Nathan Stormer is a visual scholar and professor of communication and journalism at the University of Maine, specializing in rhetorical history, argument, and persuasion.

Stoned Moon

In the early 1960s, NASA administrator James Webb initiated a new arts program giving invited artists special, behind-the-scenes access to Cape Canaveral space center in Florida. In July 1969, **Robert Rauschenberg**, one of seven artists in the program, was present for the launch of Apollo 11, the first of America's manned space flights to land on the moon. Known for his interest in technology and works featuring boldly painted abstract gestures in juxtaposition with photographic images taken from the media, Rauschenberg went on to produce an extended series of innovative prints and drawings based upon his NASA experience. The works in his Stoned Moon series not only incorporated official NASA photos, press releases, diagrams, and documents, but also images that referenced the histories of astronomy and flight, Florida's tropical locale, and the sense of urgency fueling the United States' efforts to beat the Soviet Union in the Cold War's space race.

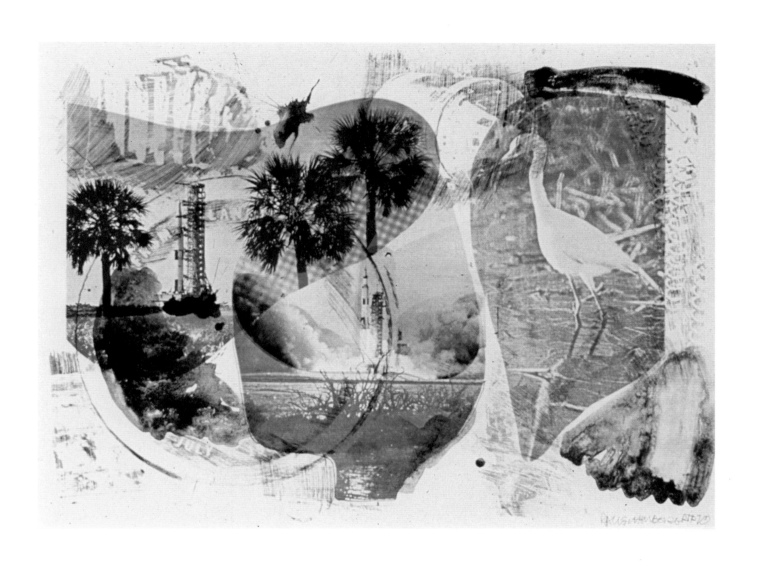

Robert Rauschenberg,
Local Means, 1970, from the series Stoned Moon

Seen by So Many

If the moon is the most widely watched single object in our collective field of vision, it is one of the most popular photographic subjects, as well. To make *Everyone's Photos Any License* (2015–16), **Penelope Umbrico**—whose works often begin with explorations of specific image category types online—searched Flickr for detailed images of the full moon. Because equipment far more sophisticated than a phone camera is required to make one, Umbrico was quite surprised to find, as she described it, "1,146,034 nearly identical, technically proficient images." But most surprising to her, given the number of similar images, was that most had an "All Rights Reserved" license notice attached. Fascinated by what she encountered and wanting to create a wall-size installation from these lunar images, Umbrico reached out to 654 photographers, asking each for permission to include their image in her project and promising to pay a proportionate fee of her commission should the work be sold. Many agreed and she replaced images by those who refused or didn't respond with similar Creative Commons licensed images. The graphically striking and conceptually rich work Umbrico produced—which is accompanied by a map and attribution list providing pertinent personal and technical data, as well as licensing terms, for every image included—speaks to some of our singular and shared fascinations, vision, and goals when it comes to science and photography alike.

Penelope Umbrico,
Everyone's Photos Any License (654 of 1,146,034 Full Moons on Flickr, November 2015), Installation of 654 digital chromogenic prints, variable dimensions, overall 9.16 x 27 feet, 2015

Image key for Everyone's Photos Any License (654 of 1,146,034 Full Moons on Flickr, November 2015), Map of installation for corresponding attribution list, black-and-white laser print, 6 x 16 inches, 2015

Science in Silhouette

Born and raised in Japan, **Kunié Sugiura** studied physics there for two years until she realized how limited career options were for women in the sciences. When she moved to the United States in the mid-1960s, she switched fields to study photography and film, but her early interests in experimentation, materiality, and scientific imaging continued. Starting in the 1980s, Sugiura began producing photograms—bold, life-size, and one-of-a-kind images made without cameras or negatives by placing objects or her subjects on or in front of photographic paper and then exposing them to a flash of light. For a 2003–4 series of innovative portraits of leading scientists, Sugiura asked each to strike poses or appear with objects that suggested their interests and accomplishments. The stark, X-ray-like silhouette images that resulted from those improvised sessions range from the mysterious to the playful. They are unconventional and startlingly different from the stereotypical images of scientists that the news media, science journals, and stock photography have conditioned us to expect.

Clockwise from top:

Kunié Sugiura,
Dr. Susan Lindquist, 2003

Dr. James Rothman, 2003

Dr. Günter Blobel, 2003

Plants and Public Art

As soon as photography was introduced, plants became one of the medium's most popular subjects. Taken by amateurs, botanists, and landscape photographers, among many others, photographs of plants can range from the evidential to the metaphoric. In 2010, **Lynn Cazabon** began what has become a multifaceted, original, and ongoing project. The series Uncultivated draws attention to what is often overlooked as it explores the presence and fate of wild plants within urban landscapes. The images Cazabon makes are presented in a range of formats, venues, and events: on billboards, in bus shelters, via mobile apps, in repurposed buildings and community workshops, as exhibition prints, and on a carefully researched website that catalogues sites visited and plants observed.

Lynn Cazabon,
Wroclaw, Poland, 2016; from the series Uncultivated

Documentation of site-specific poster for transit shelter, North Avenue, Baltimore, 2011; from the series Uncultivated

Greg Lovett,
Toxic algae bloom in the water near Stuart, Florida, 2016

The Color of Toxicity

A conversation among visual culture experts who gathered online to discuss a selection of science-related news and media photographs on December 1, 2016, in an event sponsored by Reading the Pictures and the Center for Art, Design and Visual Culture.

Marvin Heiferman There are certain types of pictures reporting on environmental problems that we've become familiar with: the sorts of dramatic images that report on fast-spreading fires in California, melting glaciers, rising floodwaters, and smog-filled skies. But this photograph of a toxic algae bloom on the east coast of Florida, not far from Palm Beach, has a color range far different than you might expect to see in an image about toxicity. It's green, a natural and supposedly positive color, and depicts a waterway so overwhelmed with smelly algae that it was described as being guacamole-thick. Another interesting aspect of this icky image is that it suggests being trapped by the environment. It's sort of like a scene from the sci-fi movie *Fantastic Voyage*, where you get on a vessel to explore natural systems at work in the world, but get stuck in a big natural mess.

Corey Keller I think the ambiguity about what sort of substance we're actually looking at is extraordinary, and adds to the power of the picture. And that combines with the fact that the roofs of the boats are these muddy colors, not pretty colors, but muddy maroon and brown, which enhances the overall feeling of all that green in an amazing play of contrast.

Rebecca Adelman And where we have humans, we see them in silhouette, and we see their shadows at an odd angle, which increases the disorientation of the image.

Kurt Mutchler What I don't understand—maybe someone knows about it—it looks like this was frozen over and those are ices broken up.

Marvin Heiferman	And yet the photograph was made on a July Fourth weekend.
Nathan Stormer	The photo creates a sense of fragility, and its overall quality suggests that something has been smashed a bit and all the lines create fractures.
Rebecca Adelman	But the shadowy presence of the humans in the scene hints at the human causes of this. And the long history of trying to engineer and reengineer the Everglades and all the development and agriculture in Florida, I think, fights against the abstraction the image might otherwise invite.
Marvin Heiferman	The idea that things don't look like what they're supposed to is the startling point of this picture. It doesn't look like water, but mineral or stone, and shows a transformation of the environment into something that we don't recognize anymore.
Ben de la Cruz	I felt very enclosed by the photograph and, as someone who has been in the field before I became an editor, I know that when shooting these types of things, you tend to make them as concentrated and focused as possible, and I'm just wondering if this is exaggerated in any sense. What is the wider view here? I'm a little skeptical, I guess, of the extent of this algae bloom.
Kurt Mutchler	I had the same thought. What is beyond the border of the picture?
Nathan Stormer	I am reminded of oil spill images from the Gulf of Mexico, of the beautiful oranges of a horrible event, and not having people in any of those allowed you to have a very abstract relationship to this horrible event. The presence of people really makes you look at this entirely differently.
Marvin Heiferman	After I first saw this picture, I looked around online a bit because I was curious about how widespread this toxic algae bloom was. It started in a freshwater lake and spread out from there through the canals, going up from Palm Beach. And there were other pictures that were much calmer, showing rivulets of algae meandering through little streams; they're much less intense than this. But the impact of the problem was so large that it triggered a huge controversy down in the area because of the inability of politicians to do anything about it. So, the repeated imaging of it became an important local story.
Ben de la Cruz	I think the limitation of single images is a reminder of how we can sometimes benefit from the essay format when it is a complicated story, to give more context.
Nathan Stormer	The fact that people are looking at it is interesting. They're leaning over; they have an inquiring, investigative stance towards it. It's an open thing. You can read it openly.
Corey Keller	For me, that's one of the most powerful aspects of it, because I often find pictures of horrible events that have been aestheticized into beautiful abstract compositions to be really disturbing. And this kind of picture, I think, reminds us that it is beautiful in its own crazy way, but this is a terrible tragic thing that has happened both to the environment and its human population. That, for me, makes this picture work in a

way that some of those other kinds of pictures don't work for me. But I'm starting to feel that I must be an incredibly gullible consumer of pictures, actually, because it never even occurred to me to wonder what was outside the picture. Because of the way it is framed, I looked at it and said, of course it extends this great distance beyond, which, I guess, is what the photographer wanted me to feel. But it is so interesting to hear how someone who edits photographs for a living would look to say hey, what is really happening outside the frame, whereas I just look at it from inside the frame and think it indicates something happened outside the frame.

Nathan Stormer

I'm wondering about the function of the boats, which seem to be pleasure boats. So in terms of the basic semiotics of the image, you've got this bloom, this evidence of the difference we're making in the world with our stuff, and then what it's actually clinging to is excess. Just excess entertainment.

Rebecca Adelman

I think that to the extent that the photograph works, to the extent that it stimulates conversation, or alerts us that there's a problem, it reminds us that people tend to care for self-interested reasons. And so suddenly people will pay attention to these kinds of issues when it means they can't take their boat out, or when it ruins their vacation. And I think, economically, this was a tremendous loss to Florida because it happened in the summer and it ruined their tourist season in this region, but I think just the way we are talking about it is important with regard to the politics of attention. When do we start to care about the environment?

The **Center for Art, Design and Visual Culture**, University of Maryland, Baltimore County, is a nonprofit organization dedicated to organizing comprehensive exhibitions, the publication of catalogues, media, and books on the arts, as well as educational and community outreach projects. The center's programs serve as a forum for exploring the social and aesthetic issues of the day.

Reading the Pictures is a web-based, non-profit educational and publishing organization dedicated to visual culture, visual literacy, and media literacy through the analysis of news, documentary, and social media images.

Rebecca Adelman is an associate professor of media and communication studies at University of Maryland, Baltimore County, specializing in visual culture, political theory, trauma studies, ethics, and cultural studies of war, terrorism, and militarization.

Ben de la Cruz is an Emmy-nominated documentary filmmaker and journalist. He joined NPR as a multimedia editor for the Science Desk. In this role, he serves as the visual architect for NPR's coverage of global health, science, environment, energy, food, agriculture, and development.

Corey Keller is curator of photography at the San Francisco Museum of Modern Art, where she has organized a number of exhibitions, including *Brought to Light: Photography and the Invisible, 1840–1900* (2008), which explored the use of photography in nineteenth-century science.

Kurt Mutchler is a senior science photo editor at *National Geographic* magazine. He has held several positions at *National Geographic*, including photo editor, deputy director of photography, and executive editor of photography.

Nathan Stormer is a visual scholar and professor of communication and journalism at the University of Maine, specializing in rhetorical history, argument, and persuasion.

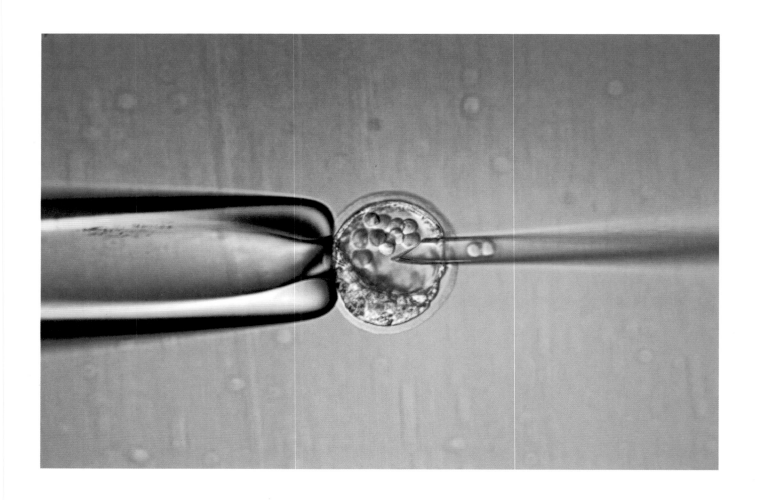

Anne-Christine Pourjoulat,
Close-up of a screen displaying a micro-injection
of stem cells into a mouse embryo at the Centre
d'Immunologie de Marseille-Luminy, Marseille, France,
2012. CIML's transgenesis laboratory creates animals
in order to understand how genes work.

Visual Generics

A conversation among visual culture experts who gathered online to discuss a selection of science-related news and media photographs on December 1, 2016, in an event sponsored by Reading the Pictures and the Center for Art, Design and Visual Culture.

Ben de la Cruz I took a little while to try to understand what this shows, as it wasn't easily readable to me. I knew what the blue signified—and I sort of understood what the organic center of the images was, but the left part of the image really threw me. I don't exactly know what it's doing there. Aside from that, I think that it speaks to the extremes of how you can view science. We've talked about the absence of humans in some science photographs, but this is a case where what is pictured is an intrusion into an embryo, through the needle. We don't see fingers or faces and everything is neat, clean, tidy, and there's no mess. But, obviously, there's a lot of ethical implications to modifying human embryos. And so, there's a lot here to unpack in terms of what people can see in this. One thing that's funny is that when I showed this image to my colleagues, because I was curious to hear their reaction to it, it seemed like the hue, the blue hue, automatically set it up: "Oh! Science photograph. The laboratory." Only eventually, after looking at it more closely, did people register the needle and the organic cells. I think the images can be read in different ways: that science can be the solution for a lot of the health issues that we face as human beings, or that we are neglecting what the impacts of making changes to our own bodies, and to the bodies of our offspring, might be.

Rebecca Adelman As I was trying to make sense of the image, I actually went back to the caption, which is scanty. [Editor's note: The caption at left is more detailed than what participants saw during their conversation] And I thought about Susan Sontag's point that photographs wait to be explained or falsified by their captions. It was interesting to me that the caption provided almost no information about what was actually happening and the science of the image, but instead immediately framed this as an ethical issue.

Marvin Heiferman	One thing that fascinates me about this image is how generic it is. It is a purposefully vague image, which may explain its popularity and why it was, for example, used to illustrate three different articles in July 2016, all of them about embryonic research. Ed Brighton, who wrote about this image online, said: "The blue kind of suggests calm, and no problem—everything is OK." And that quality of quick readability suggests why generic images are so often used to illustrate science stories when specific images might be either too specific or too narrative. You might also argue, of course, that this goes in another direction and purposely deploys its carefully constructed blandness to start to deal with what is, in fact, an enormously complicated ethical issue.
Ben de la Cruz	We were talking at the NPR Science Desk about how sometimes the ambiguity of a photograph allows people to keep looking at it, more and more, as they try to unravel it. And so when a picture is too simply read, we think we get it quickly. Maybe the fact that this is a generic image, that some parts of it are not so identifiable, is what invites us to try to research and learn more about what's going on. So maybe it's successful in that sense. It has the microscopic look without pulling us back out to see other contextual things that might give us clues, but may give viewers a reason to take things further. One thing we try to do at NPR is try to figure out what is the best way for people to engage with stories through visuals, whether it's photography, illustration, or videos. And it is often the images that are multilayered that get people—even in this very quick attention span, social media world that we live in—to stop, because they have to figure out what they are looking at. So, maybe by using this image, the publications that licensed this image were on to something. Even though I found it hard to read, I definitely spent a lot of time thinking about it afterwards.
Nathan Stormer	One of the things that is of interest to me is the needle, and the ways in which a lot of scientific images show us forms of violence that are necessary to acknowledge, like violent forces in the universe, and present them to us in some very specific, accessible, and often clinical sorts of ways.
Corey Keller	I was also struck with the pointiness, the piercing of the needle, which got me thinking back to the very earliest photographs made through microscopes in the nineteenth century and how their favorite subjects were things like bee stingers, fly feet, spider fangs, and anything that would bite or sting or prick or pierce, all of which were really popular subjects for microscopists to make photographs of because they had an immediacy that comes through in a photograph, as you see here, as well.
Kurt Mutchler	A few months ago we did a story about the "DNA Revolution." What you are looking at is almost unbelievable: scientists are able to do what they call preimplantation—genetic diagnosis—and they can sample an embryo and detect any disease that it

may carry. In the story that we did, we ran a picture like this, but to communicate the science we also photographed the family that had a healthy child as a result of a similar procedure. Both parents were carriers of the cystic fibrosis gene and they wanted to have a child, but they did not want it to be born with the disease. They were able to sample embryos, select one that was free of defect, and had a healthy child, who we were able to photograph as a fifteen-month-old. In communicating science, sometimes one picture isn't enough. And if you looked at that layout, you'd see that the caption is quite extensive, because it's a complex story to tell. Often, as a picture editor, I'm fighting for more space to be able to explain what the reader is seeing because it's just so important. A lot of times there are battles for words in online content, and images like this one get just one brief line. But in many cases it's not enough.

Nathan Stormer Well, that does raise some important questions, when it comes to seeing sciences: What actually are we seeing? What's not being shown? What couldn't be shown? All of that is incredibly important for understanding or contextualizing. And that does raise yet another question: what are the limits as well as the power of visuals to show ourselves this strange and magical practice we have developed called science in its many forms?

The **Center for Art, Design and Visual Culture**, University of Maryland, Baltimore County, is a nonprofit organization dedicated to organizing comprehensive exhibitions, the publication of catalogues, media, and books on the arts, as well as educational and community outreach projects. The center's programs serve as a forum for exploring the social and aesthetic issues of the day.

Reading the Pictures is a web-based, nonprofit educational and publishing organization dedicated to visual culture, visual literacy, and media literacy through the analysis of news, documentary, and social media images.

Rebecca Adelman is an associate professor of media and communication studies at University of Maryland, Baltimore County, specializing in visual culture, political theory, trauma studies, ethics, and cultural studies of war, terrorism, and militarization.

Ben de la Cruz is an Emmy-nominated documentary filmmaker and journalist. He joined NPR as a multimedia editor for the Science Desk. In this role, he serves as the visual architect for NPR's coverage of global health, science, environment, energy, food, agriculture, and development.

Corey Keller is curator of photography at the San Francisco Museum of Modern Art, where she has organized a number of exhibitions, including *Brought to Light: Photography and the Invisible, 1840–1900* (2008), which explored the use of photography in nineteenth-century science.

Kurt Mutchler is a senior science photo editor at *National Geographic* magazine. He has held several positions at *National Geographic*, including photo editor, deputy director of photography, and executive editor of photography.

Nathan Stormer is a visual scholar and professor of communication and journalism at the University of Maine, specializing in rhetorical history, argument, and persuasion.

Sites of Technology

Best known for austere and elegant black-and-white photographs of landscapes transformed by human development, **Lewis Baltz** produced equally striking images, but large and in color, from 1989 to 1991 in corporate and government research facilities, technology centers, and "clean rooms" in Europe and Japan. These unpopulated and anonymous-looking spaces explore, like much of Baltz's work, "things that couldn't be photographed," as the artist has noted. Their cool, minimal look is intentional, meant to suggest the power of information technology and "the sense that it proliferates, that it's everywhere in society," and will "further detach people from whatever nineteenth-century idea they had about reality, the phenomenal world and their relation to it and in it."

Clockwise from top:

Lewis Baltz,
Cray Super Computer, CERN (European Organization for Nuclear Research), Geneva, 1989–91

Artificial Intelligence, Toshiba, Kawasaki City, Japan, 1989–91

Worker, Clean room, Toshiba, Kawasaki City, Japan, 1989–91

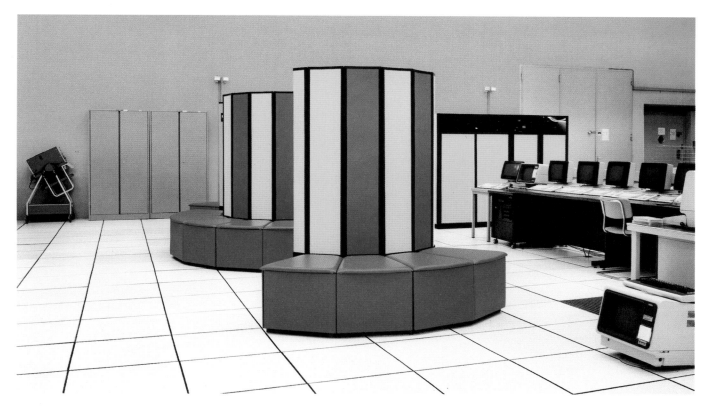

The Last Pictures

Directing attention toward things and consequences that are unseeable or hidden from sight is a strategy that drives much of **Trevor Paglen**'s multimedia work. Initially known for atmospheric images that, paradoxically, visualized surveillance sites and technology, Paglen switched gears in 2012 to produce *The Last Pictures*, a public art project designed not only to outlive the public, but the Earth as well. After consulting with philosophers, scientists, and other artists, Paglen and a team of researchers scoured archives to select one hundred photographs to represent life on Earth. Then scientists at MIT helped to nano-etch those pictures onto a thin silicon wafer that was bolted onto EchoStar XVI, a communication satellite that, once it outlives its usefulness, will forever orbit the Earth in a permanent geostationary orbit. Unlike two "Golden Records" that were carried aloft on Voyager spacecrafts in 1977—and filled with more upbeat images and texts curated to acquaint intelligent aliens with life on Earth—*The Last Pictures* offers up uncaptioned and ambiguous images to describe a planet as strongly defined by the challenges its inhabitants face or self-inflict upon each other as it is by their many accomplishments.

Clockwise from top:

Trevor Paglen,
The Last Pictures and the Gold Artifact, 2012

Cherry Blossoms, 2013

*Migrants Seen by Predator Drone,
US-Mexico Border*, 2013

Scared Scientists

What does, or what should, a scientist look like? Photographic portraits of scientists quite often fall into stereotypical categories. There are the predictable headshots, the sort of generic ID photos that pop up on websites and in professional journals. Then there are the photos of people wearing lab coats, standing in front of blackboards, and holding beakers. More animated images sometimes show scientists in the context of where they work, on top of ice sheets in the Arctic, for example, or in orbit in outer space. But for a 2014 series of portraits, Scared Scientists, the Australian photographer **Nick Bowers** came up with a decidedly different approach. Instead of picturing scientists in ways that underscored the objective nature of their work, Bowers asked his subjects, all accomplished and well respected in their fields, to contemplate the implications of the findings of their work. Bowers's goal, he said, was to capture and communicate their "humanity and vulnerability." What resulted are striking portraits that are surprisingly moving, intense, and unique.

Clockwise from top left:

Nick Bowers,
Matthew England, Oceanographer, Climate Scientist, University of NSW, Sydney. Fear: Climate Induced Global Conflict, 2015

Will Steffen, Earth System Scientist, University of Florida, University of Missouri, Australian National University. Fear: Loss of Control of the Climate System, 2015

Shauna Murray, Biological Scientist, University of Technology Sydney, University of Tokyo, University of New South Wales. Fear: Reaching the Four Degrees of Warming, 2015

Penelope Ajani, Biological Scientist, University of Macquarie, Sydney. Fear: Unknown Repercussions of Climate Change, 2015

Witnessing Climate Change

Trained as a geomorphologist, **James Balog** studied and came to rely upon photography as a way to document his climbing trips. But starting in the 1980s, when his interests shifted toward science photojournalism, Balog's photographic work began focusing on a broader range of issues: endangered species, the ecology of forests, and growing threats to the cryosphere. The Extreme Ice Survey, a project Balog initiated in 2007, brings together scientists, videographers, and extreme-weather specialists to track the effects of global warming. Time-lapse cameras, which shoot hourly during daylight hours year-round, each yield approximately eight thousand frames a year that, taken together, track glacial retreat in locations, including Greenland, Iceland, the Himalayas, and the Antarctic. Those still images, often combined to create stunning time-lapse videos, reveal how rapidly climate change is transforming our planet. Widely covered in print and online media and featured in exhibitions and documentary films, the dramatic images and valuable data the Extreme Ice Survey collects underscores the pivotal role photographic images play in raising awareness and educating the public about the urgent need for responsible global stewardship and environmental action.

James Balog,
Bridge glacier, British Columbia, 2009

Bridge glacier, British Columbia, 2017

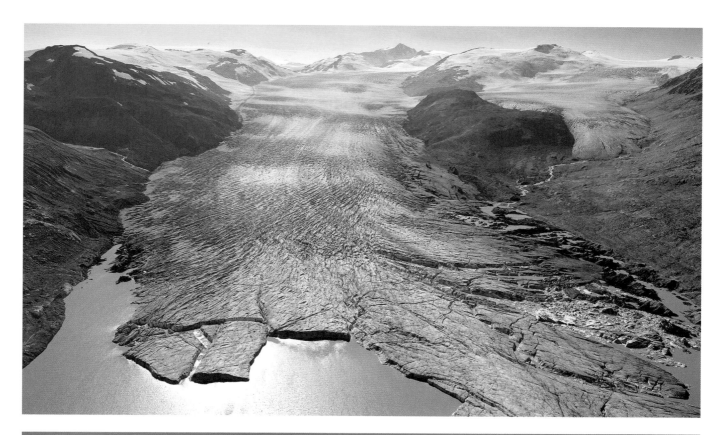

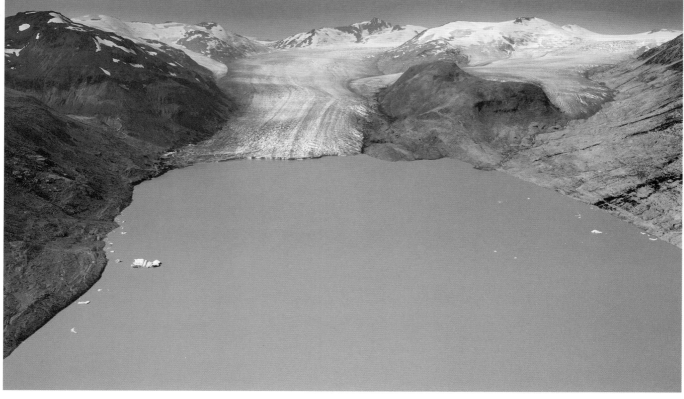

Nacho Doce,
Jackeline, twenty-six, holds her son who is four months
old and born with microcephaly, in front of their house in
Olinda, near Recife, Brazil, February 11, 2016

Empathy and Science Journalism

A conversation among visual culture experts who gathered online to discuss a selection of science-related news and media photographs on December 1, 2016, in an event sponsored by Reading the Pictures and the Center for Art, Design and Visual Culture.

Ben de la Cruz Well, I eventually came to admire and love this photograph, but my first impression was that it was an artistic response to something very serious. I wondered why it didn't show the baby's face. But after looking at it longer, it is a photograph that revealed more and more to me. Gesturally it is iconic, since the mom is holding her baby in a way that's very common when you're grasping and caring for your kid. But then the near-silhouette of the head is indicative or a manifestation of microcephaly, which is easily readable, too. I also initially thought I saw the front of the baby's face and its eyes were hiding underneath the collar of the shirt. But it wasn't the case. So, to me, this picture brings up a question: when you're dealing with a public health crisis and you're a news agency, what is the most effective way to communicate how important, impactful, or how dangerous a health issue is? Is it by showing case studies versus data, or by trying to outline the broad scope of what the problem is? This photograph does a really great job of showing what the contours of the crisis are, without distracting us, as one of my colleagues put it, with the personal face of the disease. I think that you could pair this with lots of other coverage, of course, where you see moms holding their kids, and you see their faces, and differently sense the impact of the disease. The Ebola coverage, one of the previous public health epidemics before this one, was really impactful because you saw such anguish in images from West Africa. I scanned many of those images filled with lots of faces and representing the personal and emotional impact of the disease, trying to understand what that photographer's take was, and how they communicated the seriousness of the disease to viewers. But what is more effective? What is our responsibility, weighing when to show peoples' faces versus making sure people understand the very real human repercussions of a disease like this?

Michael Shaw	The ambiguity of the gesture is important because it is, at the same time, evidentiary and intimate. The mother is gazing at the child, and then at the same time too it seems like the hands could be offering the child to us, or expecting us to take hold. This picture works on all those levels.
Kurt Mutchler	Well, if I sent a photographer to photograph Jackeline and her four-month-old son, and they brought this picture back, I would send them back. It doesn't do anything for me. I think it's a story that doesn't need ambiguity. It needs understanding, it needs empathy, it needs more context than what we're seeing here, and it's a little distorted with the lens—it's a wide-angle lens. The hands look out of proportion; there is just not enough information in it for me.
Rebecca Adelman	I was thinking about the image, historically, and the history of representing bodies that have some kind of physical malformation. To me, it seems like the picture relies on a pretty old trick, which is using the scale of the normal to mark some kind of deviation, like the old freak-show postcards of the world's tallest man next to a "normal-size" person. So I think, in some ways, the thing I am objecting to in the image is the way it replicates these spectacular logics, even without meaning to. My intuition is that this is meant to be a very compassionate photograph, but I think its reliance on visual rhetorics for representing bodily difference or deformity is part of what is a little troubling about the image.
Corey Keller	That's interesting, because the thing I liked about the picture was the way it rose above the specifics of a single story to become symbolic, and that vulnerability of the nape of the neck symbolizes a much larger human condition. I agree that it pretty much relies on every trick in the book. I think when tragedy strikes, sometimes it's easy to say, "Yes, that's terrible, but that's not me, that's someone else," and it's that specific person and you can look and feel pity. But with this picture it could be any baby, it could be any hands, and to me the sort of showing just that vulnerability of the human organism worked in a way.
Max Mutchler	My reaction is that I appreciated that the baby was facing away and that you don't actually see the mother. It's a heartbreaking image; we've seen a lot of heartbreaking images in recent years, if you think of that little boy in Aleppo seated alone in the ambulance. There's more of a respect for the dignity of this child and the mother, and you can make a heartbreaking image that isn't somehow exploitative. Some recent images of Syrian refugees almost feel like, I shouldn't be seeing this, this is the worst moment in this person's life, and it almost feels gratuitous or exploitive. But this image does seem to respect the dignity of this child and the mother by not showing their faces. It doesn't make it about them.
Marvin Heiferman	Right. What astounds me, though, is what happens if you look at this and put yourself in the mother's place. Imagine seeing the baby from her point of view and this instantly becomes a very intimate photograph, unlike the expected kind of

public display of a situation like this. Also, this makes me think about the challenge of representing a situation like the Zika virus outbreak. Of course there'll be the mosquito pictures, the spraying pictures, but this seemed to me to be a worthwhile and provocative visual strategy.

Ben de la Cruz It definitely is a photo that hasn't been done as often, which I know as someone who has covered a lot of this story over the past year, looking through the wire services and the photography that we've commissioned. This does stand out. A lot of the imagery was sort of based on that front view or the side view. One interesting group of images to come out of the coverage of Zika, which was one of the most popular stories on NPR, featured brain scans of those who had been infected. People were really interested to see the actual ways the brain was deformed. So, I was thinking of those images and how this particular silhouette helped people understand the impact of the disease on an infant's brain.

The **Center for Art, Design and Visual Culture**, University of Maryland, Baltimore County, is a nonprofit organization dedicated to organizing comprehensive exhibitions, the publication of catalogues, media, and books on the arts, as well as educational and community outreach projects. The center's programs serve as a forum for exploring the social and aesthetic issues of the day.

Reading the Pictures is a web-based, non-profit educational and publishing organization dedicated to visual culture, visual literacy, and media literacy through the analysis of news, documentary, and social media images.

Rebecca Adelman is an associate professor of media and communication studies at University of Maryland, Baltimore County, specializing in visual culture, political theory, trauma studies, ethics, and cultural studies of war, terrorism, and militarization.

Ben de la Cruz is an Emmy-nominated documentary filmmaker and journalist. He joined NPR as a multimedia editor for the Science Desk. In this role, he serves as the visual architect for NPR's coverage of global health, science, environment, energy, food, agriculture, and development.

Corey Keller is curator of photography at the San Francisco Museum of Modern Art, where she has organized a number of exhibitions, including *Brought to Light: Photography and the Invisible, 1840–1900* (2008), which explored the use of photography in nineteenth-century science.

Kurt Mutchler is a senior science photo editor at *National Geographic* magazine. He has held several positions at *National Geographic*, including photo editor, deputy director of photography, and executive editor of photography.

Max Mutchler is a manager of the Space Telescope Science Institute and the head of their Research and Instrument Analysis Branch. He works on solar system observations with the Hubble Space Telescope and also contributes to planetary missions such as Dawn and New Horizons.

Michael Shaw is the founder and publisher of the organization Reading the Pictures. He is an analyst of news photos and visual journalism, and a frequent lecturer and writer on visual politics, photojournalism, and media literacy.

Picturing Science

To the public at large, *science* is a catchall word, shorthand for an intimidatingly wide range of specialized pursuits whose goal is to understand the principles and forces at work in the universe. How that array of activities ends up being depicted in visual culture is the subject of Picturing Science, an artist project created by **Oliver Wasow** for *Seeing Science*. On each of the following pages, a grid of details extracted from images found online explores how science photography frequently falls into self-defining genres and how, when seen together, images expose the sorts of stereotypical visual solutions that are used, again and again, to popularize science. Each grouping, ranging from "mad scientists" to border-control technology, focuses on a specific subject matter or meme to highlight both the similarities between and the variations among the visual languages of science. "Separated from their original sources," Wasow explains, "the images reveal new meanings because of their recontextualization and transformation." What results is a better understanding of how science-related images are conceived, constructed, put to work, and perceived.

 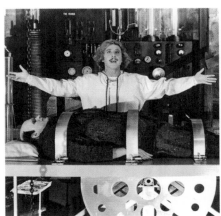 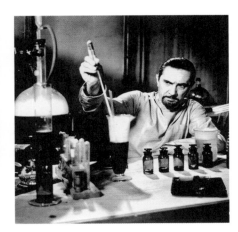

Oliver Wasow, *Mad Scientists*, 2018

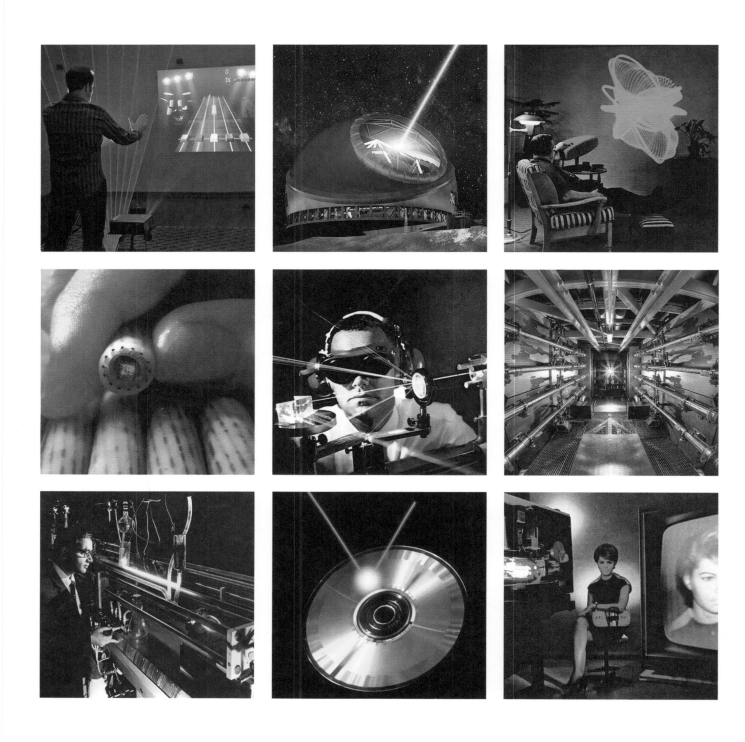

Oliver Wasow, *Lasers*, 2018

Oliver Wasow, *1970s Science Textbooks*, 2018

Oliver Wasow, *Scientists Staring at Beakers*, 2018

Oliver Wasow, *Rockets*, 2018

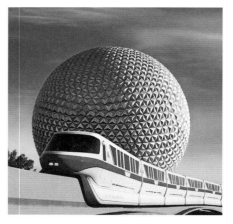

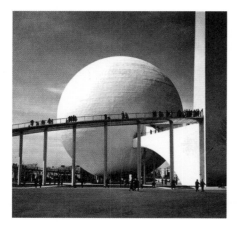

Oliver Wasow, *Science Pavilions*, 2018

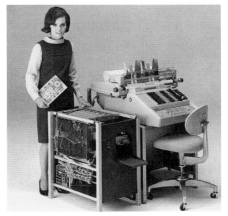

Oliver Wasow, *Women Selling Technology*, 2018

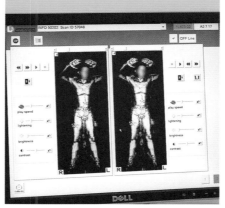

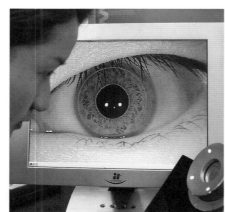

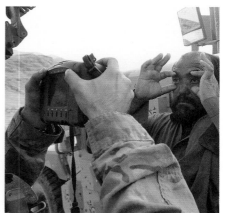

Oliver Wasow, *Border Security*, 2018

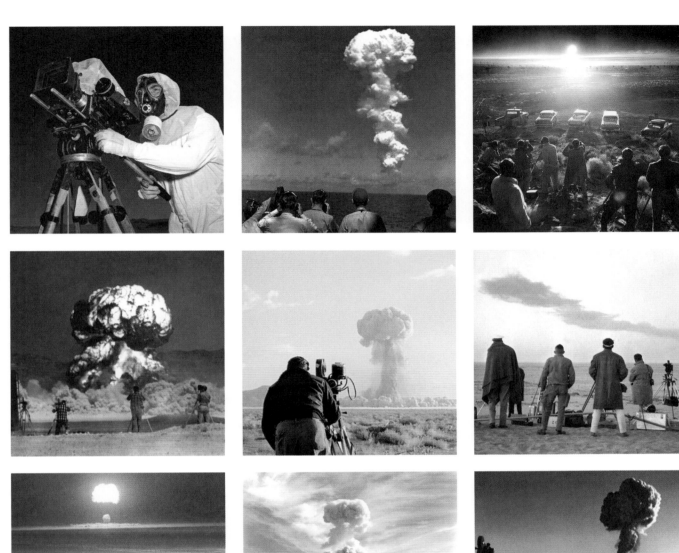

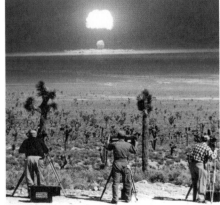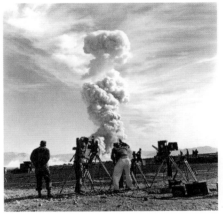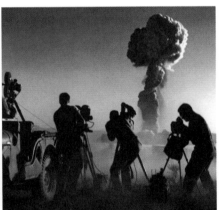

Oliver Wasow, *Photographing the Bomb*, 2018

Photography
+ Science

Imagination

03

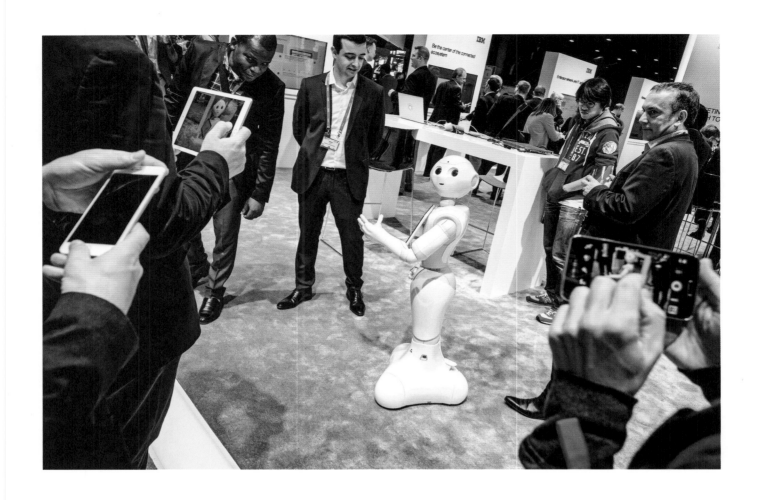

David Ramos,
Visitors attend a demonstration of a robot named
"Pepper" at the IBM stand on day three of the Mobile
World Congress, Barcelona, 2016

Pepper the Robot

A conversation among visual culture experts who gathered online to discuss a selection of science-related news and media photographs on December 1, 2016, in an event sponsored by Reading the Pictures and the Center for Art, Design and Visual Culture.

Rebecca Adelman This was an interesting image to me. Looking at this, I started thinking about the Turing test and the benchmark of computer technology being that it could be so responsive and humanlike that someone who didn't know any better would think they were interacting with another human instead of a machine. Then, as we fast-forward fifty or sixty years, we've done a one-eighty. Now what we want to do is interact with machines and know that we are interacting with a machine. This photo dramatizes some of the ambivalence around that. The people surrounding Pepper have this hesitant body language, and it's the robot himself who's reaching out—or there are the other people who have decided to further mediate this already artificial interaction by interacting with the robot through their phones or filming it. Considering the sort of ambivalence that is embedded into this relationship, I was thinking about how the design of the robot itself seems to want to invite interaction. It's been described as being cute and cartoony. It is small and I think it matters that it is white, and supposedly has a childlike voice, all meant to kind of soften the inherent weirdness factor of interacting with a robot. But one of the things I like about the image is how people don't seem to know what to do with Pepper, and it captures that ambivalence.

Max Mutchler That was my impression, too, and this image also reminds me of car shows. In the 1950s they'd always have a teardrop-shaped car of the future. And in the next decade, the car of the future would be teardrop-shaped, too, although nobody has ever made a teardrop-shaped car because people don't really want one. And I bet you could go back to the '70s and see a similar display like this one and where people said, "Oh, look, here's what a robot is going to look like." And you'd imagine that by now we'd all have a robot like this in our house, but nobody really wants that, exactly. And yet we are surrounded by robotic devices that do handle a lot of things for us. We don't think of it as the science-fictiony kind of robot, like the one you see here, so there's this romantic idea of a robot that we've been talking about for decades, and then there's the reality of the robotics that are all around us. That's very different.

Rebecca Adelman	If I understand correctly, Pepper is powered by Watson, which is IBM's cognitive system that won on *Jeopardy!*, and IBM advertised Watson on television in commercials featuring Serena Williams, Stephen King, and Bob Dylan. It is interesting that IBM is selling technology which is not, at this point, a consumer technology. I can't go out and buy a robot or get Watson. Instead, what I think that it is selling or trying to get us to consent to is a new relationship to technology by making it funny or nonthreatening or convenient or just making it cool. We can't underestimate the power of that, but it is interesting to see how all of this gets negotiated, and we see that happening in the image itself.
Corey Keller	This picture to me feels so well seen in terms of the way it was composed, the way that the table is framing Pepper, and then the frame of the person's iPad echoes the frame of the table around the robot. The fact that everybody seems to be wearing blue or black and the whole place is decked out in white, blue, and black. Those red lanyards just pop out and call attention to the guys wearing them, who have incredulous expressions on their face. It's kind of an extraordinary picture, compositionally. I think Pepper is a girl, and all of these grown men are in this circle around this tiny white robot and somehow up close and personal and a little fearful of her.
Rebecca Adelman	I read that Pepper is supposed to be a boy, but some of the feedback developers have gotten is that other people read the robot as feminine. Pepper's answer to that is "I'm just a robot." There was an effort to build in this gendering of the technology, it failed, and so Pepper just opted out altogether. "I'm just a robot," it doesn't matter.
Ben de la Cruz	I think this is probably incidental, but the way we react to something uncomfortable—as I've noticed, and as a lot of you probably have, too, when you're on the subway or have a spare moment—you take out your phone and it functions like a shield, "Oh my God there's something new, I want to take a picture, or record it, or look up something." And to me, roughly half of these people are having this same automatic response. Here's technology, oh, I'm going to take out my technology. I don't know, I think we're not quite robots yet, but unfortunately we're moving in that direction. Me included.
Kurt Mutchler	I'm always thinking about how we had the agricultural and industrial revolutions and now we're into the next revolution, and this picture is indicative of that. This may just be the birth of robots, but they're going to become more and more prevalent in our society as we progress. No doubt about it.
Rebecca Adelman	I think that the idea of Pepper is that robotic systems will ultimately be used to replace humans in the sectors of the economy that we previously thought were probably immune to automation. Apparently, there's a Pepper that is like a hotel concierge in Virginia, and the idea is that Pepper will ultimately be able to do retail and the kinds of service work, which had been the refuge of the postindustrial

economy. You couldn't automate those jobs in the past, but apparently now you can, or you can try, so the answer is to make the technology humanlike, and to claim that it can think, reason, feel, and respond to feeling. It's pushed this argument to the point of considering, what is the thing that we can't automate, what is the final element, the irreducible element of humanness that cannot be reduced to an algorithm?

Kurt Mutchler I think they might design Pepper to look harmless, because when they make humanoid robots too human, we tend to freak out, we're averse to that. But it is going to be interesting to see how that plays out. In Japan, they have a huge elder population, and just to have somebody that can interact with them, just to have a conversation, really helps even with mental health. I know in Japan they're already testing driverless trucks. In a Lowe's store in California, they have a robot you can ask, "I'm looking for this screw, can you tell me where it is?" And it will take you to the aisle where the screw is.

The **Center for Art, Design and Visual Culture**, University of Maryland, Baltimore County, is a nonprofit organization dedicated to organizing comprehensive exhibitions, the publication of catalogues, media, and books on the arts, as well as educational and community outreach projects. The center's programs serve as a forum for exploring the social and aesthetic issues of the day.

Reading the Pictures is a web-based, non-profit educational and publishing organization dedicated to visual culture, visual literacy, and media literacy through the analysis of news, documentary, and social media images.

Rebecca Adelman is an associate professor of media and communication studies at University of Maryland, Baltimore County, specializing in visual culture, political theory, trauma studies, ethics, and cultural studies of war, terrorism, and militarization.

Ben de la Cruz is an Emmy-nominated documentary filmmaker and journalist. He joined NPR as a multimedia editor for the Science Desk. In this role, he serves as the visual architect for NPR's coverage of global health, science, environment, energy, food, agriculture, and development.

Corey Keller is curator of photography at the San Francisco Museum of Modern Art, where she has organized a number of exhibitions, including *Brought to Light: Photography and the Invisible, 1840–1900* (2008), which explored the use of photography in nineteenth-century science.

Kurt Mutchler is a senior science photo editor at *National Geographic* magazine. He has held several positions at *National Geographic*, including photo editor, deputy director of photography, and executive editor of photography.

Max Mutchler is the manager of the Space Telescope Science Institute and the head of their Research and Instrument Analysis Branch. He works on solar system observations with the Hubble Space Telescope and also contributes to planetary missions such as Dawn and New Horizons.

The Wonder of Evidence

by Mark Alice Durant

In his book *Still Life with a Bridle*, the Polish poet/essayist Zbigniew Herbert writes of an apocryphal letter composed by the Dutch painter Johannes Vermeer and addressed to his friend and neighbor Antonie van Leeuwenhoek, an early practitioner of what we now call microbiology. Every student's first microscopic encounter with paramecia in middle school can be traced back to Leeuwenhoek's experiments in optics in the late 1600s, when he refined the magnifying potential of lenses and designed at least two dozen microscopes of varying powers and uses.

In the letter, Vermeer recounts his negative epiphany one afternoon in Leeuwenhoek's study when he peered down one of his microscopes into a drop of water. For Vermeer, what had always represented purity and simplicity was now revealed to be an environment where "strange creatures swirl in it like in Bosch's transparent hell." He compliments his friend on the scientific advancement, but fears that wonder will be drained from the world. "With each new discovery a new abyss opens. We are more and more lonely in the mysterious void of the universe."

One can sympathize with Vermeer's anxiety; are wonder and knowledge fundamentally at odds? There is an awkward dance between our need for a stable worldview and our restless curiosity. Vermeer himself allegedly employed lenses to sharpen, so to speak, his cool observational powers.

When photography was applied to the microscope in the mid-nineteenth century, science and enchantment found new expression. J. J. Woodward, assistant surgeon general of the United States, was the first scientist to actively explore photomicrography, as it was termed at the time, as a tool to assist biological science in a rigorous manner. One of his research images, *Proboscis of Butterfly*, employs the denotative power of microscopic photography to reveal a precise and detailed view of a butterfly's curled feeding tube. Yet isn't the image more than description? Does it not also inspire amazement, even astonishment at the precise and universal patterns of creation even on the smallest of scales?

Photography also came to the assistance of those who turned their viewing devices upward to gaze at, ponder, and study the celestial dome. Charles Fabre, who penned the earliest encyclopedia of photography, called on the medium to give us "the geography of the heavens," although it took several decades in the mid-nineteenth century to improve the technology of light-sensitive materials before celestial mapping could begin in earnest. Naturally, our closest celestial neighbor, the moon, was the first night-sky subject of the new medium, and there are early instances of successful daguerreotypes made, most notably by John Adams Whipple.

James Nasmyth, British businessman, inventor, and amateur astronomer, made what appeared to be the most impressive nineteenth-century photographs of the moon (p. 41). Yet they are deceptive. Based upon careful telescopic observations, Nasmyth constructed three-dimensional plaster models of the moon's surface pockmarked with craters and wrinkled with mountain ranges. Nasmyth then photographed the models as if they had been seen through a telescope, each precise topographic detail functioning like the moon's fingerprint. While Nasmyth did not pretend that the images were authentic documents, he disseminated the images through his newly invented photomechanical process, and they were accepted, celebrated even, by scientists and the public alike, as the most accurate photographic representations of the moon to date. They are impressive even today, although Nasmyth's images of active volcanic activity on the moon give evidence that his wishful imagination was as least as acute as his empiricism.

WAR DEPARTMENT,
Surgeon General's Office, Army Medical Museum.

PROBOSCIS OF BUTTERFLY.

Magnified 40 diameters. Objective used, 1½ inch (Wales).
(Negative No. 316. Microscopical Series.)

Photographed by Brevet Major EDWARD CURTIS, Asst. Surg., U. S. A.

BY ORDER OF THE SURGEON GENERAL:
J. J. WOODWARD,
Bvt. Lt. Col. and Asst. Surg., U. S. A.

J. J. Woodward,
Proboscis of Butterfly, ca. 1870

The invention and near-instant ubiquity of photography in the nineteenth century was concurrent with the growth of the social sciences. Archaeology, sociology, anthropology, criminology, and pseudosciences such as phrenology embraced photography, largely because this new medium could give evidential weight to any number of theories, reasonable and otherwise. While the ability to provide false evidence has haunted and undermined photography over the course of its existence, it has also provided artists interested in the quivering line between fact and fiction lots of gray area to explore and exploit.

Which brings us to the Spanish photographic artist Joan Fontcuberta, who has made a career playing with the "truthiness" of photography. Fontcuberta has stated that growing up under the Franco dictatorship made him wary of all authority, including the unquestioning acceptance of photographic truth. Among his many projects, he has made fake celestial images of dust and crushed insects and photographically inserted himself as a cosmonaut in historic images of Soviet space flight. His magnum opus to date is a project titled Fauna, for which he assembled an entire archive of a fictional early twentieth-century German naturalist, Dr. Ameisenhaufen. Evidence, such as taxidermied monstrosities, field notes, X-rays, and identifying creatures with Latin terminology, all accompany elaborately staged photographic tableaux of strange creatures in their natural habitat, in order to construct irrefutable proof of a wondrous bestiary. While gently mocking our sometimes-naive assumptions about science, Fontcuberta's Fauna simultaneously enchants us with the marriage of observation and whimsy captured by the seductive gaze of the camera.

Mark Alice Durant is an artist and writer whose essays have appeared in journals, including *Art in America*, *Aperture*, *Dear Dave*, *Photograph*, and *Afterimage*, and in numerous catalogues, monographs, and anthologies. Durant is the author of *Robert Heinecken: A Material History* (2003); *McDermott and McGough:* *A History of Photography* (1998); and his most recent book, *27 Contexts: An Anecdotal History in Photography* (2016). His ongoing publishing project, Saint Lucy, produces both online and print projects. Durant is a professor in the department of visual art at the University of Maryland, Baltimore County.

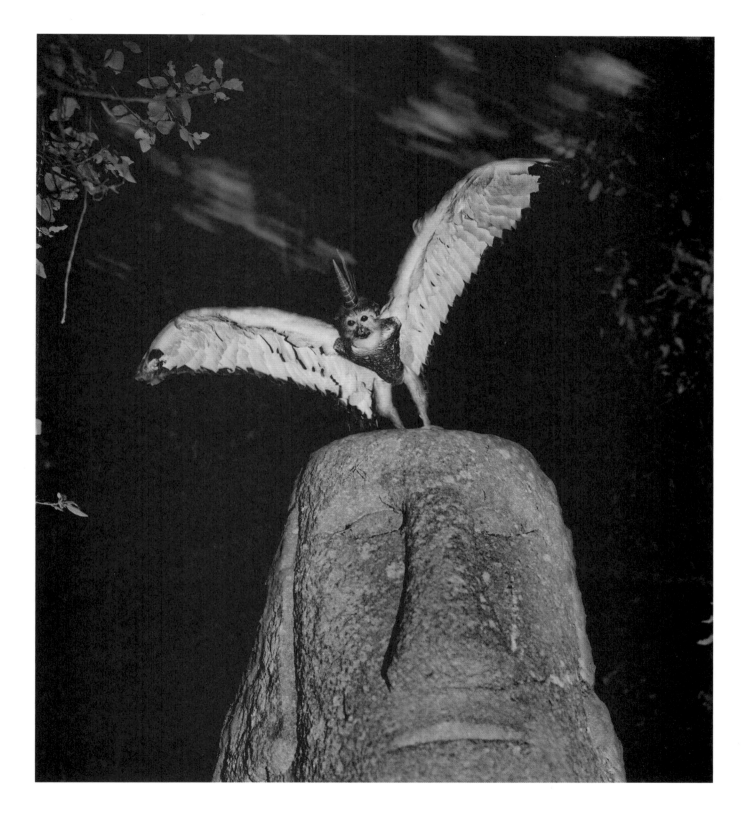

Joan Fontcuberta and Pere Formiguera, *Cercopithecus icarocornu*, 1985; from the series Fauna

Wolfgang Pauli's Aura

During his lifetime, the celebrated physicist Wolfgang Ernst Pauli, who postulated the existence of the neutrino in 1930 and was awarded a Nobel Prize in 1945 for breakthroughs in quantum theory, was also known as a jinx. According to colleagues, all Pauli had to do was enter a room and things went wrong: objects broke, machinery stopped working, and experiments failed. That curious phenomenon, dubbed the "Pauli effect," layered an unintended and secondary narrative onto the scientist's legacy.

French artist **David Fathi** studied math and computer science, and now his work explores what separates fact from fiction. For his recent project Wolfgang, he scoured historic photos in the online archives of CERN (the European Organization for Nuclear Research) and selected images that referred to Pauli or hinted at his mysterious aura. And since most of the pictures that fascinated Fathi had no captions attached to them, he felt free to take liberties with them. In Wolfgang, Fathi pays homage to Pauli in intriguing images— some left untouched, some carefully Photoshopped—that at first seem austere, then weird, then amusing, then unsettling.

Clockwise from top left:

David Fathi,
all from the series Wolfgang

Untitled, 2016

Untitled 098a, 2016

Untitled 012, 2016

Untitled 003, 2016

Seen in a Flash

While one of his images was featured in the Museum of Modern Art's first photography exhibition in 1937, **Harold E. Edgerton**, who made some of the twentieth century's most radical and iconic images, was emphatic about who he was and what he did: "Don't make me out to be an artist. I am an engineer. I am after the facts, only the facts." Edgerton's pioneering work in stroboscopic photography and stop-motion film transformed not only research science, but also the realms of photojournalism, manufacturing, nighttime surveillance, oceanography, archaeology, and entertainment. An inventor, entrepreneur, and educator, Edgerton devised techniques and patented equipment that allowed for previously invisible moments in time and space to be visualized—and made comprehensible—in images that were as unexpectedly beautiful and audacious as they were useful. Flashes of bright light lasting only 1/100,000 of a second allowed for unprecedented categories of image capture. Edgerton photographed golfers and tennis players mid-swing, isolated the movement of gymnasts and dancers hurtling through the air, and captured hummingbirds as they hovered, atomic bombs in the split second they exploded, and familiar household objects—like playing cards, balloons, and fruit—as bullets pierced through them.

High-Speed Photography,
Bullet and Banana, 1978

Bullet through Apple, 1964

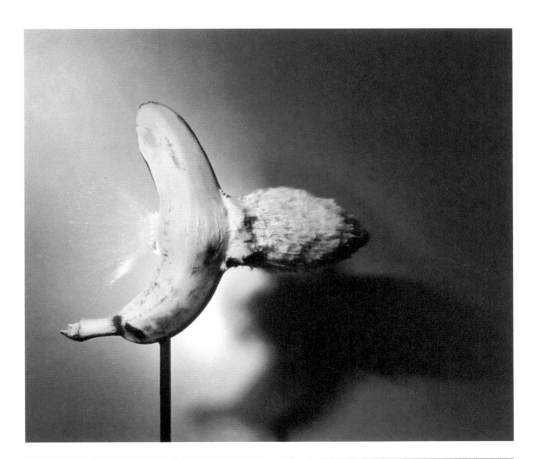

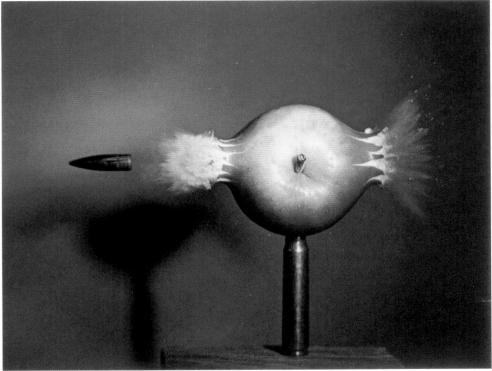

Representing Science at Work

by Felice C. Frankel

Some time ago, I was privileged to have some of my photographs exhibited along with those of Berenice Abbott and Doc Edgerton at the MIT Museum, Cambridge, Massachusetts. The title of the show was *Images of Discovery: Communicating Science through Photography.* The word *discovery* is important, and its use was intended to be double-edged—making the photographs was an act of discovery for the photographer, as well as for those looking at the images.

That exploration has been and continues to be the most rewarding part of my process. Think about it. In order to create the most communicative image of a particular phenomenon in science, I must first understand what I am imaging. Creating a science photograph teaches the science to the photographer and, conversely, teaches photography to scientists.

Abbott photographed phenomena in physics and created a stunning collection of black-and-white photographs while collaborating with MIT physicists. Her science colleagues worked closely with her, advising her on which event to image while playing an important role in setting up the systems for her to photograph. Edgerton took what Eadweard Muybridge and others began and brought high-speed and strobe photography to the broader public. His spectacular images give us the eyes to see movement in one image. The difference in my work is that I capture ongoing research in laboratories across a number of disciplines, where the images are used for journal submissions and presentations. They show evidence of scientific progress and often are explanatory, creating visual metaphors of that which we cannot see.

What we three photographers have in common is that our images have the power of grabbing the viewer's attention, to visually explain what is happening—and quite differently from how it is detailed or described in captions and text. These pictures are not intimidating formulas or graphs. In our visually oriented global community, they are a powerful means to engage viewers to ask questions, in order to help them gain a deeper understanding of complicated research. Learning how to make communicative, compelling, and technically well-executed images should be part of every scientist's education. The audience can be enormous. Along with students and teachers, it can include print and online journal readers, policy makers, potential funders, government representatives, and so many more who can be made aware of important research and critical challenges our laboratories are investigating.

Compare the two images of rubber materials. The top image on p. 169 was created by researcher Alice Nasto at MIT. Her group, with adviser Anette (Peko) Hosoi, is fabricating bio-inspired, fur-like rubbery pelts in order to learn how certain mammals stay warm and even dry while diving underwater. I made the image on the facing page of the very same material.

Felice Frankel,
Fabricated bio-inspired material, imitating
sea otter fur, 2017

Photography + Science = Imagination

By simply folding the material, playing with light, and using a technique in photography called "focus stacking," I came up with a photograph that most of my colleagues see as more compelling and even more informative.

Learning how to photograph science should be part of every scientist's training, even if their research is not necessarily photographable. Conjuring a metaphoric image, for example, which can visually describe a complicated concept, helps the viewer grasp the idea under discussion. For example, to best illustrate how a particular chemical alteration could help scientists extend the lifespan of medical devices—by blocking the formation of scar tissue around a device—I combined various pieces of images to suggest the process that researchers were advancing in their lab. The challenge was to illustrate how a macrophage is deactivated, to suggest that it could no longer attack a medical device being registered as a foreign body—something that cannot actually be visually documented. First, for the background, I used an image I had previously made in the researchers' lab to suggest the presence of capsules which contain material related to the process. Using that background was also a design decision. In addition, I needed to include the important macrophage shape in the foreground of this image, but didn't have anything like that in my files, so I looked through the Science Photo Library archive in the UK, where I found and purchased the rights to a colored scanning electron microscopic image created by Dennis Kunkel. I then used various Photoshop filters to change Kunkel's image and create a different "feel." In the final image, the altered macrophage was overlaid on the background capsules. I was creating a metaphor here, intended as a journal cover submission rather than a document of the chemical action. The researchers and I were pleased when the journal *Nature Materials* did, in fact, use the image on its cover.

John Berger wrote, "We only see what we look at. To look is an act of choice." Those of us who have experienced the joy of choosing to look at science, and to represent it, have the responsibility to develop ways to share that experience with the world.

Felice C. Frankel is an award-winning science photographer and a research scientist in the Department of Chemical Engineering with support from the Department of Mechanical Engineering at MIT, Cambridge, Massachusetts. She is the author of numerous books on imaging, including *Visual Strategies* (2012) and *Picturing Science and Engineering* (2018).

Alice Nasto,
Fabricated bio-inspired material, imitating
sea otter fur, 2016

Felice Frankel,
Assemblage of various photos, creating a metaphoric
representation of a process that deactivates
macrophages; from the cover of *Nature Materials*, 2017

Seeing Around Corners and Below Surfaces

In the mid-1840s, British imaging pioneer William Henry Fox Talbot published *The Pencil of Nature*, in which he described how "photogenic drawing" would enable the recording of images through "the agency of Light alone, without any aid whatever from the artist's pencil." Since photography's introduction, breakthroughs in scientific imaging—X-rays, stroboscopic cameras, and digital photography—have regularly been achieved by expanding upon how various types of light are sensed and recorded by cameras. Today, researchers are stretching the parameters of imaging through what is called femto-photography, a process in which very short and rapid laser pulses are bounced off targeted areas or objects, and the data that the light reflects back is used to construct pictures of what lies outside the conventional fields of human and mechanical vision. Femto-photography can record light at one-trillionth of a second—fast enough to capture photons (particles of light) as they move over objects. Ramesh Raskar and Andreas Velten, researchers at MIT's Media Lab, have spent the past decade developing imaging systems that can see beneath the surface of objects and around corners and then create three-dimensional images of what might normally go unseen, by analyzing the light scattered off the visible objects in the frame and into areas beyond the camera's line of sight. It is hoped that, in the near future, the technology will contribute to the further development of self-driving cars, show firefighters the interiors of burning spaces without their having to enter them, and provide doctors with endoscopic cameras that can see more clearly. "We're still trying to get our heads around what this means," Raskar has said, "because no one has been able to see the world in this way before."

Di Wu and Andreas Velten,
Collecting data from rapid bursts of laser light,
researchers at MIT visualize data as light scatters
below the surfaces of solid objects, *Camera
Culture*, MIT Media Lab, 2011

Blood Samples

Soon after Louis Daguerre's photographic advances were made public in 1839, Alfred François Donné, who taught at the Medical Faculty of Paris, grasped how the new photographic technology, linked with microscopy, could be of great educational use. Donné's textbook and medical atlas, *Cours de microscopie complémentaire des études médicales* (1845), featured engravings of bodily fluids, including blood, that were based upon the pioneering microphotographic images he made.

In 1998, the artist **Joan Fontcuberta**, long fascinated with the production and meaning of scientific imaging, began to produce large-scale works he called *Hemograms*. "The idea was to invite friends and people close to me to provide a sample of their blood . . . [on] a piece of transparent film. . . . Immediately afterward, I make an enlargement on photographic paper using the blood as a negative." The resulting Cibachrome prints—each titled with the donor's initials and dates—are strikingly abstract, viscerally powerful, and as evocative as they are documentary. Seemingly forensic, they trigger associations ranging from the evidential to the romantic; reference the laboratory and the battlefield; and boldly visualize a symbol of both life and loss.

Clockwise from top left:

Joan Fontcuberta,
all from the series Hemograms

Hemogram: D.A. I 24-6-98, 1998

Hemogram: T.G. 15-8-98, 1998

Hemogram: S.B. 25-8-98, 1998

Hemogram: M.S. 16-7-98, 1998

Vanitas
(in a Petri Dish)

Petri dishes, named after the German bacteriologist Julius Richard Petri (1852–1921), are the round, shallow glass vessels used variously in laboratories to grow bacteria, germinate plants, and view liquid samples under low-powered microscopes. For these photographs **Suzanne Anker**, whose multimedia works bridge the arts and sciences, fitted out petri dishes with dense and seductive mini-landscapes largely comprised of naturally occurring, but sometimes including man-made, materials. Titled *Vanitas*, and named after the genre of seventeenth-century Dutch still-life paintings that juxtaposed symbols of life and decay, this series exploits the flatness of photography to survey improbably seductive and miniature environments that Anker carefully created. The resulting images suggest natural cycles of life and death, speak to the manipulation of nature and the consequences of that, and remind us, too, that the term "petri dish" is also used to describe hospitable arenas—like the sciences and the arts—where inquiry and new ideas can develop.

Clockwise from top left:

Suzanne Anker,
Vanitas (in a Petri dish) 01, 2013

Vanitas (in a Petri dish) 10, 2013

Vanitas (in a Petri dish) 29, 2013

Vanitas (in a Petri dish) 18, 2013

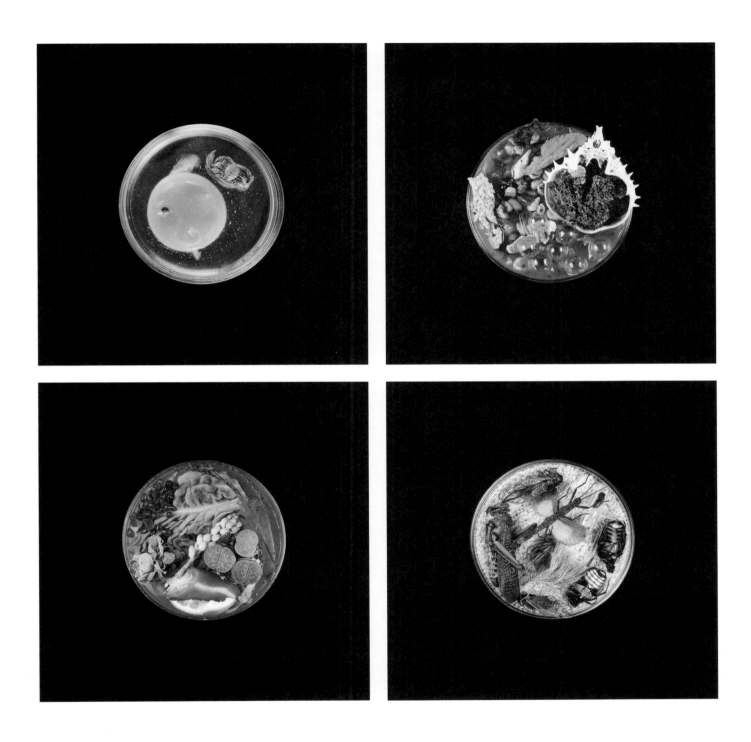

Science Fiction and Moving Images

by Joseph N. Tatarewicz

When the Soviet Union put Sputnik 1, the first artificial satellite, into orbit on October 4, 1957, the shock of the event seemed to usher in the "space age." The fact that the two then-superpowers, the USSR and the United States, were able to mobilize their resources and orbit satellites within months of each other, however, shows that there had been a lot of preparation, only some of it public. Besides the many and well-funded secret programs on both sides, the public face of space had long been cultivated in print and by film science fiction, as well. These imaginative and compelling stories had, in fact, emboldened numerous budding scientists and engineers to believe that space travel was imminent. Memoirs and oral history interviews with space engineers, scientists, and administrators provide abundant testimony to the power of science-fiction images and stories.

Cinema, television, and new media arose from scientific and technological innovations, often incorporating these very themes into their artistic productions. Crude "moving pictures" emerged from late nineteenth-century shops of inventors to captivate and entertain the public. The medium grew rapidly from short vignettes to longer productions with narrative frameworks, including stories about science and technology itself, which already had a strong public following in fact and fiction of the period. Newsreels brought the discoveries of science and the marvels of engineering to the screen,

bolstering the celebrity of public scientists and engineers. Feature films quickly adopted scientific and technical genres of existing fiction, which could be brought to life by featuring sound, rapidly developing special effects, and other techniques.

Early filmmakers cut their teeth on the popular imaginative fiction of the Victorian era, especially the futuristic science- and technology-infused novels of Jules Verne and H. G. Wells. Verne's *From the Earth to the Moon* (1865) imagined the limited technology of the day enabling a lunar voyage: a huge cannon was used to propel a group of scientists and adventurers in an artillery shell vehicle into space.

The inventor and well-versed stage magician Georges Méliès produced his famous sixteen-minute *Le voyage dans la lune* (1902) using Verne's story and characters. Méliès is credited with producing the first "long" film with a narrative structure, as well as developing the first use of many special effects and editing techniques. His work was lovingly portrayed in the concluding episode of Tom Hanks's twelve-part miniseries *From the Earth to the Moon* (1998), intercut with a narrative of the final Apollo landing of 1972. Martin Scorsese departed from his more usual subject matter to explore Méliès's later life in the lavishly produced, three-dimensional *Hugo* (2011). H. G. Wells's *The War of the Worlds* (1898), *The First Men in the Moon* (1901), *In the Days of the Comet* (1906),

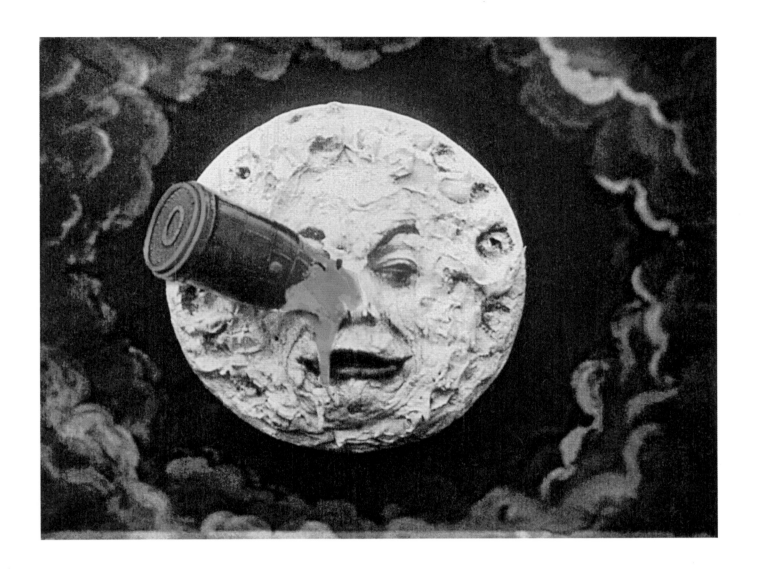

Film still from Georges Méliès,
Le voyage dans la lune (1902)

and *The Shape of Things to Come* (1933) similarly formed the basis for numerous film interpretations well into the actual space age. Just as Verne's writing had incorporated then-current nineteenth-century theories of the moon's surface and interior, Wells's works also used contemporary science and technology throughout.

Fritz Lang's *Frau im Mond* (*Woman in the Moon*, 1929) drew on Wells to imagine an updated journey to the moon, but the director also relied upon the input of a host of technical advisors, including a who's who of the budding field of rocketry. Lang brought special effects to new heights, busted his budget, produced a film that was spectacular and far too long, and otherwise seemed a thoroughly modern filmmaker.

At Lang's side was the young Wernher von Braun and his more senior tutors in rocketry. Von Braun and his colleagues would go on to develop rocketry for Germany during the Second World War, missiles for the US and the USSR afterward, and then the giant rockets and infrastructure for America's Apollo missions to the moon.

Von Braun and his US group traded Lang for Walt Disney, helping to infuse the latter's numerous productions with enthusiasm and making the imaginary technology in them seem palpably real and achievable. Disney's chief animator, Ward Kimball, recalled that President Eisenhower had requested that a copy of the 1955 "Man in Space" episode aired on Disney's primetime television program be shown to the Pentagon staff. Subsequent episodes focused on lunar and then Mars journeys, combining Disney production values with the know-how and even on-camera presence of von Braun's network of engineers and scientists.

Joined by the complementary medium of television in the second half of the twentieth century, the omnibus genre of "science fiction" became a repository of existing knowledge and technique that was expanded upon to reflect new and imaginative projections of future developments. Blurring the distinction between documentary and fiction, media productions of scientific and technological stories became a forum where the public confronted the benefits, dangers, drama, hopes, and fears of an avowed scientific and technological age.

Joseph N. Tatarewicz is associate professor in the University of Maryland, Baltimore County Department of History, and director of the Human Context of Science and Technology program. His course Images of Science and Technology in Cinema and Media introduces historical media analysis and criticism, applying it to more than a century of productions that shaped public images of scientists and engineers, their work, and its implications for the future.

Photographer unknown,
Walt Disney (left) meets with Wernher von Braun
(right), who worked with Disney Studios as technical
director on three films for television about space
exploration, Huntsville, Alabama, 1954

Horst von Harbou, On the set of *Frau im Mond*, 1929

Digital Blends

Composite images, as photo historian Kelley Wilder wrote, "belong in many ways to the traditions of the ideal scientific drawings of the eighteenth century." In the mid-nineteenth century and after photography's introduction, composite photographic images were made and used by criminologists and eugenicists alike. In the 1970s—more than a dozen years before Photoshop was released—artist **Nancy Burson** began a pioneering collaboration with MIT engineers that explored a computer's ability to simulate the effects of aging through a system of morphing faces. (Their work was later used by the FBI to update existing photos of missing children and adults.) In the 1980s, Burson's interests and projects broadened to produce novel and sometimes startling projects in which digitally blended images were created to explore diverse issues, including racial and gender identity, cultural constructs of beauty, political and religious iconography, the healing powers of visualization, and the malleability of genetics. Burson's artworks, widely exhibited and featured in the media, are often as unsettling as they are compelling, the result of a canny blending of photographic fact and fiction—because they underscore how easily images can be used to influence as well as to inform.

Top row:

Nancy Burson,
Androgyny (6 Men + 6 Women), 1982

Nancy Burson,
Mankind (images used are from a nineteenth-century book of racial stereotypes and were weighted to reflect world population statistics), 1983–85

Bottom row:

Nancy Burson, Left: *Etan Patz (Age 6)*, 1984;
Right: *Etan Patz (Age 13)*, 1984

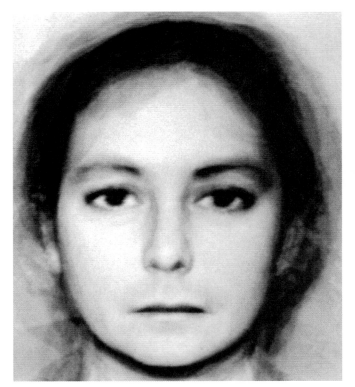
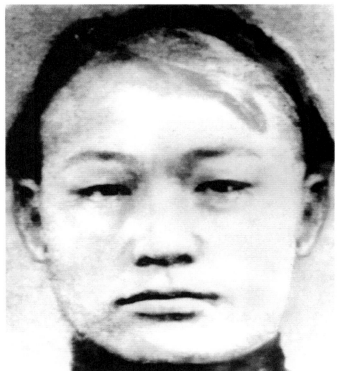
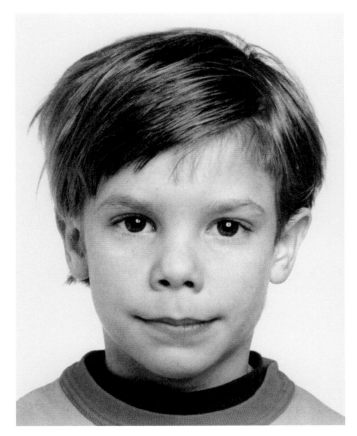
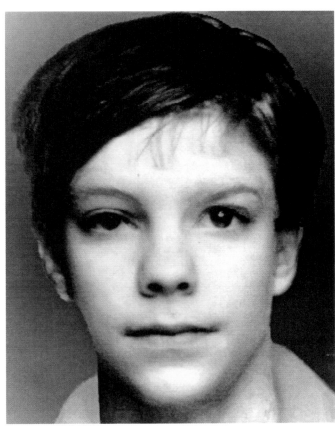

Sampling Worry

Once the first microscopes were developed in the late sixteenth century, it became commonplace for specimens to be pressed between disks of transparent mica to hold them firmly in place as they were seen and studied. Two centuries later, photography became a valued tool in both capturing data and sharing images of what magnification might reveal "unmarked"—as Lorraine Daston and Peter Galison described it in their book, *Objectivity* (2007)—"by prejudice or skill, fantasy or judgement, wishing or striving." In a recent project, Fret & Focus, **Melissa Penley Cormier** has purposefully, charmingly, and with a touch of humor made both microscopic slides and images of them to pit objectivity and subjectivity against one other. Every day for one year, Cormier gathered physical samples of the things that she was concerned with and worried about; then she made slides from those samples that she went on to archive, photograph, and make visible through a variety of viewing devices. "Cobbled together projectors," she has said, help her to "enlarge and explore hidden details of collected specimens," face her fears, and—as important, and through quasi-scientific means—"start new conversations."

Clockwise from top:
Melissa Penley Cormier,
Studio process of Fret & Focus project, a year of documenting worries using microscope slides, 2016

5/19/2016, 2016

4/30/2016, 2016

A Genetic Self-Portrait

Traditionally, photographic portraiture is an activity in which external facial and bodily features are depicted through a variety of representational strategies. But in the last decade of the twentieth century, as teams of scientists were engaged in a highly publicized race to map the intricacies of the human genome, **Gary Schneider** began a series of unconventional images in which he explored the nuances of selfhood from a novel bodily perspective: from the inside out. His Genetic Self-Portrait evolved into a project comprising fifty-five images that not only reflect Schneider's conversations with physicians and geneticists, but also were shaped by his engagement with diagnostic and forensic procedures. Though the images originated from lab tests, such as MRI scans, tissue samples, and X-rays, his poetic interpretations transform them for artistic rather than diagnostic purposes. Considered together, the pictures reveal something altogether different and expansive about the self beyond the scientific information they contain. Schneider's Genetic Self-Portrait challenges what we can really know about ourselves and shows both the limits and possibilities of technology.

Top row:

Gary Schneider,
Genetic Self-Portrait: DNA DYZ3/DYZ1, 1998

Genetic Self-Portrait: Chromosomes 11, 1997

Bottom row:

Genetic Self-Portrait: Retinas, 1998

Photochemical Residue

In August 1860, the Reverend F. F. Statham delivered a paper to the South London Photographic Society to confirm: "It is true that photography is the child of chemistry. . . . But I am prepared to maintain that, if a child once, photography has been a grateful child; and . . . is repaying the advantages received in her condition of pupilage with a most bountiful interest." In a recent and ongoing body of work, **John Cyr** explores, quite literally, how chemistry and photography are related. Having worked as a professional fine-art photographic printer and skilled in the subtleties of printmaking, Cyr now forgoes traditional subject matter to direct attention to the science and evolution of image production. He places sheets of exposed photographic paper—some with latent images ready to be revealed on them, some without—in a developing tray, and drips or splashes developer of varying dilutions on them. Then he watches, waits, and records what happens. Each of the lyrical, unique photographs that result are documentary of sorts, are a touch nostalgic (hinting at the transition from analog to digital photography), and graphically underscore how powerfully the mechanics and art of image-making intertwine.

John Cyr,
all *Developer Abstraction*, 2015

Science Photography and the Art Museum

by Ben Burbridge

What do the histories of art have to teach us about the histories of science and technology? I want to address the question with reference to three exhibitions of scientific photography held in art museums: *Film und Foto*, curated by Bauhaus artist László Moholy-Nagy in Stuttgart, Germany, in 1929; *The New Landscape in Art and Science*, curated by György Kepes at the MIT Hayden Gallery, Cambridge, Massachusetts, in 1951; and *Once Invisible*, curated by John Szarkowski at the Museum of Modern Art, New York, in 1967. Together, these projects provide us with a sense of what is at stake when scientific imagery is exhibited as art, along with the important ways that public perceptions of science and technology invariably inform the meanings of these shows.

The earlier exhibitions had a lot in common. Each focused on the types of science photography that surpassed the capacities of unaided human vision. Pictures showed the astronomically distant and microscopically small, revealed the hidden nuances of rapid motion, and depicted the effects of invisible sources such as electricity and radiation. Removing the texts, written explanations, and diagrams that originally accompanied the photographs, curators drew attention toward the aesthetic and formal characteristics of the imagery.

Dynamic installations placed disparately sized images in three-dimensional arrangements, an effort to convey something about the excitement and disturbance involved in new modes of technological seeing. This points toward a common concern with the changing relationship of man and machine, which the photographs were used both to demonstrate and to allegorize.

For all these similarities, the three exhibitions were by no means the same. Moholy-Nagy described his interest in scientific imagery in terms of a "New Vision," explaining that it fell to artists to explore the potential of technological seeing in order to change how the world was perceived. This was a social as much as an aesthetic project. Moholy-Nagy believed that a transformation of perception could help to forge new social relationships and bring egalitarian societies into being.

That utopian project was the result of the artists' experience of 1920s Weimar Germany: a site of exhilarating industrial production and political possibility. The optimism could not survive Moholy-Nagy's migration to the USA to flee the threat of the Nazis, nor the horrors of a second world war and news of the atomic bomb. "Saturated with old ideologies," he explained, society had "failed to translate . . . newly gained experience into emotional language and cultural reality." The result "has been and still is misery and conflict, brutality and anguish, unemployment and war."

György Kepes set aside utopian visions in favor of using aesthetic encounters with scientific imagery to orientate society in a landscape "made strange and unfamiliar" through the applications of scientific discovery. That shift can be understood against the backdrop of the early Cold War. By the late 1940s, 85 percent of the research budget at MIT (the institution at which Kepes was employed and that hosted *The New Landscape*) came from the military and the Atomic Energy Commission.

If it was the political instrumentalization of science that helped call earlier utopian visions into question, it has also raised questions about the artistic model Kepes proposed in response. For art historian John Blakinger, the idealistic notion that art and science could achieve a poetic unity "risked overlooking the ways in which the arts were already subsumed by the sciences."

By the time Szarkowski's exhibition opened in 1967, the Cold War had heated up. Artist Berenice Abbott's educational science photographs, which were included in the show, received federal funding in 1957 only after the Soviet Union launched Sputnik 1. The project provides a telling example of the intimate relationship shared by geopolitics, science, and visual culture by that time.

A list of lenders to *Once Invisible* reads like a who's who of key players in the US military-industrial complex. Captions explained how the photographs aided the applications of scientific discovery within industry. *Once Invisible* marks an important departure from the earlier projects, setting aside

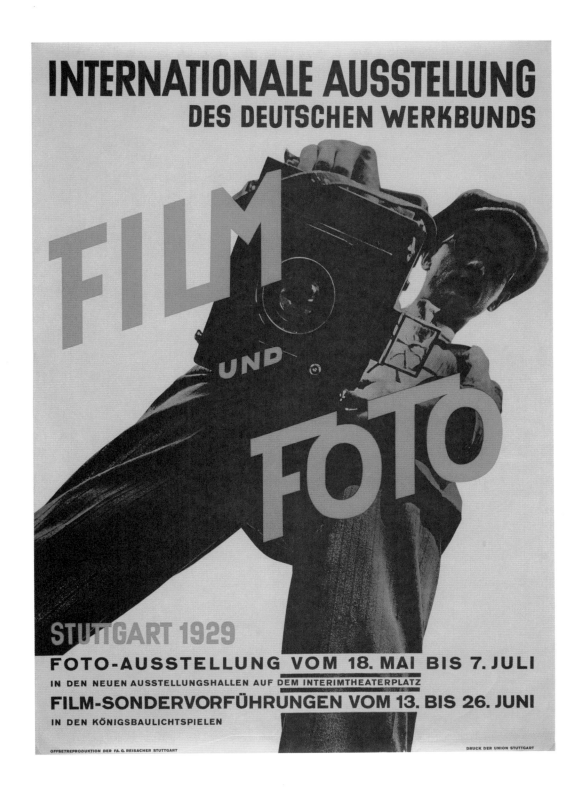

Willi Ruge,
Poster for the exhibition *Film und Foto*, organized by
Deutsche Werkbunds, the German association of
architects, designers, and industrialists, 1929

the productive tension between art and science to explore the potential of photographic form while also publicly celebrating the USA's technological achievements.

The political philosopher Walter Benjamin once suggested that our understanding of the past will always be shaped by experiences of the present, just as experiences of the present will be molded by the presence of the past. When I finished work on my own exhibition about early science photography and its importance for the histories of art, *Revelations: Experiments in Photography* (2015), it was the narrative sketched out above that pointed me toward the importance of wider contexts in defining the show's potential meanings. It also helped me to appreciate what it might have been about our current moment that caused this particular history to "flash up," in the manner described by Benjamin.

We live in a world moving rapidly toward automation. This means that questions that Moholy-Nagy and others posed about our relationship to technology have renewed importance today: Will society be liberated from toil, and a better quality of life secured for the many? Or will the growing surplus workforce drive wages down, while profits remain concentrated in the hands of the few? Will green technologies be harnessed to build sustainable futures? Or will that promise be sacrificed to the short-term thinking of a narrowly defined STEM agenda that, in the words of former British prime minister David Cameron, is about "a global race for the best jobs"?

These are just a few among many of the issues that will necessarily frame exhibitions of science photography today, because they are the issues helping to define the wider public perception of science and technology. If we embrace this fact, and invest in the old Enlightenment promise of the museum as a space for public discourse, then these kinds of exhibition could provide valuable opportunities to reflect again on the types of future we want to build through technology, and to take stock of the social, political, and economic questions that help define and delimit the meanings of science.

Installation view of *The New Landscape of Art and Science* at the Hayden Gallery, MIT, Cambridge, Massachusetts, 1951

Installation view of *Revelations: Experiments in Photography* at the Science Museum, London, 2015

Ben Burbridge is senior lecturer in art history and codirector of the Centre for Photography and Visual Culture at University of Sussex, UK. His writing on photography, contemporary art, and politics has been published widely. His curated exhibitions include *Revelations: Experiments in Photography* (2015) and the 2012 Brighton Photo Biennial, *Agents of Change: Photography and the Politics of Space*. Burbridge is coeditor of *Photoworks* and cofounder of Ph: The Photography Research Network. He is currently working on a book about photography, contemporary art, and neoliberalism.

The Nature of Sciences

To make photographs for his recent series Into the Woods, **Victor Schrager**—known for his studio-based and still life work—took his wooden, large-format film camera out of doors to suggest how our experiences in and understanding of nature are influenced by images of the natural world. In earlier projects, he worked with a gardener to capture the variety and beauty of heirloom tomatoes and made elegant, if unsettling, photographs of birds held in the hands of ornithologists. For this project, Schrager took a different and more conceptual approach: he selected and then pinned up reproductions, including historic images referencing the sciences, on trees. Experimenting with focus and blur, he made photographs that transformed wooded scenes into walk-through collages that hint at dream states as much as they suggest environmental awareness. Portraits of Charles Darwin and Robert Crumb's iconic 1960s counterculture character, Mr. Natural, intermingle. So do images of a waterfall, a zebra, the sun, a Philip Guston drawing, and the bookshelf of photographic pioneer William Henry Fox Talbot, upon which volumes about philosophy, science, and the arts rest and—like Schrager's pictures themselves—suggest interconnection.

Clockwise from top left:

Victor Schrager,
Muse #10, 2015

WoodWork #21, 2015

Muse #9, 2015

Muse #3, 2015

Experiments
and Observations

If our twenty-first-century familiarity with everyday technology makes us think we know what science looks like, **David Goldes**'s photographs suggest otherwise. Having studied biochemistry, then molecular genetics, and then photography, he eschews the conventional and high-tech look of much contemporary scientific representation to create images that are surprisingly charming, intimate, and mysterious. "In an age of big science and specialist interpretation," Goldes says, "I have turned to homebrew experimentation and observation translated through photography." His tabletop images employ humble materials to investigate subjects like fluid dynamics, electricity, and air movement. And while based upon historical research, Goldes's images also suggest elastic narratives and metaphors rather than the nailing down of explanations. Instead of striving to maintain their neutrality or assert their objectivity, his works celebrate the ingenuity and willfulness of those driven to figure out the "hows" and "whys" of the universe.

David Goldes,
Smoke Ring, 2009

Untitled, 2015; from the series
Snake in the Garden

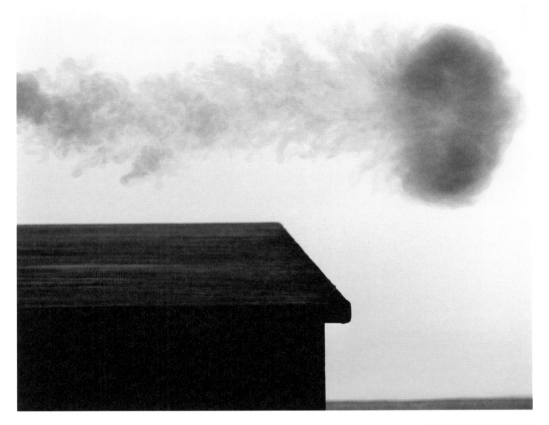

Health of
the Planet

In 1895, when the German physicist
Wilhelm Conrad Röntgen showed his
wife an X-ray image of her hand, she
exclaimed, "I have seen my death"
(p. 9). Almost a century later, **Steve
Miller**—tired of art world exclamations
about the "death" of painting—began
to incorporate science-based imaging
into his artworks, which often are
made in response to conversations
and collaborations with noted
research scientists. On a trip to Brazil
in 2005, fascinated by the beauty
and complexity of the country's
tropical environment, Miller worked
with Brazilian radiologists and began
the ongoing project Health of the
Planet. Works in it—paintings, silk
screens, works on paper, sculptures,
and surfboards and skateboards—
incorporate images of Amazonian
flora and fauna. Photography in the
nineteenth century was often used
to collect specimens and create
picture atlases of the natural world.
In his multimedia works exploring
environmental diversity, controversy,
and stewardship, Miller both celebrates
nature and reminds us of our very
consequential interactions with it.

Steve Miller,
Snake Leaves, 2011

Ways of Knowing

Instead of making conventionally serious portraits of scientists for his project Ways of Knowing, London-based **Daniel Stier** photographed science researchers, professors, and students in ways that reflect both his and their shared sense of curiosity. "I have a fascination with the work they do, which I liken to the work of artists," Stier has said. "It's research for research's sake, so the work isn't clearly purposeful, it can always go wrong, and most of the time it does." His portraits, sly and respectful, often depict scientists who appear to be momentarily hemmed in as they push up and against the unknown. Those portraits, combined with the fanciful studio still lifes he constructs that riff on laboratory setups, are simultaneously startling and evidential, and point to the combination of wonder and work that characterizes life in the sciences.

Daniel Stier,
all images from *Ways of Knowing*
(London: YES Editions, 2015)

Abstraction and Beauty

In the 1920s, German graphic designer **Carl Strüwe** was mesmerized by the sharp-focus look, content, and beauty of scientific specimens viewed under intense magnification. "When, in 1924, I first looked through a microscope," he explained, "my schoolboy knowledge of the natural sciences had long but disappeared. My mind was therefore like a blank canvas in that respect . . . so I saw mostly forms, shapes, and a wealth of variations of black, gray, and white. I saw images." To frame and transform those images, Strüwe methodically crafted and inserted tiny rectangular cardboard templates into the microscopes he photographed his subjects through. The visually striking and elegant images that resulted bridged science and art. They were exhibited widely in Europe after World War II, featured in György Kepes's influential exhibition *The New Landscape in Art and Science* at MIT in 1951, and published in the monograph *Formen des Mikrokosmos* (*Forms of Microsms*, 1955).

Carl Strüwe,
Archetype of Individuality, 1933

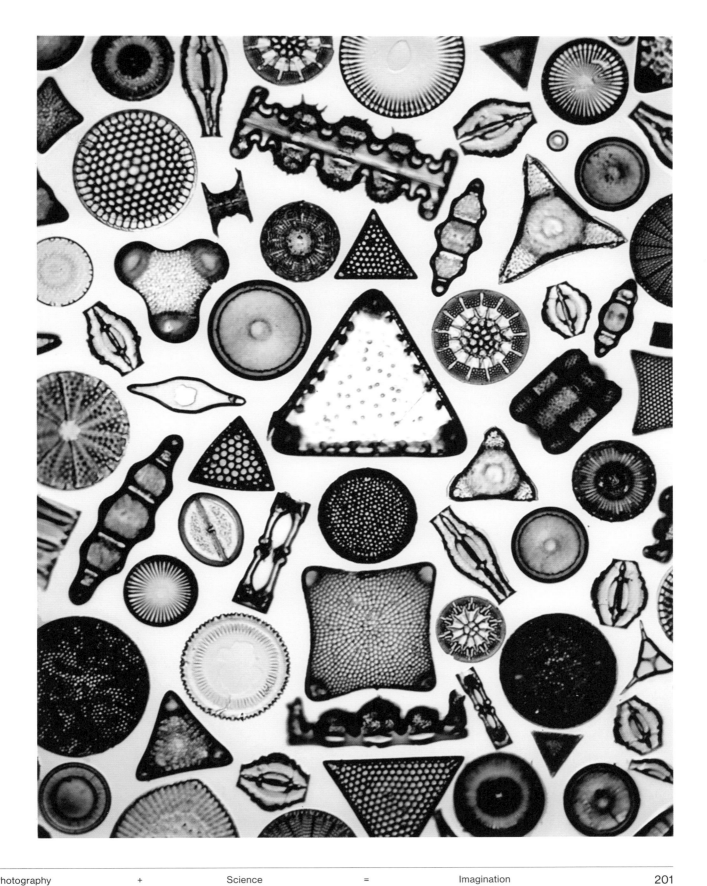

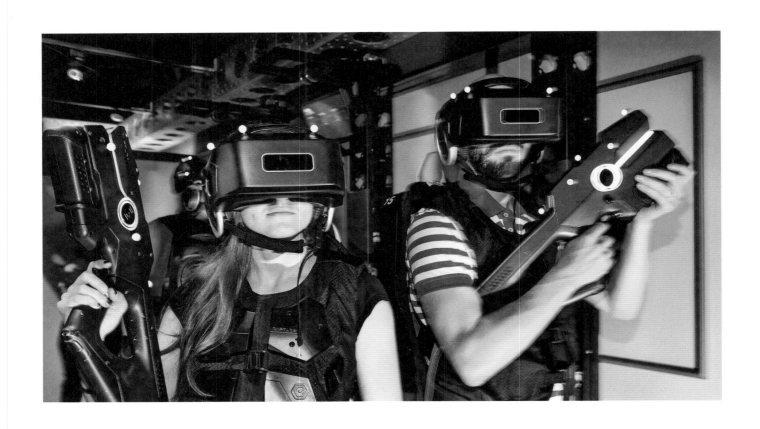

James Bareham,
A *Ghostbusters*-themed VR experience at Madame
Tussauds Wax Museum in Times Square, 2016

Virtual Reality

A conversation among visual culture experts who gathered online to discuss a selection of science-related news and media photographs on December 1, 2016, in an event sponsored by Reading the Pictures and the Center for Art, Design and Visual Culture.

Rebecca Adelman I've been really interested lately by the increased marketing of virtual reality as this everyday thing, like when the *New York Times* uses virtual reality simulations to take us to the most immiserated places on earth, such as a tour of refugee camps. There's everything from that to commercials for virtual reality smartphones where everybody's having life-changing experiences on the train, or in their basement, or wherever it is. It's fascinating to me that virtual reality is increasingly being marketed as an element of everyday media consumption, and I want to think about what happens when media becomes immersive in this way. We typically talk about media consumption, but the promise here is that media is going to consume *us*. That's the experience that we really want. It is also interesting to me that in all of the marketing for virtual reality technologies, we never see what users are seeing. We see people in space-age goggles or with guns, or hear them exclaiming about whatever magical thing is transforming before their eyes, but we don't see it. So, here again, we are being sold a particular way of interacting with technology and a particular promise, and it doesn't seem like it is so much about the content as it is about the medium, or the experience that it provides, which is an interesting shift.

Kurt Mutchler We've talked about how women have been segregated out for being women in science photography. Here we have a woman totally suited up and ready to kick ass, just like her male counterpart. I like this picture because of that.

Rebecca Adelman	Historically, the initial radical promise of virtual reality is that in a virtual world you could be anybody. And then that argument gets shifted onto new media in general, that it is a disembodied world where all this physical baggage that you carry doesn't matter, so maybe this is a rearticulation of that promise. I had a similar thought about this image, about how it almost looks like a movie poster for something like *Ghostbusters*, right? So, it is a double mediation of the real. It is virtual reality, but you can experience it like a movie, so it is another level of remove.
Nathan Stormer	And yet there's a hokey quality to this image at the same time. There's an element of humor baked into it, which is interesting in terms of selling an experience, like paintball, that features organized teams as a form of militarism, but makes it palatable and lighthearted by the tons of technology that are thrown into forms of recreational violence these days. I keep coming back to violence, I'm sorry, but it's on my mind.
Marvin Heiferman	Another aspect of this image is how it raises the topic of wearable technology. Virtual reality is one aspect of the ways we're enabling ourselves to insert ourselves into other worlds, or other objects into ours. This picture touches on the Google Glass and Snapchat Spectacles phenomena, and the fact that there are ingestible cameras that take endoscopic pictures at this point. This photo illustrates how photography, technology, and science have become integrated. We're constantly imaging for entertainment purposes and for the most serious of purposes. The fact that we're not only wearing cameras, but becoming cameras ourselves, is interesting.
Max Mutchler	What strikes me about this image is the heights to which gaming technology has gone and how popular it is, not only with kids, but adults just as well. An enormous amount of human time and energy goes into gaming, there's only so many waking hours in the day, only so many years in our lives, and you do see people coming up with games that have a purpose. It's not just for entertainment. And I don't mean to devalue entertainment, we all need to be entertained and have an escape every once in a while, but I'm intrigued by the possibility of harnessing just a small percentage of that towards some purpose, and I don't know what that is. I know I've read about people who are coming up with games that actually can solve a problem. I know in science there's something called citizen science, where we try to engage the public to contribute to scientific projects and it has led to actual publications, actual results. So, I am intrigued by the possibility that this technology could have a purpose beyond entertainment.
Nathan Stormer	To some extent we've been talking about one aspect of seeing science being "science as seeing." In an equally significant way, science is about showing, and lots of different ways of showing. And so to your comment, the ways in which we capitalize on that or convert that to our benefit is a huge part of how we relate to science.
Rebecca Adelman	But here that's become commodified—for fifty dollars you can have this experience, and maybe that is sort of a gloomy way to think about this, but that is ultimately the telos of this technology. In some ways, thinking back to the history of virtual reality, which seemed to have all sorts of potential, if it was going to land us here I imagine the people originally engineering all this stuff might be a little disappointed. I'm not sure. But it seems like a bit of a default on that promise.

Kurt Mutchler	I was recently at a demonstration given by someone who heads up Google Street View, who presented some virtual reality software featuring shots made by the *Curiosity* rover on Mars and in the Gusev crater. When I put the headset on I was standing in the crater and could walk around and see the landscape. It really felt like I was on Mars, which was very, very cool. I imagine one day we'll all be flying around the Pillars of Creation [p. 22] in the same way.
Ben de la Cruz	I'm secretly rooting for the gaming people to spread these headsets all over the place because I think there are lots of applications in the news business, and science in particular. No one has these things at home yet. I see people wanting to participate in VR as this photograph shows, and I'm like, "Yeah, do it, buy some VR headsets!," because it will help the rest of us eventually when we want to create other things.
Corey Keller	It's funny, and just occurred to me, that at Madame Tussauds wax museum—a place you go to look at wax models, but which don't do anything—that they felt the need to introduce an activity where people are doing something. It's as if the act of just looking now has itself become obsolete, that it is no longer believed to be sufficiently interesting. You pay a lot of money already to go into the wax museum, so that you now have to add this virtual reality experience is this kind of interesting statement about the condition of looking today.

The **Center for Art, Design and Visual Culture**, University of Maryland, Baltimore County, is a nonprofit organization dedicated to organizing comprehensive exhibitions, the publication of catalogues, media, and books on the arts, as well as educational and community outreach projects. The center's programs serve as a forum for exploring the social and aesthetic issues of the day.

Reading the Pictures is a web-based, non-profit educational and publishing organization dedicated to visual culture, visual literacy, and media literacy through the analysis of news, documentary, and social media images.

Rebecca Adelman is an associate professor of media and communication studies at University of Maryland, Baltimore County, specializing in visual culture, political theory, trauma studies, ethics, and cultural studies of war, terrorism, and militarization.

Ben de la Cruz is an Emmy-nominated documentary filmmaker and journalist. He joined NPR as a multimedia editor for the Science Desk. In this role, he serves as the visual architect for NPR's coverage of global health, science, environment, energy, food, agriculture, and development.

Corey Keller is curator of photography at the San Francisco Museum of Modern Art, where she has organized a number of exhibitions, including *Brought to Light: Photography and the Invisible, 1840–1900* (2008), which explored the use of photography in nineteenth-century science.

Kurt Mutchler is a senior science photo editor at *National Geographic* magazine. He has held several positions at *National Geographic*, including photo editor, deputy director of photography, and executive editor of photography.

Max Mutchler is a manager of the Space Telescope Science Institute and the head of their Research and Instrument Analysis Branch. He works on solar system observations with the Hubble Space Telescope and also contributes to planetary missions such as Dawn and New Horizons.

Nathan Stormer is a visual scholar and professor of communication and journalism at the University of Maine, specializing in rhetorical history, argument, and persuasion.

A Timeline of Science and Photographic Seeing

ca. 1000 BCE
The Nimrud lens, a piece of Assyrian rock crystal and the earliest known lens—which was excavated by British anthropologist John Layard (1891–1974) in 1950—may have been used as a magnifying glass or to focus the sun's rays to ignite fires.

ca. 400 BCE
First mention of pinhole camera concept and camera obscura image occurs, attributed to Chinese philosopher Mozi (470?–?391 BCE).

350 BCE
Aristotle (384–322 BCE), Greek philosopher and scientist, observes a partial solar eclipse using pinhole camera technique.

1021 CE
Alhazen (965?–?1040), an Arab physicist, publishes the seven-volume *Book of Optics*, in which the pinhole camera and camera obscura are described.

ca. 1266
Roger Bacon (1214?–1292), an English friar based in Paris, describes the optics of corrective lenses (worn by monks and scholars) in his *Opus Majus*.

1550s
Girolamo Cardano (1501–1576), an Italian scientist and philosopher, inserts a biconvex lens in his pinhole camera and advances the quality and brightness of camera obscura images.

1604
Johannes Kepler (1571–1630), German scholar and astronomer, is first to use the term "camera obscura" in print in his published work on astronomy, *Ad Vitellionem Paralipomena*.

1608
The earliest known patent filing for a refracting telescope appears, attributed to German-Dutch spectacle maker Hans Lippershey (1570–1619).

1609
Galileo Galilei (1564–1642), Italian astronomer, builds a small telescope with a lens approximately one-and-a-half inches in diameter.

1625
The word *microscope* is first used by German botanist and physician Giovanni Faber (1575–1629).

1660s
Sir Isaac Newton (1642–1727), English physicist, discovers the composition of light, which leads the way for spectroscopy, the study of visible light dispersed into wavelengths.

1668
Newton builds the first practical reflecting telescope.

1670
Johannes Hevelius (1611–1687), Polish astronomer, builds a 150-foot-long refracting telescope, made of lenses hung by ropes from a pole.

1789
Sir William Herschel (1738–1822), German-born English astronomer, completes a forty-foot-long telescope.

ca. 1800
Thomas Wedgwood (1771–1805), an early British photographic experimenter, attempts to produce permanent camera-recorded images on surfaces coated with light-sensitive chemicals. He captures only shadows and silhouettes, which he is unable to preserve permanently.

1824
Nicéphore Niépce (1765–1833), French inventor, captures the first durable, light-fast photograph on the surface of a lithographic stone, but it is destroyed during subsequent experiments.

ca. 1826–27
Niépce succeeds in making the earliest-known surviving photograph from nature, *View from the Window at Le Gras*, which required an exposure of at least eight hours.

1834
The term "scientist" used by William Whewell (1794–1866), an English scholar, appears in print for the first time.

Nimrud lens

Illustration of a camera obscura taken from a nineteenth-century English encyclopedia

Hans Lippershey, after a portrait by Hendrik Berkman, artist unknown, ca. 1655

Forty-foot-long telescope designed by Sir William Herschel, *Encyclopaedia Britannica*, 1797

Thomas Wedgwood, Photogram of a leaf, early twentieth century

 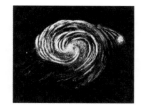

1839

François Arago (1786–1853), director of the Paris Observatory, makes the first public announcement of Louis Daguerre's photographic process at a meeting of the Académie des Sciences.

British inventor William Henry Fox Talbot (1800–1877) counters Daguerre's claim of inventing photography by exhibiting images of photomicrographic specimens made with his solar microscope at the Royal Society in London.

Working in France and awaiting a patent for the telegraph, American inventor Samuel Morse (1791–1872) meets French artist Louis Daguerre (1787–1851), who shows him light-sensitive images on metal plates, which Morse calls "one of the beauties of the age."

Sir John Herschel (1792–1871) discovers that the action of hyposulphite of soda fixes photographic images permanently, experiments, makes photographs on glass, and is said to introduce the word *photography* to the public.

1840

John William Draper (1811–1882), English-American scientist, makes the first successful photograph of a full celestial body, a daguerreotype of the moon, during a twenty-minute-long exposure.

Alfred François Donné (1801–1878), a French pioneer in microscopy, photographs sections of bones and teeth.

Andreas Ritter von Ettingshausen (1796–1878), a Viennese physicist, produces some of the earliest daguerreotype photomicrographs.

1841

William Henry Fox Talbot introduces his patented calotype (or "talbotype") paper negative process.

1844

Talbot publishes the first installment of *The Pencil of Nature*, the first photographically illustrated book offered for sale to the public.

1845

William Parsons (1800–1867), Anglo-Irish astronomer, builds the "Leviathan of Parsonstown," a reflecting telescope with a six-foot-diameter primary lens that leads to the discovery of the first spiral nebulae.

1846

Charles Brooke (1804–1879), British surgeon, invents self-recording instruments (including barometers, thermometers, and magnetometers) that use photographic paper to record variations in measurement.

1847

A streak of lightning is recorded on a daguerreotype by T. M. Easterly (1809–1882) in St. Louis, Missouri.

1848

German-born brothers and Philadelphia entrepreneurs Frederick (1809–1879) and William Langenheim (1807–1874) perfect photographic lantern slides that allow for the projection of large images, transforming science and art history education.

1849

Sir David Brewster (1781–1868), Scottish physicist, inventor of the kaleidoscope, and popularizer of science, introduces an improved stereoscope, which leads to the first three-dimensional photography craze.

American inventor John Adams Whipple (1822–1891) makes high-quality daguerreotypes of lunar images at Harvard.

1850

First photograph of a star, Vega, is made by American astronomer William Cranch Bond (1789–1859) and his son George Phillips Bond (1825–1865).

ca. 1850

British psychiatrist and medical doctor Hugh Welch Diamond (1809–1886), a founder of the Royal Photographic Society, photographs the expressions of people suffering from mental disorders.

Thomas W. Smillie, *Samuel F. B. Morse's Daguerreotype Equipment*, 1888

Attributed to John William Draper, *Daguerreotype of the Moon*, 1840

William Henry Fox Talbot, Title page from *The Pencil of Nature* (1844)

William Parsons, Sketch of M51 whirlpool galaxy, 1845

Brewster stereoscope, 1849

1851

The Great Exhibition of the Works of Industry of All Nations, the first World's Fair, is held in London's Crystal Palace, celebrating technology and featuring displays of photographic images and equipment.

William Cranch Bond takes what may be the first photograph of a planet, Jupiter.

Dr. August Ludwig Busch (1804–1855) commissions Prussian daguerreotypist Johann Julius Friedrich Berkowski (fl. 1850s) to make an image of a solar eclipse at Königsberg observatory.

British artist Frederick Scott Archer (1813–1857) revolutionizes photography by using collodion, a medical dressing, to make glass plates photosensitive.

1853

First collodion photomicrographs, prepared by J. Delves (fl. 1850s) and S. Highley (fl. 1850s), are published in a British scientific journal.

First issue of the *Journal of the Photographic Society*, with a strong interest in scientific photographic discoveries and uses, is published in England.

American daguerreotypist Platt D. Babbitt (1823–1879) sets up a pavilion on the American side of Niagara Falls to take and sell images of the natural wonder to tourists.

1855

The Exposition Universelle in Paris celebrates scientific and technological progress with a large display of photographs on subjects such as astronomy, plant and animal species, people of the world, mental and physical illness, and natural disasters.

1856

The first underwater photograph is taken by Englishman William Thompson (1822–1879), who uses a camera attached to a pole.

1858

The first aerial photograph is taken by French photographer and balloonist Gaspard–Félix Tournachon (1820–1910), better known as "Nadar."

Britain's *Photographic News*, a trade journal edited by chemist William Crookes (1832–1919), begins publication.

British astronomer and meteorologist John Waterhouse (1806–1879) develops the earliest variable aperture stops for lenses and cameras.

Scottish physicist James Clerk Maxwell (1831–1879), interested in color theory, works with photographer Thomas Sutton (1819–1875) to produce the first three-additive color photographic image.

1861

First reported photograph of a "genuine" ghost is produced by Boston engraver William H. Mumler (1832–1884).

In England, William Henry Olley (fl. 1860s) publishes *The Wonders of the Microscope, Photographically Revealed by Olley's Patent Micro-Photographic Reflecting Process.*

1862

French neurologist Duchenne de Boulogne (1806–1875) publishes photographs of induced expressions triggered by electric shock in *Mécanisme de la physionomie humaine* (*The Mechanism of Human Facial Expression*).

1865

Photographs of wounded Civil War soldiers, made by New York surgeon Reed B. Bontecou (1824–1907), are used to verify their injuries, document treatment, and determine postwar pension payments.

1870

American astronomer Charles A. Young (1834–1908) is first to photograph a solar prominence.

Thomas W. Smillie (1843–1917), appointed the Smithsonian Institution's first photographer, documents museum specimens and performs chemical experiments for Smithsonian scientific researchers.

Johann Julius Friedrich Berkowski, first image of a solar eclipse, 1851

Platt D. Babbitt, *Niagara Falls*, ca. 1855

Honoré Daumier, *Nadar Elevating Photography to Art*, lithograph, 1863

William H. Mumler, Female "spirit" standing next to a table with a photograph propped against a vase with flowers, 1862–75

Reed B. Bontecou, *G. Porubsky*, 1865

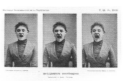

1872
British naturalist Charles Darwin (1809–1882) publishes *The Expression of the Emotions in Man and Animals*, one of the first scientific texts to include photographic illustrations.

American physician Henry Draper (1837–1882), son of John William Draper, makes the first photograph of the star Vega's spectrum, clearly showing spectral lines.

1873
The Moon, featuring dramatic photographs by Lewis M. Rutherfurd (1816–1892), is published.

1874
James Nasmyth (1808–1890) and James Carpenter (1840–1899), British astronomers, publish *The Moon: Considered as a Planet, a World, and a Satellite*, featuring photos of plaster models of the lunar surface believed to be more realistic than was obtainable with telescopic photography of the period.

Many nations, including France, Britain, the United States, Russia, and Germany, dispatch astronomers and photographers to document the transit of Venus by recording the planet's silhouette against the sun so its position could be measured carefully later.

French astrophysicist Jules Janssen (1824–1907) uses a photographic revolver to record sequential images of the transit of Venus.

1876
Swiss chemist Ferdinand Hurter (1844–1898) and British chemical engineer V. C. Driffield (1848–1915) begin systematic evaluations of the characteristics of various photographic emulsions.

1877
German physician and pioneering microbiologist Robert Koch (1843–1910) is first to publish photographs of bacteria.

1878
In Palo Alto, California, English-born photographer Eadweard Muybridge (1830–1904) uses high-speed stop-motion photography to capture the gait of a horse in motion.

Late 1870s–1880s
Jean-Martin Charcot (1825–1893), a French neurologist, incorporates photographic imaging in his work on hysteria at Salpêtrière Hospital in Paris.

British sociologist, statistician, and eugenicist Francis Galton (1822–1911) creates composite portraits as tools to visualize, characterize, and identify distinct human "types": the criminal, the mentally ill, and the socially inferior.

1880
Using the new dry-plate photographic process, Henry Draper makes a fifty-one-minute exposure of the Orion Nebula.

1881
American inventor Frederic Ives (1856–1937) patents a halftone printing process that enables photographs to be more easily printed with texts in books, newspapers, and magazines.

1882
French scientist Étienne-Jules Marey (1830–1904) makes the first chronophotographs, which combine multiple movements into a single image.

William N. Jennings (1860–1946), an American commercial photographer, begins to systematically capture the various forms of lightning strikes.

Page from Charles Darwin's *The Expression of the Emotions in Man and Animals* (1872)

Lewis M. Rutherfurd, Stereograph of the moon, 1865

Robert Koch, *Bacillus anthracis*, 1877

Albert Londe, *Baillements Hystériques*, for French neurologist Jean-Martin Charcot's work on hysteria at Salpêtrière Hospital in Paris, 1878–1910

Étienne-Jules Marey, Chronophotograph of a pelican in flight, ca. 1882

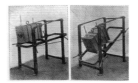
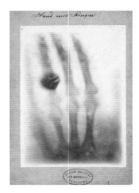

1885
First photographs of individual snowflakes are made by Vermont amateur photographer Wilson A. Bentley (1865–1931).

1886
The first photograph of a supersonic flying bullet is taken by Austrian physicist Peter Salcher (1848–1928).

First photographs of the human retina are made by W. T. Jackman (fl. 1880s) and J. D. Webster (fl. 1880s) in London.

The earliest known photographs of shock waves are made by Austrian physicist Ernst Mach (1838–1916), his son Ludwig (1868–1951), and Peter Salcher.

1887
Eadweard Muybridge publishes the massive 781-image photographic collection *Animal Locomotion: An Electro-Photographic Investigation of Consecutive Phases of Animal Movements.*

Scientists meet in Paris and initiate the Carte du Ciel (Sky chart), an international photographic observation project whose goal is to map the heavens.

1888
George Eastman (1854–1932) perfects and patents the first Kodak box camera.

1890s
Nature, a weekly science journal first published in 1869, introduces photographic images in its pages.

1890
German manufacturer Zeiss introduces the Protar lens by Paul Rudolph (1858–1935), the first to successfully correct for all visual aberrations.

1891
Participating observatories around the world begin making photographic plates for Carte du Ciel, the first complete photographic survey of the sky.

First photo of an asteroid is made by German astronomer Maximilian Franz Joseph Cornelius ("Max") Wolf (1863–1932).

1893
Biologist Louis Boutan (1859–1934), advances the field of underwater photography in the course of his work in the University of Paris marine laboratory.

1895
German physicist Wilhelm Conrad Röntgen (1845–1923) makes a startling X-ray image of his wife's hand and revolutionizes medical photography.

1896
Atlas of Nerve Cells by American neurologist M. Allen Starr (1854–1932) features the first published microphotographs of neurons.

1900
The Kodak Brownie camera is introduced and sells for $1, making photography more accessible and affordable to the public.

1902
German physicist Arthur Korn (1870–1945) devises telephotography, which allows photographic images to be transmitted as electrical signals by wire to distant locations.

1905
American businessman and astronomer Percival Lowell (1855–1916) makes photographs of Mars, and claims they show life-supporting canals on the planet's surface.

1908
Arthur Worthington (1852–1916), an English physicist and educator known for his research, drawings, and photographs about fluid mechanics, publishes *A Study of Splashes.*

Ernst Mach, Bow shock wave around a supersonic brass bullet, 1887

Advertisement for the Kodak camera, 1889

Louis Boutan's underwater camera, ca. 1890s

Wilhelm Conrad Röntgen, X-ray image, *Hand with Rings*, 1895

Arthur Korn, Inventor of telephotography, n.d.

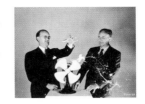

1909
French microbiologist Jean Comandon (1877–1970) attaches a movie camera to a microscope and records time-lapse images of syphilis bacteria.

1910
First filmed version of *Frankenstein*, based on the 1818 novel by Mary Shelley (1797–1851), tells the story of a young scientist who, in trying to create a perfect human being in the laboratory, makes a monster.

1913
Berlin pathologist Albert Salomon (1883–1976) uses an X-ray machine to study mastectomy specimens and observes black spots at the center of breast carcinomas.

1917
During World War I, American art photographer Edward Steichen (1879–1973) becomes chief of the Photographic Section of the American Expeditionary Forces, and develops new aerial photographic surveillance techniques.

The one-hundred-inch Hooker telescope at the Mount Wilson Observatory in California receives "first light."

1919
Photographs of a solar eclipse by British astronomer, physicist, and mathematician Arthur Eddington (1882–1944) confirm Albert Einstein's theory of relativity, are published worldwide, and turn Einstein (1879–1955) into an "overnight" celebrity.

1920
Harry G. Bartholomew (fl. 1920s) and Maynard D. McFarlane (1895–?1983) of Britain invent the Bartlane cable picture transmission system and, in 1921, send photographic images across the Atlantic in less than three hours.

1921
The American news agency Science Service is established to help circulate scientific news to the general public via articles, photographs, films, radio broadcasts, records, and demonstration kits.

1923
American electrical engineer Harold E. Edgerton (1903–1990) invents the xenon flashlamp for strobe photography.

1925
Hungarian-born artist László Moholy-Nagy (1895–1946) publishes the manifesto *Painting, Photography, Film* and encourages artists to look to science photography for inspiration.

1927
Portuguese neurologist António Egas Moniz (1874–1955) uses contrasting agents to make brain imaging in live patients possible.

At the Fifth Solvay International Conference in Brussels, international physicists discuss the newly formulated quantum theory and pose for photos. Among those pictured are Marie Curie (1867–1934), Niels Bohr (1885–1962), Werner Heisenberg (1901–1976), Max Planck (1858–1947), Wolfgang Ernst Pauli (1900–1958), and Albert Einstein.

Film still from *Frankenstein*, 1910, 12 mins., made by Edison Studios

N.W. Grenzen to S.W. Ransbach, 1919: a page from an album of aerial photographs

Newspapers announcing the confirmation of Einstein's Theory of Relativity, November 10, 1919; (left) *New York Times*, (right) *Illustrated London News*

Harold E. Edgerton dropping an egg into a fan, photographer unknown, 1940

Portrait of László Moholy-Nagy by Lucia Moholy, 1926

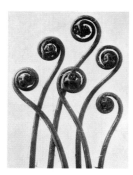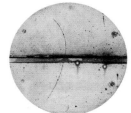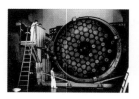

1928
German photographer Albert Renger-Patzsch (1897–1966) publishes *Die Welt ist schön* (*The World Is Beautiful*), in which equally elegant photographs of both natural forms and mass-produced objects are juxtaposed.

German photographer Karl Blossfeldt (1865–1932) publishes *Urformen der Kunst* (*Art Forms in Nature*), featuring elegant macrophotographs of plants.

1929
Hungarian physicist Kálmán Tihanyi (1897–1947) invents prototypes for anti-aircraft, infrared, night vision television cameras for the British Air Ministry.

1930
German optician Bernhard Voldemar Schmidt (1879–1935) devises a corrector plate that enables telescopic images of the sky to be made with wide fields of view and limited distortion.

1931
German engineer Ernst Ruska (1906–1988), working with Max Knoll (1897–1969), builds a prototype for an electron microscope, the first instrument to provide better definition than a light microscope.

In Rouben Mamoulian (1897–1987)'s film *Dr. Jekyll and Mr. Hyde*, based on Robert Louis Stevenson (1850–1894)'s 1886 novel, a man of science ingests a potion he developed and turns into a maniac.

1932
Edwin H. Land (1909–1991), an American scientist, works with a physics instructor, George Wheelwright III (1903–2001), to commercialize polarizing filter technology.

Flexible gastroscope is introduced by German physician Rudolf Schindler (1888–1968).

Images made in a cloud chamber, set up by Caltech scientists Carl Anderson (1905–1991) and Robert Millikan (1868–1953), present strong evidence for the existence of a new particle, the positron.

1933
In James Whale (1889–1957)'s movie *The Invisible Man*, a scientist discovers a way to become invisible and turns insane.

1934
The 200-inch, 29,000-pound telescope mirror for the Palomar Observatory, California Institute of Technology (Caltech), San Diego County, is cast, but takes eleven years to polish; the telescope becomes operational in 1949.

American artist Man Ray (1890–1976) photographs physical models of mathematical functions on display at the Institut Henri Poincaré in Paris. Twelve are published in 1936 in the journal *Cahiers d'Art*.

1934–37
RCA develops vacuum tubes, extremely sensitive to light in the ultraviolet, visible, and near-infrared ranges, that become useful in nuclear and particle physics, astronomy, and medical imaging.

1936
Photographer and delphinium breeder Edward Steichen displays his flowers in a one-week exhibition at the Museum of Modern Art, New York.

Karl Blossfeldt, *Adiantum pedatum*, 1928

Electron microscope built by Ernst Ruska and Max Knoll, early 1930s

Carl Anderson, Cloud chamber of cosmic radiation, 1932

200-inch mirror blank for the Hale Telescope prior to being shipped to Caltech for grinding and polishing, 1936

Edward Steichen, Installation view of *Edward Steichen's Delphiniums*, Museum of Modern Art, New York, 1936

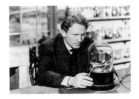

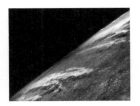

1937
One of Harold E. Edgerton's milk drop coronet photographs is included in the Museum of Modern Art's first photography exhibition, *Photography 1829–1937*.

1938
Xerography, images created by attracting carbon black to paper by electrostatic forces, is pioneered by American physicist and patent attorney Chester Floyd Carlson (1906–1968).

1940
Two feature films about Thomas Edison (1847–1931)—*Edison, the Man*, starring Spencer Tracy (1900–1967), and *Young Tom Edison*, starring Mickey Rooney (1920–2014)—are released.

1942
An early form of ultrasound is employed in medical procedures.

1943
First use of radar to detect storms.

1945
The first atomic bomb is detonated in the New Mexican desert (code name: Trinity) and photographed by dozens of cameras placed at various distances from the blast site.

First electron micrograph of an intact cell is published in the *Journal of Experimental Medicine* in March 1945 in "A Study of Tissue Culture Cells by Electron Microscopy," by Keith R. Porter (1912–1997), Albert Claude (1898–1983), and Ernest F. Fullam (1911–2002).

1946
First image of Earth seen from space is taken by a camera atop a German V-2 missile (which had been captured by Americans during World War II), launched from White Sands, New Mexico.

1947
US military develops infrared line-scanner thermal imaging.

1948
British-Hungarian scientist Dennis Gabor (1900–1979) develops theory of holography.

1950s
American radiologists Russell Morgan (1911–1986) and Edward Chamberlain (1929–1957) and physicist John W. Coltman (1915–2010) develop a method of screen intensification that reduces radiation exposure and leads to advances in medical and military imaging, including night vision.

British chemists Max Perutz (1914–2002) and Sir John Kendrew (1917–1997) use X-ray crystallography to determine the structure of the oxygen-carrying proteins myoglobin and hemoglobin. They win the Nobel Prize in chemistry in 1962.

Premiere of "Better Things for Better Living through Chemistry," a DuPont advertising slogan, which is widely used through 1982.

1951
The New Landscape in Art and Science, an exhibition at MIT curated by Hungarian-born artist/theorist György Kepes (1906–2001), features macro photography and photomicrography, cloud chamber images, and high-speed photographs.

Don Herbert (1917–2007) stars on the popular children's TV show *Watch Mr. Wizard* (1951–65), where he demonstrates the science behind everyday objects and events.

Spencer Tracy as Thomas Edison in the film *Edison, the Man* (1940)

Radar image of thunderstorm and heavy rain, southwest of Spring Lake, New Jersey, August 1945

View of Earth from a camera on V-2 #13, launched October 24, 1946

Surgeon uses a fluoroscope while operating on a soldier during World War I, from *The Book of Modern Marvels* (1917)

Cover of the catalogue for *The New Landscape in Art and Science* (1956)

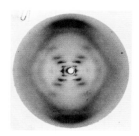
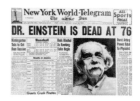

1952

Harold E. Edgerton and business partners, working for the Atomic Energy Commission, develop the rapatronic (rapid action electronic) shutter so cameras can photograph atomic bombs as they explode.

English chemist and X-ray crystallographer Rosalind E. Franklin (1920–1958) and graduate student Raymond G. Gosling (1928–2015) capture Photo 51, the X-ray diffraction pattern image that provides James Watson (b. 1928) and Francis Crick (1916–2004) with the key to understanding the double helix structure of DNA.

1952–54

Life magazine publishes a popular and widely read series of thirteen science articles, The World We Live In, featuring photographs by Fritz Goro (1901–1986), Alfred Eisenstaedt (1898–1995), and others.

1954

Sonographic images, referred to as "sonograms," are reported on in *Life* magazine.

1955

Albert Einstein dies.

1956

In an article published in *The New Statesman* C. P. Snow (1905–1980) introduces his controversial concept of "The Two Cultures," analyzing Western culture's intellectual split between the sciences and the humanities.

French oceanographer Jacques Cousteau (1910–1997) codirects the documentary film *Le Monde du Silence* (*The Silent World*) with Louis Malle (1932–1995).

1957

The Russians' launch of the Sputnik 1 satellite into an orbit around the Earth triggers the Cold War space race.

First computer-scanned photograph, captured by Russell Kirsch (b. 1929) at the US National Bureau of Standards, is a portrait of his three-month-old son.

1958

American electrical engineer and biophysicist Hal Anger (1920–2005) invents a camera that uses gamma rays emitted by a radioactive isotope to detect tumors, and ushers in the age of nuclear medical imaging.

1959

Explorer 6, a small, earth-science satellite launched to study geomagnetism and other properties, also tests a device to scan and photograph the Earth's cloud cover, and transmits the first pictures of the Earth from orbit.

The first photo of the far side of the moon is taken by the Soviet spacecraft Luna 3.

Scottish physician Ian Donald (1910–1987) and colleagues develop practical applications for ultrasound as a diagnostic tool in obstetrics and gynecology.

Sodium deoxyribose nucleate from calf thymus, Structure B, Photo 51, taken by Rosalind E. Franklin and R. G. Gosling, 1952

New York World-Telegram on the day of Albert Einstein's death, April 18, 1955

Promotional poster for *The Silent World*, 1956

Sputnik 1, 1957, photographer unknown

First automatic medical scanner, designed by Tom Brown, operated by Ian Donald and John MacVicar in the Western Infirmary, Glasgow, ca. 1960

1960s
Lidar, similar to radar but using focused laser-light imaging, is first used by meteorologists to measure clouds.

Science images produced by American photographer Berenice Abbott (1898–1991), sponsored by the Physical Science Study Committee, are featured in a high school physics textbook.

1961
Images of Hurricane Esther are captured by Tiros III satellite, in orbit four hundred miles away from Earth.

In *The Absent-Minded Professor*—directed by Robert Stevenson (1905–1986) and starring Fred MacMurray (1908–1991)—a professor formulates an antigravity substance, which a corrupt businessman tries to steal.

Scripted TV shows about medical doctors, such as *Ben Casey* and *Dr. Kildare* (both 1961–66), become popular.

1962
American biologists Sy Rankowitz (fl. 1960s) and James Robertson (fl. 1960s) invent the first positron emission tomography (PET scan) transverse section instrument, which facilitates the diagnosis of different types of cancer, heart disease, and other diseases.

NASA inaugurates an arts program and begins inviting artists, including Robert Rauschenberg (1925–2008) and Norman Rockwell (1894–1978), to make work based on space flight.

1963
British primatologist and anthropologist Jane Goodall (b. 1934) publishes an account of her work, "My Life Among Wild Chimpanzees," in *National Geographic* magazine.

1964
Computers are used to enhance the quality of images of the moon taken by the Ranger 7.

1964–65
American computer scientists Woody Bledsoe (1921–1995), Helen Chan Wolf (fl. 1960s), Charles Bisson (fl. 1960s), and colleagues work with databases of photographic images and pioneer facial recognition systems.

1965
First close-up photo of Mars, transmitted from the Mariner 4 satellite, is published.

Groundbreaking images of an eighteen-week-old human fetus, made by Swedish photographer Lennart Nilsson (1922–2017), are featured in the April 30 issue of *Life* magazine.

1966
In the feature film *Fantastic Voyage*, a submarine shrinks to microscopic size and travels through an injured scientist's circulatory system and body to repair brain damage.

The first lidar laser altimeter was later used on the Apollo 15 Moon mission, 1971

Publicity photograph for the television show *Ben Casey*, starring Vince Edwards, 1961

Robert Rauschenberg, *Horn*, 1969; from the series Stoned Moon

Hugo van Lawick, *Jane Goodall reaches out to touch hands with Flint, the first infant born at Gombe* [Tanzania] *after her arrival*, 1960s

Promotional poster for the film *Fantastic Voyage*, 1966

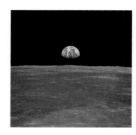

1967

Once Invisible, an exhibition of science photographs curated by John Szarkowski (1925–2007), opens at the Museum of Modern Art, New York.

Sir Godfrey Hounsfield (1919–2004), an English electrical engineer, conceives the idea for computed tomography (CT) scanning, which eventually leads to the building of a whole-body scanner.

1968

Astronauts on Apollo 7, the first piloted Apollo mission, conduct two scientific photographic sessions and transmit television pictures to the American public from inside the space capsule.

Apollo 8 astronaut William Anders (b. 1933) takes a color photograph of Earth rising over the lunar surface that creates a sensation back home and, some believe, triggers the start of the environmental movement.

1969

Willard S. Boyle (1924–2011) and George E. Smith (b. 1930) invent the first successful digital sensor, a CCD (charge-coupled device), which transforms light into signals that can be captured electronically rather than on film.

1970

Albert V. Crewe, British-born American physicist (1927–2009), is the first to photograph single atoms with a scanning transmission electron microscope.

American zoologist and conservationist Dian Fossey's (1932–1985) work with gorillas is featured in photographs in *National Geographic* magazine.

1971

The work of American chemist Paul C. Lauterbur (1929–2007) helps conceptualize and define magnetic resonance imaging (MRI), which uses magnetic fields and pulses of radio-wave energy to picture organs and structures inside the human body, providing different data than other scanning types.

Godfrey Hounsfield and South African–born American physicist Allan Cormack (1924–1998) independently develop the computerized axial tomography scanner used to produce CAT scans, which combine multiple X-ray images to generate cross-sectional views and three-dimensional images of internal organs and structures.

Apollo 15 astronauts use lidar technology to map the surface of the moon.

1972

Landsat, a joint project of NASA and the US Geological Survey, begins to create a continuous map and photographic archive of images of the globe made from space for monitoring agricultural productivity, water resources, urban growth, deforestation, and natural change.

The Blue Marble (bottom right on this book's cover), a photograph of Earth taken by the crew of the Apollo 17 on December 7, twenty-eight thousand miles away, becomes one of the most widely distributed images in human history.

1973

Astronauts on Skylab, the first US space station, capture detailed images of Earth using remote-sensing photographic systems mounted on the spacecraft, in addition to a handheld Hasselblad camera.

1974

NOVA, a popular and award-winning American TV series featuring interviews with scientists, based upon an earlier BBC2 series, *Horizon*, is distributed worldwide.

William Anders, *Earthrise*, 1968

Zero Gradient Synchrotron's Cockcroft-Walton Pre-accelerator, a machine that enabled important advances in particle physics, a result of work by Albert V. Crewe, n.d.

First CAT scan of a living brain, 1971

Landsat 1 (path/row 32/34), center-pivot irrigation near Garden City, Kansas, August 16, 1972

NASA poster of prime crews for Skylab II, III, and IV, 1972

Mid-1970s
Conspiracists question whether the Apollo moon landings ever happened, claiming NASA faked photographs and shot the scenes on Hollywood sound stages.

1975
Steven Sasson (b. 1950) invents the first digital camera at Eastman Kodak. It has 0.01 megapixels, weighs 8 pounds (3.6 kg), and takes twenty-three seconds to record an image to a cassette tape.

The flatbed scanner is invented by American computer scientist/futurist Ray Kurzweil (b. 1948).

Lander from Venera 9, an unmanned Soviet mission to Venus, sends the first images from the surface of another planet back to Earth.

1977
First full MRI scan of a human being is produced.

Powers of Ten: A Film Dealing with the Relative Size of Things in the Universe and the Effect of Adding Another Zero, a film by Charles (1907–1978) and Ray Eames (1913–1988), largely made from still photographs animated into a zoom shot, explores the nature of scale and the limits of the observable universe.

1978
Connections, a ten-episode BBC documentary featuring science historian James Burke (b. 1936), airs and takes an interdisciplinary approach to science.

1979
Voyager 1 spacecraft, nearing Jupiter, captures hundreds of images of its approach.

NASA begins operation of its Infrared Telescope Facility in Hawaii, with an approximately 120-inch reflector.

1980
On the TV miniseries *Cosmos*, American astronomer Carl Sagan (1934–1996) explores and reports on various elements and theories of the universe.

1981
German Gerd Binnig (b. 1947) and Swiss Heinrich Rohrer (1933–2013), physicists working for IBM, design and build the first scanning tunneling microscope (STM), an instrument for imaging surfaces on the atomic level.

1984
Beyond Vision exhibition and book by Jon Darius (1948–1993) for Britain's National Museum of Photography, Film and Television features one hundred photographs tracking the history of science photography.

1986
Gerd Binnig, Cal Quate (b. 1923), and Christoph Gerber (b. 1942) introduce the atomic force microscope (AFM), which is used in nanotechnology, polymer science, and micro- and cellular biology.

The Tagged Image File Format (TIFF) is developed by Microsoft and Aldus to be compatible with multiple-processing programs and devices.

1987
Real-time movie imaging of a single cardiac cycle is made using echo-planar imaging (EPI).

1990
Adobe Photoshop 1.0 is introduced.

The Hubble Space Telescope, a cooperative effort of the European Space Agency and NASA and named after astronomer Edwin Hubble (1889–1953), is sent into orbit, and is designed to be regularly serviced by shuttle crews over its expected fifteen-year life span.

1991
Introduction of functional MRI imaging (fMRI) allows for mapping regions of the brain responsible for thought and motor control, and facilitates early detection of acute stroke.

Sasson digital camera, Eastman Kodak Company, 1975

First magnetic resonance imaging (MRI) scan of a live human body (a cross-section of the human chest), 1977

Jupiter and two of its satellites (Io and Europa) taken by Voyager 1 on February 13, 1979, and assembled from three black-and-white negatives at Jet Propulsion Laboratory, Pasadena, CA

Screenshot of the tools palette for Adobe Photoshop 1.0, 1990

Functional magnetic resonance imaging (fMRI) photograph, 2014

1993
The Face Recognition Technology (FERET) Evaluation works with the Defense Advanced Research Projects Agency (DARPA) in an effort to encourage the development of facial recognition algorithms and technology.

Bill Nye the Science Guy, a live-action educational comedy television program, debuts.

1995
Portable Network Graphics file format (PNG) is created as a flexible file format that allows data compression without loss, cross-platform consistency, and variable transparency.

1997
French-born technology entrepreneur Philippe Kahn (b. 1952) sends the first camera-phone photograph of his newborn daughter.

Beauty of Another Order: Photography in Science, an exhibition curated by Ann Thomas (b. ca. 1944), opens at the National Gallery of Canada, Ottawa.

1999
The Chandra X-Ray Observatory is launched, created to discover X-ray emissions from areas in space that give off heat, such as clustered galaxies, exploded stars, and black-hole matter.

2000
CSI: Crime Scene Investigation (2000–2015), a TV show about a team of Las Vegas police forensic experts, premieres.

2001
First generation of PillCams are introduced.

2003
Launch of the Spitzer Space Telescope, the most sensitive infrared space observatory ever produced, which joins three other space observatories (Hubble, Compton, and Chandra), each observing the universe in a unique light.

2005
The photographic mapping program Google Earth is released for public use. Its development was financed by Keyhole, Inc., a Central Intelligence Agency (CIA)–funded company acquired by Google in 2004.

First light for the Southern African Large Telescope (SALT) in South Africa. It is thirty-six feet in diameter, making it the largest optical telescope located in the Southern Hemisphere.

2006
On assignment for *National Geographic*, American George Steinmetz (b. 1957) is the first photographer to use digital camera traps to photograph wildlife.

2007
The Big Bang Theory (2007–present) premieres on TV, featuring comedic stories about nerdy scientists, their lives, loves, and relationships, and occasional cameo appearances by well-known scientists.

2008
American Roger Tsien (1952–2016) shares the Nobel Prize in Chemistry with Japanese Osamu Shimomura (1928–2018) and American Martin Chalfie (b. 1947) for their work on green fluorescent protein (GFP), used in imaging living cells and tissues.

GigaPan Systems equipment becomes commercially available, using software devised for NASA's Mars *Spirit* and *Opportunity* rovers to create hyperdetailed gigapixel panoramic images.

First light of the Large Binocular Telescope in Arizona, which will have ten times the resolution of Hubble Space Telescope images.

Publicity photograph for the television show *Bill Nye The Science Guy*, 1993

Screenshot from *PillCam SB 2 3D Animation*, YouTube, 2010

Workers at the Kennedy Space Center, Florida, inspecting the Spitzer Space Telescope, 2003

Still from an episode of *The Big Bang Theory* titled "The Separation Oscillation," 2015

Simon Troeder, Fluorescent microscopy picture of HeLa cells expressing a mitochondrially targeted version of green fluorescent protein (mtGFP), 2014

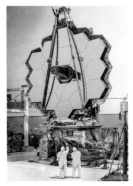

2011

A new microscope developed by scientists at Howard Hughes Medical Institute, Chevy Chase, Maryland, enables the making of three-dimensional movies of living cells.

Lytro announces the first pocket-size light-field camera for consumers, capable of refocusing images after they have been taken.

MIT, using a technique called "femto-photography," develops a camera that captures one trillion frames per second, including light as it moves through space.

Collide@CERN, a program that brings artists and scientists together in a free exchange of ideas, is inaugurated by the European Organization for Nuclear Research, Geneva.

2012

Chinese-born American based computer scientist Fei-Fei Li (b. 1976) and colleagues launch the ImageNet Large Scale Visual Recognition Challenge data set with the goal of collecting millions of images as a resource for computer vision researchers.

2013

NASA launches its Instagram account.

2014

European Space Agency's *Rosetta* spacecraft, after traveling ten years and four billion miles, provides unprecedented close-up images of a comet.

2015

NASA's *New Horizons* satellite, launched on January 19, 2006, conducts a six-month photo-reconnaissance study of Pluto and its moons, and sends unprecedented hi-res images back to Earth.

2016

Scientists at the University of Stuttgart, Germany, create a tiny camera, the size of a grain of salt, that can be injected into the human body through a syringe. University of Washington researchers explore how to convert data from digital image files into strings of DNA, so that images can be stored, retrieved, and read back at a later date.

2017

Using a "streak camera" capable of capturing one hundred billion frames a second, researchers at Washington University in St. Louis, Missouri, record the equivalent of a photonic "sonic boom" in real time.

Swiss Jacques Dubochet (b. 1942), German-born American Joachim Frank (b. 1940), and Scottish Richard Henderson (b. 1945) are awarded the Nobel Prize in Chemistry for developing 3-D, ultra-high-resolution, and molecular level images of proteins, DNA, and RNA.

2018

The Event Horizon Telescope, a worldwide consortium of observatories, collects data and develops algorithms with the goal of producing the first image of a black hole.

Google AI is able to predict risk factors for heart disease by analyzing photos of the retina.

SoFi, a camera-equipped, flexible robotic fish, mingles with real ones to capture unprecedented pictures of underwater life.

Work continues on the complex James Webb Space Telescope (the next-generation successor to the Hubble), a joint project of NASA, the European Space Agency (ES), and the Canadian Space Agency (SCA), now scheduled for a 2021 launch.

MIT Media Lab, Rapid pulses of laser light bounced off of targeted areas enable researchers to see around corners, 2012

Screenshots of ImageNet classification in proceedings of the 25th International Conference on Neural Information Processing Systems, 2012

Taken from the *Rosetta* spacecraft, OSIRIS wide-angle camera image of Comet 67P/Churyumov-Gerasimenko, 2014

Jinyang Liang and Lihong V. Wang, Video still of an optical mack cone captured using compressed ultrafast photography (CUP), 2017

Chris Gunn, 21.3-foot (6.5-m) primary mirror of NASA's James Webb Space Telescope, 2016

Acknowledgments

Seeing Science was developed at the University of Maryland, Baltimore County (UMBC), a joint project of the Vice-President's Office of Research and the Center for Art, Design and Visual Culture (CADVC). The idea for it evolved after I completed *Photography Changes Everything*, which I'd organized for the Smithsonian Photography Initiative, and because I wanted to continue exploring the numerous and active roles photographic images play in shaping knowledge, experience, and culture. Science—as it is practiced and pictured—has always fascinated me and I reached out to UMBC, one of America's leading science research universities, and to CADVC, known for its adventurous programming and innovative visual culture projects. With the enthusiastic support of two successive UMBC Vice Presidents for Research—physicist Gregory Simmons and, now, mechanical engineer Karl V. Steiner—and working closely with Symmes Gardner, CADVC's insightful and encouraging director, an ambitious project took shape. Over three years—as we produced a major website, public and online events, film screenings, and educational outreach programming—the content and themes that shape this book were developed and sparked interdisciplinary dialogue.

At CADVC, contributing to the project were Janet Magruder, whose navigation of logistics and administrative details was skillful and smooth, and Kelley Bell, whose design for *Seeing Science*'s website and outreach projects was smart, upbeat, and bold. Given the multiple components and participants involved, I was lucky to have had talented graduate students working along with me as curatorial and project management assistants. For almost three years, Mitchell Noah played a major role in juggling people, deadlines, social media accounts, and logistical challenges. More recently, Rahne Alexander's work in readying multiple aspects of *Seeing Science* for publication has been welcome, reassuring, and steadying. Thanks, too, to Sandra Abbott at CADVC for reaching out to local area teachers and school groups, the many faculty members I met with, and, in particular, people at UMBC and in the Baltimore area, whose affiliation with the project is appreciated: Rebecca Adelman, Chelsea Alderman, Parastoo Aslanbeik, Dan Bailey, Tom Beck, Lee Boot, Catherine Borg; Steve Bradley, Rachel Brubaker, Scott Casper, Thomas Cronin, Mark Alice Durant, Don Engel, Steve Freeland, Emily Hauver, Preminda Jacob, Mia Jordan, Marie Lilly, Kathy Marmor, Kara Martin, Janet McGlynn, Tom Moore, Tim Nohe, Christopher Shuman, Michelle Starz-Gaiano, Wes Stitt, Joseph Tatarewicz, and Dinah Winnick. Early on, a grant from the Alfred P. Sloan Foundation was instrumental in fueling *Seeing Science*'s online and audience development, and we were both honored by and grateful for that.

The ten conversations about how science is pictured in media that thread through this book are based upon an online event that UMBC produced with Reading the Pictures, a media literacy group, and my collaboration with Michael Shaw and Meg Handler on that was, for me, a project highlight. So was, of course, working with the artists in the project, whose creativity and fascination—with what images can and cannot do, and what we do and do not know—drive the project's visual energy and set off many of its conceptual sparks. I'm also deeply appreciative of the writers who contributed essays and whose thinking underscores how science, photography, and visual culture continually redefine each other.

Instrumental, in still other ways, to the book's development were individuals and organizations whose expertise, advice, and support helped *Seeing Science* take shape: Ed Brydon, Divya Rao Heffley, Mark Lubell, Tony Misch at the Lick Observatory, Saul Ostrow, Rachael Robinson at MIT Museum, the Robert Rauschenberg Foundation, Thomas Seelig, and Andreas Velten from MIT's Media Lab. Special thanks are due to Effie Kapsalis, Liza O'Leary, Tammy Peters, and Heidi Stover at the Smithsonian Institution Archives, and to Charles Traub, Chair of the School of Visual Arts' MFA Program in Photography, Video and Related Media.

It's been a joy for me to work, once again, with Denise Wolff, Aperture's senior editor, whose love of and brilliance at book-making played a major role in the shaping and production of this book. Editorial Assistant Charlotte Chudy's hands-on engagement in and valued insights into all aspects of this publication were essential in keeping things on track. And thanks to Rachel Kober, an Aperture work scholar, who worked with us every step of the way. Knowing how challenging coming up with a fresh and appropriate design for a book like this would be, it's been great to work with Brian Berding, whose vision and precision give this volume its distinctive look. Thanks to Susan Ciccotti and Sally Knapp for their careful eyes over the text and to True Sims and Nelson Chan for their work on the photographs.

Lastly, thinking about *Seeing Science* and life in general, I'm lucky to have Maurice Berger at my side every step along the way. His intelligence, wisdom, and encouragement were invaluable during the development of *Seeing Science*, as they've been in my other adventures in photography and visual culture over the past twenty-five years.

Image and Text Credits

Cover: (top row, left) Courtesy Smithsonian Institution Archives, Record Unit 31, Image No. SIA2013-09131; (top row, center) Courtesy The Roslin Institute, The University of Edinburgh; (top row, right) Courtesy NASA; (middle row, center) Courtesy George Eastman Museum; (bottom row, right) Courtesy NASA; page 5: Courtesy NASA; page 7: Courtesy NASA; page 8: (top) © Universal Pictures/Photofest; page 9: (bottom) © David Gray/Reuters Pictures; page 10: (top) Courtesy Wellcome Collection; (bottom) © 2015, Linus Pauling and the Race for DNA, Special Collections & Archives Research Center, Oregon State University Libraries; page 11: (top) Digital image courtesy the Getty's Open Content Program; (bottom) © 2018 Associated Press; page 12: (top) © 2010 MIT, Courtesy MIT Museum; (center) Courtesy Smithsonian Institution Archives, Image No. SIA2007-0124; page 13: (top) Courtesy The Roslin Institute, The University of Edinburgh; (center) Courtesy Adam LeWinter/Earth Vision Institute; (bottom) Courtesy NASA; page 14: (top and center) Courtesy Wellcome Collection; page 15: (top) Courtesy the Peabody Museum of Archaeology and Ethnology, Harvard University, PM# 35-5-10/53037; page 16: (top) © Carl Strüwe Archive Bielefeld, Germany, Prof. Gottfried Jäger/VG Bild-Kunst Bonn, Germany, Courtesy Steven Kasher Gallery, New York, 2018; (bottom): © 20th Century Fox/Photofest; page 17: (top) © Technical.ly; (center) © Justin Hofman/SeaLegacy; page 18: © 2010 MIT, Courtesy MIT Museum; page 22: Courtesy NASA, ESA and the Hubble Heritage Team (STScI/AURA); page 29: Digital images courtesy the Getty's Open Content Program; page 31: (left) Courtesy The Museum of Fine Arts, Houston, Museum purchase funded by the Buddy Taub Foundation, Dennis A. Roach and Jill Roach, Directors, 2015.62; (right) Courtesy The Museum of Fine Arts, Houston, Museum purchase funded by the Buddy Taub Foundation, Dennis A. Roach and Jill Roach, Directors, 2015.45; page 33: Courtesy Panthera; pages 35, 37: Courtesy Lucy Schneider and The Estate of Paul Byers; page 39: Courtesy University of Toronto, Gerstein Science Information Centre; page 41: Courtesy Rijksmuseum, Amsterdam, Purchased with the support of the Mondriaan Stichting, the Prins Bernhard Cultuurfonds, the VSBfonds, the Paul Huf Fonds/Rijksmuseum Fonds and the Egbert Kunstfonds; page 43: Courtesy NASA; page 45: Courtesy George Eastman Museum, Gift of the 3M Foundation, ex-collection Louis Walton Sipley, 1983.0679.0003; page 47: (top) Digital image courtesy the Getty's Open Content Program; (bottom) Courtesy University of California Observatories and the Lick Observatory Historical Collections Project; page 51: (top left) Courtesy Smithsonian Institution Archives, Record Unit 31, Image No. SIA2013-09170; (top right) Courtesy Smithsonian Institution Archives, Record Unit 31, Image No. SIA2013-09135; (bottom right) Courtesy Smithsonian Institution Archives, Record Unit 31, Image No. SIA2013-09127; (bottom left) Courtesy Smithsonian Institution Archives, Record Unit 31, Image No. SIA2013-09131; page 53: Courtesy The Metropolitan Museum of Art, Twentieth-Century Photography Fund, 2009; page 54: © Stegerphoto/Getty Images; page 59: Courtesy Butterfly Network, Inc.; page 67: Courtesy The Metropolitan Museum of Art, Purchase, Alfred Stieglitz Society Gifts, Joyce F. Menschel Photography Library Fund, and Maureen and Noel Testa Gift, 2011; page 69: Courtesy Smithsonian Institution Archives, MAH-21466; page 71: Courtesy Benrubi Gallery; page 73: © 2015, Linus Pauling and the Race for DNA, Special Collections & Archives Research Center, Oregon State University Libraries; page 75: © World History Archive/Ann Ronan Picture Library; page 78: © Todd Spoth Photography, LLC; page 82: © Saul Loeb/AFP/Getty Images; page 87: Courtesy Smithsonian Institution Archives, Science Service Records, ca. 1920s–70s, Acc. 18-094, E&MP 68.001; page 89: © Docubyte; page 93: (bottom) Courtesy of the artist, from *Last House Standing: How Once We Looked: Photographs of the Past* (Arlington, MA: See-Saw Editions, 2017); page 95: Courtesy http://repeatphotography.org/ and The University of Arizona; page 97: © David Doubilet, National Geographic Image Collection; page 99: Courtesy Peter J. Cohen; page 101: Courtesy the artist, Anglim Gilbert Gallery, San Francisco, and Gallery Luisotti, Los Angeles; page 105: Courtesy Creative Commons; page 115: © Robert Rauschenberg Foundation and Gemini G.E.L., Los Angeles; page 117: Courtesy the artist and Bruce Silverstein Gallery; page 122: © Greg Lovett/*The Palm Beach Post* via ZUMA Wire; page 126: © Anne-Christine Poujoulat/AFP/Getty Images; page 131: © Successors of Lewis Baltz, Used by permission, Courtesy Galerie Thomas Zander, Cologne, and Gallery Luisotti, Los Angeles; page 133: Courtesy the artist and Metro Pictures, New York; page 137: Courtesy James Balog/Earth Vision Institute; page 138: © Nacho Doce/Reuters Pictures; page 143: All courtesy Photofest, Inc.; page 154: © David Ramos/Getty Images; page 159: Courtesy The Historical Medical Library of the College of Physicians of Philadelphia; page 163: All manipulations by the artist, All images from CERN Photo Archive; page 165: © 2010 MIT, Courtesy MIT Museum; page 169: (top) Courtesy Alice Nasto/MIT; page 171: Courtesy Di Wu and Andreas Velten, Camera Culture, MIT Media Lab; page 177: Courtesy Photofest, Inc.; page 179: (top) Courtesy NASA; (bottom) © Horst von Harbou/Deutsche Kinemathek; page 189: Courtesy The Museum of Modern Art, New York, Gift of The Lauder Foundation, Leonard and Evelyn Lauder Fund; page 191: (top) Courtesy MIT Museum; (bottom) Photography by Kate Elliott, Courtesy Kate Elliott and the Science Museum, London; page 195: Courtesy David Goldes/Yossi Milo Gallery, New York; page 201: © Carl Strüwe Archive Bielefeld, Germany, Prof. Gottfried Jäger/VG Bild-Kunst Bonn, Germany, Courtesy Steven Kasher Gallery, New York, 2018; page 202: Courtesy James Bareham, The Verge, Vox Media, Inc.; page 209: (first image) Smithsonian Institution Archives, Accession number: RU95_Box77_10625; page 210: (fourth image) Digital image courtesy the Getty's Open Content Program; page 211: (fourth image) Courtesy Wellcome Collection; page 213: (fourth image) © 2010 MIT, Courtesy MIT Museum; (fifth image) © 2018 Artists Rights Society (ARS), New York / VG Bild-Kunst, Bonn; page 214: (fourth image) Courtesy Palomar Observatory/Caltech; (fifth image) Digital Image © The Museum of Modern Art/Licensed by SCALA/Art Resource, New York; page 215: (first image) © MGM/Photofest; (third image) © White Sands Missile Range/Applied Physics Laboratory; page 216: (first image) © 2015, Linus Pauling and the Race for DNA, Special Collections & Archives Research Center, Oregon State University Libraries; page 217: (first image) Courtesy NASA; (second image) Courtesy ABC/Photofest; (third image) © Robert Rauschenberg Foundation and Gemini G.E.L., Los Angeles; (fourth image) © Hugo van Lawick/National Geographic Creative; page 218: (first image) Courtesy NASA; (second image) Courtesy Argonne National Laboratory; page 219: (first image) Courtesy George Eastman Museum; (second image) Courtesy National Science Foundation/FONAR Corporation; (third image) Courtesy NASA/JPL; page 220: (first image) © Buena Vista Television/Photofest; (third image) Courtesy NASA; (fourth image) © CBS/Photofest; page 221: (first image) Courtesy Christopher Barsi and Andreas Velten/MIT Media Lab; (third image) © ESA/Rosetta; (fourth image) Courtesy Caltech Optical Imaging Laboratory; (fifth image) Courtesy NASA/Chris Gunn

Text Credits:
In addition to "On Seeing Science" and "A Timeline of Science and Photographic Seeing," texts on the following pages were written by Marvin Heiferman: 28, 30, 32, 38, 40, 42, 48, 50, 52, 58, 60, 62, 64, 66, 68, 70, 86, 88, 90, 96, 98, 100, 102, 104, 106, 108, 114, 116, 118, 120, 130, 132, 134, 136, 142, 162, 164, 170, 172, 174, 180, 182, 184, 186, 192, 194, 196, 198, 200

Seeing Science

How Photography
Reveals the Universe

By Marvin Heiferman
Foreword by Scott Kelly

Front cover: From left to right, top to bottom: Wilson A. Bentley, *Snowflake 1152*, ca. 1890 (detail); Photographer unknown, Dolly the Sheep in a field at the Roslin Institute, date unknown (detail); Neil Armstrong, Buzz Aldrin Deploys Apollo 11 Experiments, 1969 (detail); Sanna Kannisto, *Act of Flying 13*, 2006 (detail); Photographer unknown, Sasson digital camera, Eastman Kodak Company, 1975; Thomas Wedgwood, Photogram of a leaf, early twentieth century; William Parsons, Sketch of M51, a whirlpool galaxy, 1845 (detail); Sanna Kannisto, *Amanita muscaria*, 2016 (detail); Photographer unknown, *The Blue Marble*, 1972 (detail)

Editor: Denise Wolff
Editorial Assistant: Charlotte Chudy
Designer: Brian Berding
Design Assistance: Alexander Reyes
Senior Production Manager: True Sims
Production Manager: Nelson Chan
Senior Text Editor: Susan Ciccotti
Copy Editor: Sally Knapp
Work Scholars: Rachael Baker, John Kilbane, Rachel Kober, Julia Martin, Kaija Xiao

Additional staff of the Aperture book program includes:
Chris Boot, Executive Director; Lesley A. Martin, Creative Director; Amelia Lang, Associate Publisher; Taia Kwinter, Managing Editor; Kellie McLaughlin, Director of Sales and Marketing; Richard Gregg, Sales Director, Books

First edition, 2019
Printed in China
10 9 8 7 6 5 4 3 2 1

Library of Congress Cataloging-in-Publication Data

Names: Heiferman, Marvin, editor. | Kelly, Scott, 1964- writer of foreword. |
 Aperture Foundation, editor, issuing body. | University of Maryland,
 Baltimore County, issuing body.
Title: Seeing science : how photography reveals the universe / edited by
 Marvin Heiferman ; foreword by Scott Kelly.
Other titles: Seeing science (Aperture Foundation)
Description: First edition. | New York : Aperture ; Baltimore : University of
 Maryland, Baltimore County, 2019.
Identifiers: LCCN 2018051694 | ISBN 9781597114479 (hardcover : alk. paper)
Subjects: LCSH: Photography--Scientific applications. | Science--Pictorial works.
Classification: LCC TR692 .S44 2019 | DDC 770--dc23
LC record available at https://lccn.loc.gov/2018051694

Copublished by Aperture and the University of Maryland, Baltimore County

UMBC

To order Aperture books, contact:
+1 212.946.7154
orders@aperture.org

For information about Aperture trade distribution worldwide, visit:
aperture.org/distribution

aperture

Aperture Foundation
547 West 27th Street, 4th Floor
New York, NY 10001
aperture.org

Aperture, a not-for-profit foundation, connects the photo community and its audiences with the most inspiring work, the sharpest ideas, and with each other—in print, in person, and online.